The Discovery of the

GREEK
BRONZE AGE

The Discovery of the

GREEK

BRONZE AGE

J. Lesley Fitton

HARVARD UNIVERSITY PRESS

Cambridge, Massachusetts

1996

ƧƧCCA

CONTENTS

For John

What song the Syrens sang, or what name
Achilles assumed when he hid himself
among women, though puzzling questions,
are not beyond all conjecture.

<small>SIR THOMAS BROWNE</small>, *Urn Burial,* 1658

ACKNOWLEDGEMENTS

I would like to thank most warmly the colleagues and friends who have kindly helped me by reading and commenting on some or all of the text of this book before it reached its final form: Lucilla Burn, Donald Easton, Olga Krzyszkowska, Stephen Quirke, Louise Schofield, Veronica Tatton-Brown, Dyfri Williams and Susan Woodford. Particular thanks are due to Ian Jenkins, for inspiration as well as much bibliographical help, and to my father Joseph Fitton for a detailed critique from a non-specialist point of view.

I am grateful to Nina Shandloff and Anne Marriott for their patient and helpful collaboration, to Susan Bird for her maps, drawings and chronological chart, and to 'Nick' Nicholls and Ivor Kerslake for the photographs originating in the British Museum. Katie Demakopoulou kindly provided photographs from the National Museum in Athens, and I thank Manfred Bietak, Tucker Blackburn, Ann Brown, Julie Clements, Christos Doumas, Lisa French, Alexandra Karetsou, Manfred Korfmann, Elizabeth Schofield, Patricia Spencer and Fani-Maria Tsigakou, all of whom either supplied photographs or gave permission for their use.

I thank John, Rebecca, Stephanie and Madeleine for their support and encouragement.

INTRODUCTION

Realisation that Greece was once the home of flourishing and sophisticated Bronze Age civilisations is a relatively recent phenomenon: the product of discoveries made over about the last 125 years. Previously, while for two millennia the Western world had taken an interest in ancient Greece of the Classical period, the age of Pericles and the Parthenon, the origins of this world had been lost to knowledge, and it was generally assumed that the achievements of the Classical Greeks had sprung from misty and uncertain beginnings in just a few generations. The Greeks' own mythical accounts of their early history provided some background, but how much belief could be placed in them, either by the Greeks themselves or by the scholars of the nineteenth century, was a matter purely for conjecture.

Nowadays the quantity of information available can seem daunting, and perhaps never more so than when it is presented in the form of a chronological chart such as Figure 1. It seems no book about the Bronze Age is complete without such a chart, detailing a complex structure of developments, events, styles and periods. In broad outline, it is recognised that the Cycladic islands in the third millennium BC saw a distinctive Early Bronze Age culture that was both flourishing and influential, but was ultimately destined to give way to the even more influential civilisation of Minoan Crete. Crete, larger and potentially more prosperous, saw the rise of a social structure centring on elaborate palaces, built towards the beginning of the Middle Bronze Age in about 1900 BC. The Minoans became the dominant power in the eastern Mediterranean, but were to give way in their turn to the rising power of the Greek mainland and the Helladic culture, which in the Late Bronze Age is sometimes called Mycenaean because of the size and importance of Mycenae at this time. The Late Bronze Age lasted from about 1600 BC until the twelfth century BC when the Bronze Age world collapsed, for reasons that are still not entirely clear.

The arts and crafts that had characterised the sophisticated early cultures now disappeared, leaving Greece to suffer a Dark Age of disruption, relative poverty and isolation from her neighbours. This was to end with the re-establishment of contact with the East; the Geometric period which followed, named after characteristic pottery decoration, would set the scene for the emergence of Classical Greece. The introduction of iron technology in the eleventh century sees the

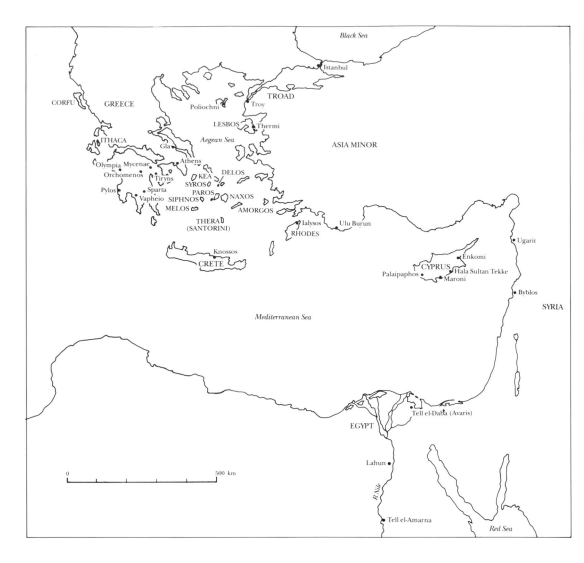

Map of the eastern
Mediterranean area.

'official' beginning of the broad cultural horizon known as the Iron
Age. The Bronze Age had itself been so called because at its beginning
bronze had replaced stone as the main material used for tools and
weapons.

The effort to assimilate this information, and in particular to cope
with notations such as LHIIIA2 and all the other abbreviations to
which the chronological system used for the Greek Bronze Age has
given rise, takes so much energy that it is hard to spare a thought for
consideration of *how* we know all this – or, indeed, whether we really
do know it or whether in fact certain elements at least are matters of
modern invention, a rationalisation devised to impose order on chaos.
These are the questions that this book tries to address, attempting to
trace the progression from a blank to a complex picture, and to show

something of the process whereby the modern view of a remote period that left no written history has been formed.

 Much of the tale is taken up with what might be called the 'heroic' age of the first excavations, spanning the time of Schliemann, Tsountas and Evans, remarkable individuals who revealed the unex-

Chronological chart showing how the cultures of the Greek Bronze Age relate to each other and to their neighbours. The tripartite scheme for Minoan development devised by Arthur Evans at Knossos remains at the heart of such charts. The cultures can only be linked approximately to absolute dates.

	MINOAN	CYCLADIC	HELLADIC	TROY	EGYPTIAN DYNASTIES	
3000						
	EM I	EC I	EH I		I	EARLY DYNASTIC
2900						
2800				Troy I	II	
2700			EH II			
2600	EM II	EC II			III	
2500				Troy II	IV	
2400					V	OLD KINGDOM
2300				Troy III		
2200	EM III		EH III		VI	
2100		EC III		Troy IV	VII VIII	F
2000	MM IA				IX X XI	I / P
1900	MM IB			Troy V	XII	
1800	MM II	MC	MH			MIDDLE KINGDOM
1700					XIII XIV	S
	MM IIIAB					I
1600					XV XVI (Hyksos)	P
	LM IA	LC I	LH I		XVII	
1500	LM IB		LH IIA	Troy VI	XVIII	
1400	LM II	LC II	LH IIB		(Amarna ca 1352–1323BC)	
	LM IIIAI		LH IIIA1			
1300	LM IIIA2		LH IIIA2			NEW KINGDOM
	LM IIIB	LC III	LH IIIB1		XIX	
1200			LH IIIB2	VIIA		
1100	LM IIIC		LH IIIC	Troy VII	XX	
	SUB MINOAN		SUB MYCENAEAN		XXI	T / I
1000					XXII	P

pected richness of important sites such as Troy, Mycenae and Knossos, discovering new cultures whose very existence was previously unknown. Later, a period of consolidation can be charted, when the science of archaeology itself 'came of age' and the interpretation of earlier finds was placed on a firmer footing. If we preface all this with a consideration of what was known or speculated before the age of excavation a tripartite arrangement emerges for our account – appropriately enough, since a glance at the chronological chart will show that, whether for good or for bad reasons, tripartite divisions are its very essence. Yet, as in all such tripartite schemes, we shall find that we need a 'late' (or 'post-' or 'sub-') period to bring the story up to date.

It is undoubtedly true that after the decipherment of the Mycenaean script Linear B in 1952 the basic elements of our modern picture were in place and the initial process that constituted the 'discovery' of the Greek Bronze Age could be said to be over. This might therefore have been a good place to end. Nonetheless, 'discovery' is not really finite and the process still goes on. Thus we may conclude by considering exactly where we stand today in relation to the Greek Bronze Age world. From our modern viewpoint it is clear that earlier interpretations of the evidence have been much affected by the predisposition and preoccupations of the individual interpreter and of his or her own time. The prehistoric period presents the perfect *tabula rasa* for this since the absence of a Bronze Age literature leaves the field particularly open for speculations and no voice from the past can be summoned either to deny or to confirm. There can never be detached judgement; we are as prone ourselves to those influences of place and time that we can see so clearly acting on our predecessors. Perhaps, though, in charting this effect we may move towards greater self-awareness, and hope that this goes some way towards correcting our inbuilt preconceptions.

I

'A PAST THAT
NEVER WAS
PRESENT'

THE ANCIENT VIEW
OF PREHISTORY

Plausible fiction can only be distinguished from fact by external evidence, which was not available to Greek historians. They had no prehistoric documents, no comparative material, no archaeological experience and no access to foreign records.

JOHN FORSDYKE, *Greece Before Homer*, 1956

By the fifth century BC the Classical Greeks had lost all factual knowledge of the period known to us as the Bronze Age. No continuous tradition of written records linked them to this remote past, and the following centuries of relative poverty and isolation – the Greek Dark Age – effectively obscured what had gone before. Until recently the modern world fared no better. The mythological tradition told of a heroic age in Greece, but it was quite possible – indeed, given the lack of evidence, quite logical – to doubt the existence of any such age and many scholars gave up the attempt to use the uncertainties of mythology to create history in the sense that we understand it. Thus in the nineteenth century the historian George Grote struck a sceptical note. He began his great *History of Greece* with the first Olympiad in 776 BC, saying that the tales told of earlier events belonged to 'a past that never was present – a region essentially mythical, neither approachable by the critic nor measurable by the chronographer'. Only the arrival of archaeology and the beginning of the age of excavation would introduce a new sort of evidence – the material remains of the past, from which vital information could be obtained. It was the development of the science of archaeology that allowed the rediscovery of the Greek Bronze Age to begin.

In spite of this, had you stood in the shadow of the Parthenon and asked an educated Classical Athenian about the early history of Greece he would have had plenty to say. The traditions of Greek mythology – the source of major themes in Greek art and thought – provided information which was specifically located in the past, often linked to individuals and places, and which took the place of history. These traditions were also concerned with the gods, the supernatural and the irrational. However, as historical consciousness in the modern sense arose to join, and indeed to challenge, some strands of tradi-

tional mythological thinking, we see the Greek historians starting to question the myths and attempting to rationalise the old stories.

Such efforts stand at the beginning of a line of research still with us today. While current approaches recognise that myths may provide insights that go beyond the rather sere considerations of historical accuracy, nonetheless the relationship between myth and early history continues to fascinate. This is particularly true when it comes to Homer: two of the greatest poems in world literature, the *Iliad* and the *Odyssey*, take their themes from Greek mythology – specifically, the stories surrounding the Trojan War – and it is not surprising that there should be abiding interest in the question of whether they contain any historical truth. This question became, as we shall see, one of the major motivating forces behind the discovery of the Greek Bronze Age, but already it was asked (though perhaps without much scepticism) in the fifth century BC. It is appropriate, then, to begin by surveying the Greeks' attitude to mythology, which largely shaped their thought about and awareness of the past.

THE GREEK MYTHS

The origins of most of the stories in Greek mythology are unchartable. Many seem to be as old as Greek culture itself, with roots going back into the Bronze Age and beyond. They are known to us from written sources that perhaps began as early as the late eighth or early seventh century BC, at about the time when the Phoenician alphabet was introduced to Greece and writing became widespread; the major elements in some stories, however, are known only from sources as late as the Roman period. The time when any particular myth was written down was a matter of chance, depending for example on the decision of a poet or dramatist to treat a certain theme, and it is certain that many stories have not survived.

We are not so much concerned here with the world of the Greek gods, but rather with that of the heroes. These were figures who often had either divine blood in their veins or other close connections with the Olympian deities, but who were still essentially human, acting largely in the human sphere, and who moreover were considered by the Greeks to have lived in an age directly preceding their own. Hesiod's well-known schematic account of the races of mankind upon the earth illustrates this. In his epic poem *Works and Days*, composed in about 700 BC, he speaks of successive ages of gold, silver and bronze being followed by the age of heroes, the time when the protagonists of Greek myth strode the earth. The heroes in their turn were succeeded by the age of iron, Hesiod's own time, about which he is characteristically lugubrious.

Hesiod sees the succession of these races as a continuum – like other Greeks of the historical period he shows no awareness of what we perceive as a Dark Age in Greece – but naturally his schematic

account is not based on material evidence. In fact, the story he tells, which seems to derive from an eastern model, is one of decline, and the successive ages named after metals see things becoming progressively worse. It is therefore significant that the race of heroes disrupts this pattern: they stand out both because their age is not named after a metal and because it does not represent a decline from what went before. It bears all the signs of an addition to the prototype of the tale, and therefore shows how strongly the Greeks inherited a 'real' memory of an earlier age. Hesiod had to add the age of heroes because he and his audience 'knew' that there had been such an age before their own, one which provided the setting for many familiar tales.

Hesiod's description of consecutive bronze and iron ages seems to prefigure the modern definition of cultural phases in these terms, and the poems of Homer certainly preserve knowledge of the fact that bronze preceded iron in general use. It is possible to argue that the schematic ages of Hesiod and other writers, combined with this element of actual knowledge, influenced the recognition of the ages of stone, bronze and iron that still form the basis of our classification today. The development of this so-called 'Three Age' system depended, however, not upon the ancient traditions of man's origins but on the analysis of material culture. The new nineteenth-century positivism was a long way from the speculations of Hesiod, though he should perhaps be given the credit for coining the term 'Bronze Age'.

The Homeric poems are slightly earlier than those of Hesiod. They do not contain a schematic view of early history, nor does Homer speak of the Bronze Age. It is clear, though, that his exclusively bronze-using heroes lived in the not-too-distant past. How distant is not made explicit, but it was long enough ago for things to have been very different. Heroic deeds and heroic men were larger than life, on quite a different scale from the poet's own world. We now see the Homeric poems as one of the elements in the Greek renaissance – the rebirth which came at the end of the Dark Age and Geometric periods, and which ushered in the great age of Classical Greece. Homer, like Hesiod, shows no awareness of the Dark Age, nor of his own place in history. Indeed some scholars would argue that 'he' should not be thought of as an historical individual, and it is true that so few facts are known about him that his very existence cannot really be 'proved'. Various arguments would make the *Iliad* and the *Odyssey* the products of two or more authors, or even of a process which gave rise to the word 'Homer' but which was really one of gradual compilation. However this may be, the Homeric epics, like those of Hesiod, could perhaps be considered to follow a model of decline, in the sense that they describe a past world of heroes that was obviously 'better' – that is, grander and more magnificent than the audience's own time – but this may of course be mainly because such magnificence is what makes that world a suitable subject for epic poetry.

Although the *Iliad* and the *Odyssey* are among our earliest sources, the mythological tradition included many stories that were thought to belong to the generations before the Trojan War. Most of these have only the most general or indefinable relevance to the search for the Bronze Age, but an exception worth remembering here is the story of Theseus.

Theseus was a hero particularly dear to Athenian hearts, and the Athenian attitude clearly shows the quasi-historical status of such figures, since they attributed to him not only such typically heroic

Athenian pottery vase, decorated in the red-figure technique, showing Theseus slaying the Minotaur. About 480 BC (BM Cat. Vases E441)

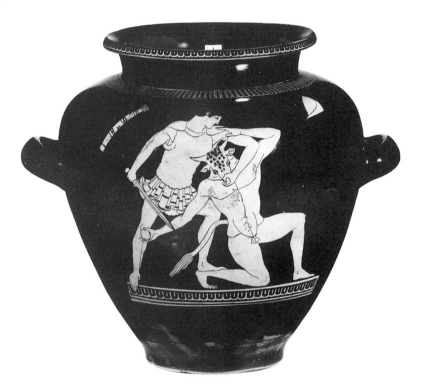

exploits as his encounter with the Minotaur – in other words, actions in the supernatural sphere – but also various significant and practical contributions to the history of their city, namely the shaping of some of their religious and democratic institutions. These latter took place when he became king. it was earlier in his career that he asked to be sent with the tribute of youths and maidens cruelly demanded by King Minos of Crete to be fed to the monstrous bull-man in the heart of the labyrinth. Once arrived in Crete, Theseus killed the Minotaur with the help of Ariadne and escaped safely from the labyrinth. However, the story did not have an entirely happy ending – certainly not for Ariadne, whom Theseus abandoned on the island of Naxos, and not for his father Aegeus who, when Theseus (rather unheroically but perhaps forgivably, after all he had been through) forgot to change

the sails of his ship from black to white in order to signal his safe return, precipitately threw himself into the sea. Thus Theseus, on his return to Athens, became king.

The ability of King Minos to command tribute from Athens in this story seems to preserve a memory of the actual balance of power in the Bronze Age, when the influence of Crete was strongly felt in the eastern Mediterranean. This tradition of the early strength of Crete was certainly accepted by the fifth-century Greek historian Thucydides, who described King Minos as the first person to organise a navy and gain control of the sea. The underlying reality was dramatically confirmed when the Minoan civilisation of Crete was revealed by the spade. Even the details of the story received some support: the Minotaur may have been 'supernatural', but the importance of bulls in Minoan religion, and in particular the Minoan representations of bull-leaping and bull-grappling, seemed to provide a plausible real-life background for the tale of tribute paid to a bull-headed monster.

It was in the next mythological generation that the Greeks sent their massed forces, under the leadership of Agamemnon of Mycenae, to besiege Troy. The events leading up to the ten-year siege, the fighting, the city's eventual fall, and the aftermath with the home-comings of the heroes, formed probably the most powerful and influential group of stories of Greek mythology. Homer's *Iliad* and *Odyssey* are our major sources for the story of the Trojan War, and allude to many of its episodes, although they themselves concentrate on two quite limited themes. The *Iliad* specifically concerns 'the wrath of Achilles', that is, the argument between Achilles and Agamemnon that led to Achilles' withdrawal from the fight, the death of Patroklos when he took Achilles' place, and Achilles' vengeful fury, in which he fought and killed Hector. Hector's funeral concludes the poem. By the time the action of the *Odyssey* begins, Troy had already fallen and the poem tells the story of Odysseus and the further ten years of vicissitudes and enchantments that exercised his resourcefulness to the limit before the gods eventually allowed him to return home.

The Homeric poems seem to have been composed at some time in the second half of the eighth century BC. Dates between *c.* 750 and 700 BC are usually suggested and the *Odyssey*, like its subject-matter, is considered to be the later of the two. Both show all the hallmarks of oral poetry – in other words, they were composed in spoken, not written, form and were essentially meant to be recited, not read. It may be more accurate to speak not of their 'composition', but rather of their 'reaching their final form', since there is no doubt that they were based on a body of pre-existing, traditional material. Precisely when they were written down, and thus preserved in the form in which we know

Bronze group showing an athlete leaping over the back of a bull. Probably Late Minoan I, about 1550–1450 BC. (BM GR 1966.3–28.1)

them, is not clear. Homer himself may have written them, though so little is known about the poet that this cannot be proved. The Greeks inherited the tradition that Homer was a blind bard, like the bard Demodocus described in the *Odyssey*, and in this case he could have worked only with the spoken word. It may be that certain followers, recognising the value of his poems, then preserved them, perhaps at first verbally but before long in writing. The exact process of the composition and preservation of the poems will probably never be known. The so-called Homeric Question is really a series of questions based on all aspects of this uncertainty, and has led to an enormously extensive body of scholarship.

While the origins of the poems are obscure, their very survival shows that they were valued from an early stage. This is underlined by the fact that at the outset they were not alone. Other epic poems existed, some of which told the rest of the tale of Troy, while others dealt with different legends or cycles of legends. Those who argue that the work of an individual poet is preserved in the *Odyssey* and the *Iliad* attribute to the consummate genius of Homer the fact that his two poems have survived the centuries while the others – apart from those of Hesiod – are known only from fragments, or from summaries of their contents jotted down by later writers.

The historical background to Homer, and the connections between the material cultures discovered by the archaeologists and the world that he describes, have formed a major thread in the discovery of the Greek Bronze Age, and will therefore loom large in the chapters ahead. We are concerned here particularly with the ancient Greek view, and there is no doubt that the story of the Trojan War, and other mythological tales, would make up the bulk of what the fifth-century Greek in the shadow of the Parthenon could have related of his country's early history. The result would almost inevitably be a mixture of the plausible and the implausible. However, there were thinkers at the time who were trying to separate the two, and this is therefore a good point at which to turn to the evidence of the Greek historians, who specifically raised the question of how much of what is described by Homer has a basis in historical fact.

THE GREEK HISTORIANS

The Greeks' view of their mythology is a complex subject and modern minds, with their own notions of rationality, may find it impossible to recreate the Greek attitude towards the myths. However, the questions asked by Herodotus about whether and in what way events described by Homer really took place seem to represent an early stage of what we can recognise as critical historical thinking of an essentially modern sort.

Herodotus was born about 484 BC and died probably not long after 430 BC. The broad theme of his work was the conflict between Greece

and Persia, and its second part covers the period from *c.* 500 to 479 BC: in other words, events of the previous generation, for which his sources could be mainly verbal accounts given by those who remembered, or took part in, the events described. In the first part of his work he casts his net more widely, dealing in discursive style with the history, geography, ethnology and folklore of Greece, Persia and Egypt. His story-telling style, and apparently rather naive acceptance of 'travellers' tales', led to harsh ancient criticism of him as a 'liar', though this is most unfair. Indeed, at various points in his narrative he distances himself from any claim to absolute truth, with such statements of principle as, 'Anyone may believe these Egyptian tales, if he is sufficiently credulous: as for myself, I keep to the general plan of this book, which is to record the traditions of the various nations just as I heard them related to me.'

Herodotus' interest in the Trojan War was due to his perception of it as an early and major episode in the East–West struggle that culminated in the Persian wars of his own century. He had no source of information other than Homer and the mythological tradition, and recognised both the difficulty of extracting factual information from poetry and the limitations imposed by his lack of written sources. He says rather wistfully of the Egyptians, 'They have always kept a careful written record of the passage of time', and for this reason when he visited Egypt he tried to check some of the facts about the Trojan War. 'I asked the priests', he says in the second book of his *History*, 'whether the story of what happened at Troy had any truth in it, and they gave me in reply some information which they claimed to have had from Menelaus himself . . .' He goes on to quote their long anecdotal reply.

This is typical of Herodotus' attitude. He poses the basic question, but then accepts and quotes a reply that presupposes the characters and events of the Trojan War to be historical, without further pursuit of the essential point. It is clear from this that he is thoroughly predisposed to assume that the war was an historical event, and does not seriously question the fact. He is more concerned to assess variant traditions about it, knowing that epic poetry is a difficult source. Thus we find him saying, of the version of the story told to him in Egypt that claimed Helen had been there, and not at Troy, for the whole period of the war, 'I think Homer was familiar with the story, for though he rejected it as less suitable for epic poetry than the one he actually used, he left indications that it was not unknown to him . . .'

In spite of his best efforts, however, Herodotus was not in reality able to apply anything other than common sense to the traditional accounts and to assess their likelihood on that basis: it was a good (and thoroughly historian-like) idea to check the Egyptian records, but they did not help, and no genuine external checks were available to him. The sort of problems he faced are most strikingly illustrated by his comment on Homer and Hesiod, whom he says lived 'not more

than four hundred years ago'. We, with our accumulated knowledge, are able to place these poets with some confidence in the later eighth century, a time which – if like the later Greeks we reckon from the first Olympiad of 776 BC – falls well within the 'historical' period. It comes as rather a shock therefore to realise how little this period really was 'historical'. If Herodotus had such problems with the eighth century, what hope had he of looking even further back? He attempts to estimate the date of the Trojan War, and arrives at about 1250 BC, basing his calculation on the traditional genealogies that had been preserved in lists of kings of Sparta. These lists themselves go back into the mythological past: the names that begin them are legendary, and they are thus seriously flawed as sources of chronological fact. Nonetheless, we can now see that Herodotus' date is at least feasible: any real event that lay behind the story of the war could quite happily lie in the Late Bronze Age, before the destruction of Mycenae in about 1200 BC, after which Agememnon's overlordship of the Greek allies would be very unlikely.

Thucydides, a generation later than Herodotus (he lived from c. 455 to 400 BC), was critical of earlier histories and 'historical' accounts, saying the poets 'exaggerate the importance of their themes', while the prose chroniclers were 'less interested in telling the truth than in catching the attention of their public'. He set himself higher standards in appraising the information he received – stories of ants the size of foxes in the remote regions of the world would not be found in his pages, as they were in those of Herodotus. What, though, could he do with the intractable problem of the lack of hard facts about the remote past, and the times 'lost' in his phrase 'in the unreliable streams of mythology'? He admits the difficulty, '. . . I have found it impossible, because of its remoteness in time, to acquire a really precise knowledge of the distant past, or even of the history preceding our own period . . .' For Thucydides too, then, it became simply a matter of rationalising the traditions he inherited. He made a determined attempt, however, in the early pages of his work to wrest a plausible account of the earliest Greek history from the patchy information available to him.

Thucydides accepts the Trojan War as fact without question. It is a sort of fixed point for him. 'We have no record of any action taken by Hellas as a whole before the Trojan War', he says, arguing that before this the land was occupied by a shifting pattern of migratory tribes, the largest of which was the Pelasgian. He makes the point that Homer, 'born much later than the time of the Trojan War, nowhere uses the term "Hellenic" for the whole [Greek] force. Instead he keeps this name for the followers of Achilles . . . the original Hellenes. For the rest he uses "Danaans", "Argives" and "Achaeans". He does not even use the term "foreigners", and this, in my opinion, is because in his time the Hellenes were not yet known by one name.'

This is perceptive, and Thucydides continues to be persuasively

reasonable when he speculates on how the Greeks became sufficiently organised and powerful to mount the Trojan campaign. This, he felt, required some urban development, with the appearance of relatively rich, often fortified cities that controlled weaker neighbours, but more importantly it required the development of naval power. Here he speaks of Minos' control of 'the Hellenic sea' and the Cyclades, and he goes on to describe widespread piracy, which he says in early times was almost a respectable pursuit and certainly contributed to the acquisition of maritime skills by a number of groups of people.

Such developments took place in unnumbered centuries before the Trojan War, and for Thucydides the War itself floats chronologically free. He is not, though, lured by the poetic version of the grand scale of life in the heroic age. He states that, while the Trojan expedition may well have been the greatest that had ever taken place, 'It was not on the scale of what is done in modern warfare', nor were old-fashioned ships as big as those of his own day. Indeed, he briskly concludes that if Agamemnon had had better lines of supply, and had not needed to live off the land while besieging Troy, the war would have been won a great deal more quickly.

The same no-nonsense approach can be seen in his comments about the cities that were home to the legendary heroes. These equally should be on an epic scale but in many cases do not seem all that impressive. Here he expresses some genuinely 'archaeological' thinking. 'Mycenae', he says 'was certainly a small place, and many of the towns of that period do not seem to us today to be particularly imposing', but what would future generations think if they had only the physical remains of contemporary Athens or Sparta? They would certainly consider Sparta relatively insignificant, while Athens would seem 'twice as powerful as in fact it is'. Thucydides concludes from this that the evidence from material remains alone can be deceptive, and the small size of Mycenae and other 'heroic' sites is not in itself good reason to doubt Homer's account of the size of the expedition – though as a poet his figures 'were probably exaggerated'.

Thucydides' account, so far as he was able to go, is both reasonable and feasible. It is perhaps the more necessary to stress again that it is a rationalisation: an intelligent reconstruction based on sketchy and uncertain evidence. In the absence of written or archaeological sources, he had no more facts at his disposal than Herodotus. Thucydides' warnings about the uncertainties of both material and Homeric evidence may seem very apt to the modern archaeologist, but he lived in an age that saw no beginning of archaeology. The notion that deductions can be drawn from a study of past material culture is implicit in his comments about remains of ancient cities, and indeed explicit in his comment about the opening of graves during the purification of Delos, where he mentions in passing that the types of weapons found in more than half of the graves showed them to be 'Carian'. The Carians were a people of southwest Asia Minor. It is

not clear what sort of weapons Thucydides meant, nor why he felt them to be Carian. The importance of his statement lies in its acceptance of the archaeological principle that deductions can be drawn from excavated objects. Yet such tangential conclusions derived from digging for other purposes clearly did not in his time spark the idea of digging in pursuit of the past. This was occasionally done for limited reasons, notably the pursuit of relics of heroes. For example, Herodotus tells of the Spartans excavating and recovering the bones of Orestes from Tegea. That aside, the Classical Greeks – in keeping with their generally philosophical and non-experimental view of history – were not interested in attempting to recover information from excavations in order to back up their thoughts about the past.

The pattern set by Herodotus and Thucydides, then, involved acceptance of many of the old traditions, rationalisation of the stories to make as much sense as possible in real, historical terms, without recourse to supernatural agencies or events, and admission that lack of evidence left many gaps. Later Greek and Roman historians could add little of substance to the stories of the age of heroes and of the Trojan War, though some were bolder than others in giving an absolute date for the fall of Troy. Particularly influential was the date of 1183 BC given by Eratosthenes, librarian at Alexandria in the third century BC and a respected authority, though his estimate – like that of Herodotus – was worked out on the basis of the Spartan king-lists, the disagreement arising only from their calculating the length of a generation differently.

Before leaving the testimony of the historians we might note that, in the approach represented by Thucydides, the heroic age is rationalised into an appropriately simple early stage in Greek history, and Thucydides firmly makes the point that such actions as the Trojan campaign would seem very small-scale and insignificant compared with the immensely important Peloponnesian War that was his own subject-matter. His preoccupation with the recent past allows no room for a sense of loss at the passing of the world of heroes and certainly no nostalgia for a time that was in any sense 'better'. The heroic world is put firmly in its place, as representing a less developed stage of history than Thucydides' own time. One looks in vain for any recognition in Thucydides, or indeed in any of the later writers, that a widespread, fully developed and mature civilisation could have existed in Greek lands at an early stage, and could have subsequently disappeared. The waxing and waning fortunes of individual cities or areas were recognised, but the possibility of truly large-scale disruption and discontinuity – of the decline and fall of an earlier civilisation, and a subsequent Dark Age – did not present itself.

There are various possible reasons for this, and perhaps chief amongst them is a tendency to see history as a linear progression from the 'simpler' times of early man to the urban complexity of the Classical world. While neither Herodotus nor Thucydides makes any

attempt to trace back the history of mankind on earth from its origins, elaborations on the way in which human society progressed from a simple to a more complex stage can be found in the ancient writers, representing a line of thought that runs contrary to Hesiod's picture of the earth's decline from a Golden Age, seeing instead a picture of man's development through increasing mastery of his environment. Thus mankind at first was at the mercy of the earth, and the first-century BC historian Diodorus Siculus paints a vivid picture of men living in caves, hunting, eating wild grasses, grouping together for safety and making major advances such as the development of language and the discovery of the use of fire. The Roman philosopher Lucretius pursues the parallels of social and technological developments, saying man first scraped a living using 'nails, teeth, stones, wood and fire', then learnt to use copper and thirdly iron, each stage of man's development being marked by the exploitation of increasingly intransigent raw materials.

Such developments could also be described in terms of mankind's relation with animals. In this scheme the first stage was that of hunting, representing the age when man pursued and snatched a living from natural resources, but did not yet tame them or bend them to his own ends. Later on, he began gradually to take control, first, according to Aristotle and later writers, as a shepherd, living a nomadic, pastoral life, then as a farmer, when he settled down to cultivate the land. This tripartite succession of hunting, pastoralism and agriculture was thought to represent a progression from the earliest times through the mythical or heroic age of pastoralism to the civilised age of settled farming.

Like the succession of stone, copper and iron this formulation strikes a modern note and seems uncannily like knowledge that man was (in modern parlance) a hunter-gatherer before the change to settled farming in the neolithic period. Again this relationship is more apparent than real, for the ancient speculation resembles the known situation only to the extent that it was rooted in real probabilities – unlike us the ancient world had no empirical proof. Such schemes might also be said to have set the pattern for the way in which the past would be viewed, and the tripartite formulation is an interesting element of this. Yet, lacking archaeological information, such theoretical reconstructions of man's history could go no further and it can be argued that, because they had no place for the possibility of a previously high level of civilisation that had later disappeared, they made it almost impossible for the Classical Greeks to envisage their actual relationship to the early past.

A further bar to what we now view as a true perspective came, paradoxically, from the nature of the oral tradition itself. On the face of it, this was not only the sole source of information, but was also a good source. The poems of Homer encouraged recognition that an age had existed that saw men living in brightly decorated palaces,

drinking from golden cups and so on. If such details were not simply to be attributed to the realm of fairy-tale, they might have suggested that although this age was as sophisticated as the Classical Greek's own time, it had collapsed and disappeared before the emergence of his contemporary world. However, it was part of the very nature of the oral tradition to be a continuous element connecting the later Greeks to the earlier world. This, therefore, was the last place to look for evidence of disruption and discontinuity. Moreover, since it was also a living tradition, changing over time, it did not present a 'fossilised' picture of a past world at a certain period, but rather contained various elements gathered together and intermingled as time passed. For this reason the modern scholar can argue that much or most of the matter of the *Odyssey* and the *Iliad* belongs to a post-Bronze Age world, though the trappings and setting contain many Bronze Age elements. The result for the ancient world was to confuse and often to telescope the chronology, making it effectively impossible to perceive the progression of Bronze Age, Dark Age and 'historical' period in the way that we see it today.

TRAVELLERS AND DESCRIBERS

While the ancient world did not see the birth of archaeology, travellers of various sorts did take an interest in the physical remains of the past, and sometimes interpreted them in the light of antiquarian knowledge. One such traveller was Strabo, who lived in the later years of the first century BC and the early years of the first century AD, and whose *Geography* survives almost intact. Another was Pausanias, writer of a guidebook to Greece in the second century AD, who describes the remains of certain sites that are important for our story, most notably Mycenae.

Pausanias' account of Mycenae is short. He mentions the circuit wall, and the tradition that such huge masonry was the work of the Cyclopes or giants, and describes the Lion Gate and the Perseia spring. He speaks of the subterranean chambers of Atreus and his sons 'where they kept the treasure houses of their wealth', and a series of graves, belonging to Atreus and 'those who came home from Troy', that is, Agamemnon and his entourage. Clytemnestra and Aegisthus are reported to have been buried outside the wall, being unfit to lie inside with Agamemnon and his fellow victims of murder.

The identification of the monuments is reported quite uncritically by Pausanias: clearly the local guides (as guides will) explained everything in terms of the great names from the heroic past and he was quite happy to believe them. Not only that, but he seems to have assumed that travellers in his footsteps would equally have the landmarks pointed out to them, and therefore his topographical detail is sketchy in the extreme. For these reasons his accounts of ancient sites often pose as many problems of identification and interpretation for

the modern reader as they solve, though they remain a fascinating indication both of what was visible in his time and of what was said about it.

Some of Pausanias' names for things have stuck – thus the Treasury of Atreus is still so called in spite of general recognition that it is a tomb, and the lions of the Lion Gate are so identified on his authority, though the heads are now missing, making it seem at least possible that they may have been griffins. His description was also to shape Schliemann's attitudes when he first approached the site. Indeed, so untroubled was Schliemann by the sketchy nature of the information given by Pausanias, and so trusting in its accuracy, that he unerringly began digging in the area of the tombs within Mycenae's walls – the so-called Shaft Graves – and happily discovered them on the basis of Pausanias' account. He seemed surprised that anyone was surprised by this, though it is far from clear that these were in fact the graves that Pausanias had seen.

The factual accounts of travellers dealt with places and monuments; early writers also began the tradition of describing and classifying objects in a way that in the wake of the Renaissance would, in the seventeenth and eighteenth centuries, be taken up by natural historians and antiquaries. The most notable of the ancient authors is the elder Pliny, whose *Natural History* of the first century AD is filled with accounts and descriptions of a wide range of items, both natural and man-made. The mixture of both types of specimen would later be characteristic of those Cabinets of Curiosities that were the forerunners of our modern scientific museums. It is sometimes forgotten that the classification and typological arrangement of archaeological objects owed much to the natural sciences before the two disciplines diverged. Thus as well as providing speculative schemes for the explanation of human cultural history the ancient world also set firm foundations for the description and classification of artefacts that would become one of archaeology's most important tools.

We have seen, then, that the 'problem' inherited by the modern world – the lack of knowledge about the earliest age of Greece that would eventually lead to disbelief in such an age – was already present for the Greeks of the fifth century BC. Their response was to fill the gap with information from traditional stories, coupled with philosophical reconstructions of the way things might, or even should, have been. Certain traditions inherited by the Classical world were later shown to be genuine reflections of early situations: an example is the reported power of Minoan Crete. Without conclusions based on the recovery of material remains, however, mythological evidence was hard to evaluate in historical terms, and failed to give any firm basis for the establishment of a chronology. Archaeology was to provide this, and

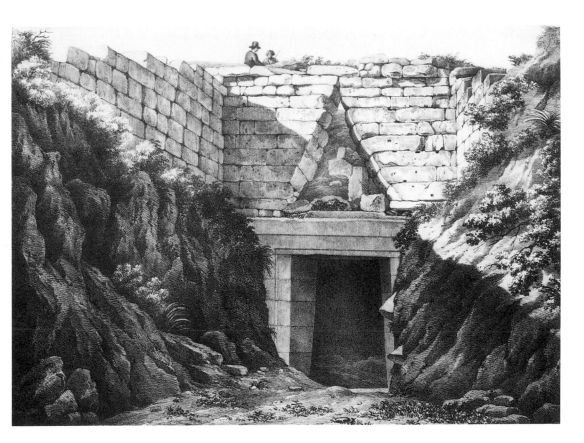

Exterior view of the tholos
tomb known as the 'Treasury
of Atreus' at Mycenae, by
Edward Dodwell, 1805.
(*Pelasgic Remains*, 1834, pl. 9)

for the age before written history effectively became the external
'check' on mythical accounts that Herodotus had sought in vain in
Egypt.

We may end where we began – with myth, and with a final
reminder of the fact that for the ancient world the historical element
of myth was only one strand in its importance. George Grote said
mythology represented 'a past that never was present', yet in a way
for the Greeks the mythological past was always present, re-enacted
not only in religious ritual, but also in drama. In our account of the
attitudes towards the past held by ancient writers we have not had
occasion to mention the dramatists precisely because for Aeschylus
or Euripides historical considerations – the date or 'real' status of
Agamemnon or Hecuba – could not have mattered less. In their hands
these characters played out contemporary dramas, immediate and
engaging, and timeless in their relevance to the human condition.

BEFORE THE AGE OF EXCAVATION

I am among those who have, in previous works, contended or admitted
1) that the poems of Homer are in the highest sense historical, as a
record of 'manners and characters, feelings and tastes, races and
countries, principles and institutions';
2) that there was a solid nucleus of fact in his account
of the Trojan War;
3) that there did not yet exist adequate data for assigning to him,
or to the Troïca, a place in the established Chronology . . .

W.E. GLADSTONE, *Homeric Synchronism*, 1876

The discovery of the Greek Bronze Age was a product of the second half of the nineteenth century, but the thread of our story can be picked up again about a hundred years before this, with the renewal in the mid-eighteenth century of interest in Greek sites, monuments and objects. This Greek revival, together with the development of the new discipline of archaeology, set the scene for the age of excavations and the first Bronze Age discoveries. At about the time that excavations began in Greece, there were dramatic finds in Near Eastern lands which we must briefly survey as part of the background against which the discovery of the Greek Bronze Age was made. While the Bible provided the major impetus for exploration in the Near East, it was the poems of Homer that inspired the search for the Greek heroic age, so this section will conclude with a look at nineteenth-century attitudes towards Homer.

THE REDISCOVERY OF GREECE

Early travellers to Greece had brought back descriptions of the country's topography and monuments, and certain antiquities had come out of Greece from as early as the later medieval period. In the seventeenth century Thomas Howard, Earl of Arundel was an unusual example of an English collector of Greek marbles. However, it was not until about 1750 that serious and scholarly effort was brought to bear on the antiquities of Greece. The London-based Society of Dilettanti was to be important in instigating and supporting such efforts.

Originally formed in the 1730s by a group of young aristocrats who had made the Grand Tour and wanted to encourage appreciation of antiquity, the Society at first concentrated on Rome. Then, in 1751, they supported James Stuart and Nicholas Revett's trip to Athens, and initiated the publication of their important work *The Antiquities of Athens, Measured and Delineated*. This was, and remains, an immensely valuable source of information on the ancient monuments of Athens that survived at that time.

Just a little later, and also of great and lasting importance, was the publication in 1764 of Johann Joachim Winckelmann's *History of Ancient Art among the Greeks*. This, above all, was the work that shaped the general acceptance of the sculpture of Classical Greece as representing artistic perfection. Fifth-century Athens was increasingly admired as the fountain-head of all that was best in Western society and institutions, and her art shared in a general way in this reputation for excellence, but it was Winckelmann who formalised the view. His work stands at the beginning of the 'modern' approach to the study of Classical sculpture because he started from the sculptures themselves, making them the object of detailed and closely observed study. He evolved a system of four supposed stylistic phases, in which the Archaic 'straight and hard' style gave way to the 'grand and square' qualities of Pheidian sculpture, which was followed by the 'flowing beauty' of Praxitelean works, until finally the tradition died away with merely imitative, decadent Roman sculptures. In fact, Winckelmann was working mainly from Roman copies, which he saw in collections in Italy and mistook for Greek originals. Nonetheless, his approach, his view of the development of sculpture through periods of growth, maturity and decay, and his conclusion that Greek sculpture approximated more nearly than any other to a Platonic ideal beauty, were to have long-standing influence.

The debate about whether the Elgin Marbles, which arrived in England in 1807, should be purchased for the nation saw a discussion of the 'ideal' versus the 'natural' as the most worthy aim of art, and the greatest achievement of Greek sculpture. The Winckelmann approach had emphasised the ideal, achieved by the sculptor amalgamating the best elements of all the natural models that he saw before him in the real world. Joshua Reynolds in his lectures to the Royal Academy had taken the 'ideal' approach further, and argued that the aim of the artist must be to achieve an ideal beauty that existed in his mind rather than in his living models, and was in reality unattainable. The Elgin Marbles were seen by some radicals as the perfect refutation of Reynolds' extreme Platonist view, as they were based on observation of nature: of real, living forms. There was, however, a middle position, which viewed the sculptures as based on nature but striving towards a perfection of representation that could be seen as 'ideal'. As so often, much depended on the definition of terms. What is beyond dispute is that after their arrival in England

the Elgin Marbles occupied a position of pre-eminence in the assessment of ancient art, and of art in general. As paradigms of artistic excellence, they influenced thinking on the much older and seemingly primitive products of the Greek Bronze Age, when these began to come to light later in the nineteenth century.

Admiration for all things Greek characterised the first half of the nineteenth century and confirmed the character of this period in Europe as that of a Greek revival. At the same time, however, the works of other cultures were increasingly being brought back from travels and excavations, vying for space in the major museums of the world and for scholarly and public attention. Paradoxically, it would be this non-Greek material that would eventually pave the way for a fuller understanding and appreciation of Greek Bronze Age artefacts. Narrow-minded 'Helleno-centric' views would be forced to change by the presence of, for example, Egyptian and Assyrian objects, which eventually came to be judged in terms of their own cultures, rather than being compared unfavourably with the art of Classical Greece.

Two marble sculptures from the Strangford collection, both acquired by the British Museum in the early 1860s. The so-called 'Strangford Apollo' (BM Cat. Sculpture B475), a kouros (*far right*) of about 490–480 BC, was immediately admired and exhibited, but it would take the changed attitudes of the early twentieth century before the much smaller Cycladic figurine (BM Cat. Sculpture A17), which dates from about 2700–2300 BC, could be viewed as anything other than a primitive curiosity.

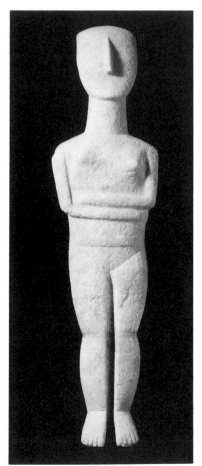

For a long time, though, all non-Classical objects, including Greek Bronze Age material, were treated as poor relations. Thus the occasional pieces of Early Cycladic sculpture that found themselves mixed in with the Classical marbles collected and brought back to western Europe were widely greeted with such scathing epithets as 'rude', 'barbaric', or even 'grotesque' – though now, in a world whose perceptions have been altered by movements in modern art, they are widely admired and much sought after for their purity of line and abstract simplicity. Minoan and Mycenaean seal-stones, too, were often included almost accidentally in collections of gems, where their chronological relationship to later pieces remained obscure, though they were often recognised as in a general sense 'early'. This 'earliness' was confirmed by comparisons with excavated material, a process that actually began with the objects found by Auguste Salzmann and Alfred Biliotti at Ialysos on Rhodes.

Salzmann and Biliotti were a pair of enthusiastic amateurs who dug several sites on Rhodes, where Biliotti was British Vice-Consul. Most of their finds were from the Archaic and Classical periods, but in 1868 they began to excavate what we now recognise as a series of Mycenaean chamber-tombs. The contents were sent to the British Museum, where they became part of the collection looked after by Charles Newton, Keeper of Greek and Roman Antiquities from 1861 to 1886.

Newton was typical of his age in holding the Elgin Marbles to be the acme of Greek art, but was exceptional in pioneering other fields of Greek archaeology, among them an interest in the earliest Bronze Age finds. He became a friend of Heinrich Schliemann, who first contacted him when he began working at Troy, and was later to profit greatly from Newton's advice about the material from Mycenae. The reason Newton was able to be so helpful depended in part upon the existence both in the British Museum's collections and elsewhere of Bronze Age material already acquired, but which floated in the limbo of general earliness rather than being properly pinned to any known chronological sequence. Such material included not only Cycladic sculpture and carved seal-stones, but also vases of the types that at Ialysos were recovered for the first time from an excavation that was at least scientific in intent, if not of a particularly high standard of execution.

The Ialysos finds had been thought by the excavators to belong to about the seventh century BC, several centuries later than their real date, and Newton only turned his attention to the whole subject when he saw Schliemann's finds from Mycenae. Here was a second group of excavated material that was obviously of the same type as that from Ialysos and – to his keen eye – obviously related to some of the 'early' things in his collections as well. Bringing the strands together, he was able to make considerable progress in defining some of the main characteristics of Mycenaean artefacts. Thus vase types such as

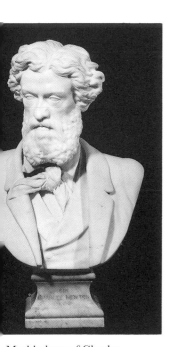

Marble bust of Charles Newton, Keeper of Greek and Roman Antiquities in the British Museum between 1861 and 1886.

Drawing of a cornelian
seal-stone of the Mycenaean
period, about 1400–1200 BC,
showing lions flanking a pillar
in a composition reminiscent of
the relief above the Lion Gate
at Mycenae. Their heads look
outwards. From Ialysos,
Rhodes. (BM Cat. Gems 46)

the so-called 'stirrup jars' and stemmed goblets (kylikes) were typical,
as was ornament based on spirals or octopus designs and other marine
motifs. The Ialysos material (plate 1) also included smaller objects
such as gold ornaments, variously shaped beads in gold, glass, corne-
lian and rock-crystal, bronze tools and weapons, and so on. It was
therefore a rich source of comparison for the finds from Mycenae, as
Newton was quick to recognise. Interestingly, having made this pro-
gress in describing and defining Mycenaean products, Newton still
tended to telescope the chronology and down-date them to about the
eleventh century BC. In view of the fact that he was aware of
Mycenaean-looking objects in a tomb painting in Egyptian Thebes
that was certainly earlier than this, and also had amongst the material
from Ialysos a scarab of Amenhotep III, who is dated to about 1390–
1352 BC, though authorities at the time told him it should not be later
than 1400 BC, this is surprising. Yet he argued that the scarab could
be an heirloom, and the objects depicted in the tomb could be of
types established much earlier than the known actual examples, and
proceeded to get the date wrong by two or three centuries.

In spite of this, Newton achieved more than anyone else in bringing
together the evidence from Greek Bronze Age material found before
the true period of archaeological excavation, and in comparing it with
the picture presented by the first excavated finds. Each helped to
throw light on the other, and provided as full a picture as was then
possible of the culture that was starting to emerge. It seems remark-
ably selfless, and the mark of a truly enquiring mind, that he should
do this in spite of the fact that he considered the material in question
to be uniformly primitive and barbaric and held it, aesthetically
speaking, in very low esteem. With the Parthenon sculptures occupy-
ing the highest point in his estimation of ancient art, he naturally did
not share the relativist approach of the modern world to objects of
different cultures. Moreover, he was predisposed to see in this early
Greek art the forerunners of the art of Classical Greece and felt that
as it stood at the beginning, it must be 'primitive' and, to quote some
of the adjectives he uses, 'clumsy', 'rudely formed' and 'inelegant'. Of
the gold face-masks from Mycenae he says, amusingly enough to
modern ears, 'As representations of life, we can hardly rate them
much higher than the work of New Zealanders and other savages'.
This was a global view, which put together 'primitiveness' in various
cultures to form one of the lowest strata in the notional ascent of the
arts.

Newton was not able to see Mycenaean art as we view it today,
as the creation of a developed civilisation that had collapsed and
disappeared, and whose achievements did not, by and large, stand in
a direct linear relationship to the Greek art of later times. It was to
continue to be a problem for Classical archaeologists to find a place
in their schemes for Bronze Age art. They had been accustomed to
derive Archaic Greek art from the art of Egypt; it was viewed, in the

memorable phrase used by Arthur Evans, as an 'enfant de miracle', springing more or less fully formed from the cradle of the older civilisation, and these earlier developments discovered in Greek lands were rather in the way. Newton solved the problem by viewing Mycenaean objects as results of the blundering first steps in the development of an art which would later be invigorated and renewed by foreign influences. We can see this in his comment about seal-stones: 'The rude gems from the Greek islands seem to carry us back to some remote time before Hellenic art had any style of its own; before it was sensibly, if at all, affected by foreign influences, whether Asiatic or Egyptian . . .'

Newton's wonderful scholarly grasp of the emerging facts about the Greek Bronze Age was rightly very influential, particularly in the reception of Schliemann's finds from Mycenae: he was quoted extensively in their publication, both by Schliemann and in the Preface written by the British Prime Minister W. E. Gladstone, a passionate amateur Homeric scholar. Newton lectured on the finds from Mycenae in London, and his name appears as an authority on the subject in articles in *The Times*. He was, though, enormously influenced by aesthetic considerations in his chronological judgements, and subject to what now seems the tyranny of the received aesthetic viewpoint of his age. Mycenaean material culture had to be judged as 'art', and had to fit into the structure within which the development of Greek art was understood. The pattern established by Winckelmann was, broadly, one of growth, maturity and decay, and these new finds had to belong at the beginning of the sequence. This framework had the effect of a strait-jacket: Newton quite rightly saw Mycenaean culture as 'early', but was prevented from recognising that it was nonetheless developed, and was not 'primitive' in the way he assumed. He would have been astonished to know of the long history of Minoan Crete and its influence on Mycenaean art.

This is not to belittle his remarkable achievements: Newton was a man of his time, and Cretan discoveries were still to come. Moreover, a further positive aspect of his attitude should be stressed. He was prepared to give both due attention and museum space to early, often small and perhaps not very impressive artefacts, believing that they formed an important element in the development of Greek art, and that the achievements of the fifth century BC could only properly be evaluated against the background of the whole picture. This view, which is maintained in the archaeologically based attitudes of the present day, was threatened by those who doubted whether such objects were really 'art', and therefore felt that their study or exhibition was unlikely to be morally improving.

The age of Bronze Age excavation proper will be dealt with in the following chapters, but first we must consider the development of archaeology as a scientific discipline. By Newton's time Classical archaeologists had already worked on sites in Greece, but progress in

the archaeology of the Near East and particularly of Egypt was also to be important in forming the background against which the discovery and interpretation of pre-Classical Greek remains would take place. Moreover, certain fundamental ideas that were important to archaeology in general, and to the interpretation of prehistory in particular, had been developed in northern Europe, especially in Denmark. It is therefore to the formation and early application of the discipline of archaeology that we must now turn.

THE ARRIVAL OF ARCHAEOLOGY

Archaeology, without which the study of the prehistory of any region could not exist, was essentially an invention of the nineteenth century. Its forebears, as Glyn Daniel has shown, were antiquarianism, history and the material sciences, especially geology, and elements from each contributed to the intellectual climate that encouraged the birth of the new discipline. Excavation, in the broadest sense of the recovery of material remains from the ground, was of course not new: chance finds, treasure-hunting and the unsystematic pursuit of ancient objects had a long history. It was, though, to become the archaeologist's primary tool. Progress towards truly controlled excavation was slow, and self-conscious efforts to dig methodically were in general a product of the later decades of the nineteenth century. Before that, though there were exceptions – the excavation of Pompeii in the early 1800s was a precocious effort to dig in a methodical way, encouraged by the unique nature of the lava-covered site – the majority of excavations took the form of a swift assault intended to recover the maximum number of museum-quality objects in the minimum time. The fact that the context of a find was important for dating and interpretation was by and large ignored.

The development of certain ideas forming the underpinning of the new science would lead to increasingly careful excavation and the adoption of techniques specific to archaeological investigations. Three of these ideas, which can broadly be dated to around the middle of the nineteenth century, were of particular importance. The first was the proof of the antiquity of man, which developed from geological proofs, and had understanding of geological stratigraphy as an essential component. The second was the introduction by the northern antiquaries of the Three Age system, which for the first time allowed a sense of chronological order to be brought to the utter obscurity that enveloped northern European history before the period of written records. The third, in the realm of the natural sciences, was the publication by Charles Darwin of the theory of evolution, which would change the whole climate of later nineteenth-century thought.

The recognition of mankind's antiquity – the fact that man's history on the planet went back to unchartably early times – depended not only on the understanding of geological strata but also on the

acceptance by geologists of the principle of 'uniformitarianism'. This was evolved by Charles Lyell, and published in his *Principles of Geology* between 1830 and 1833. It stated that no processes were to be postulated in the past that could not be seen in action on the earth's surface in the present. Thus, for example, if it could be seen that a geological stratum of a certain type was being formed at a very slow rate, it had to be assumed that comparable strata had been formed at an equally slow rate in the past, and their depth had therefore to represent the passage of a considerable length of time. This theory stood in opposition to the 'diluvialist' or 'catastrophist' point of view, which claimed that single great events – notably floods – could have caused major effects in the strata observable in the earth. According to this theory a deep stratum could be explained as the result of a single, and more or less instantaneous, phenomenon: it might, say, be silt left by an enormous flood. Lyell's principle of 'uniformitarianism' would demand that, unless such an effect could demonstrably be seen in operation in the contemporary world, it should not be admitted as an explanation for phenomena in the past.

The problem addressed by adherents of both theories was that remains of stone tools and other man-made artefacts were beginning to be found very deep in certain geological strata, sometimes in association with the remains of extinct animals. The 'catastrophist' point of view made it potentially easier to reconcile such finds with the time-scale then thought to be implicit in the biblical account of creation. Archbishop Ussher (1581–1656), basing his calculations on the genealogical lists in the Bible, had concluded that the creation of the earth as described in Genesis had taken place in 4004 BC and this date was printed in the margin of the Authorised Version: moreover at least one large-scale and momentous flood was attested there, which might be thought to have affected geology as drastically as it had mankind.

In fact, though, it was becoming increasingly clear that 'uniformitarianism' explained the observed phenomena better. This being the case, it followed that the remains left by man went back a very long way indeed, and far earlier than 4004 BC. Exact dates could not be computed, but the depth of certain strata and the assumed slow rate of deposition gave an indication, however imprecise, of man's great antiquity. From a different angle, further proof was provided by the decipherment of Egyptian hieroglyphs. This allowed the reading of early texts and the subsequent confirmation of the fact – already suggested by the king-lists of the Egyptian priest Manetho, who wrote in Greek in the third century BC – that Egyptian history went back to the late fourth millennium BC. If the first recorded king of Egypt lived before 3000 BC Ussher's chronology left little time for the developments that had to be postulated before that stage.

Acceptance of the high antiquity of man took some time, but gradually, during the second half of the nineteenth century, it became a

basis for scientific thought. It is of interest in the present context that one of the scholars in the vanguard of the research into the archaeology of Britain and France that proved the fact was John Evans, father of Arthur Evans, the discoverer of Minoan Crete.

This acceptance, however, did not help the nineteenth-century antiquaries and archaeologists to cope with the jumble of material remains that predated written records. Of course the principles of stratigraphy, learnt from geology, could help with the relative dating of finds from known strata and were to be of inestimable value in excavations, but finds that had been recovered unsystematically could not be sorted by layer, nor could finds from different sites be related in this way. It was in an attempt to solve some of the problems of this prehistoric obscurity that the Danish archaeologists C.J. Thomsen and J.J.A. Worsaae came up with the 'Three Age' system.

Thomsen, and his assistant Worsaae, had to deal with the arrangement of the large number of objects in the National Museum of Denmark, and they chose to group them into three major divisions: those made of stone, those made of bronze and those made of iron. It has been argued that they did not in fact invent this scheme; it may have been 'in the air' at the time and indeed, as we have seen, even in Classical times schematic developments based on materials had been postulated. Now, though, the classification was based on the study of real artefacts, and was backed up by information from stratigraphic excavations, which confirmed the successive use of the three materials. Its application in Copenhagen was the first occasion on which a large group of actual objects had been sorted in this way, and the classification demonstrably made sense, providing a solid framework for the more detailed typological arrangement of artefacts. Soon the notion of the successive Stone, Bronze and Iron Ages gained currency. It was recognised that the new metal technologies were introduced to Scandinavia from elsewhere – the succession of the Three Ages was not seen as evolutionary, in the sense of each arising of necessity from its predecessor by the operation of some natural law – and it was therefore also clear that each Age had no independent chronological existence but had to be located within geographical boundaries. Thus the system of classification was a flexible and valuable tool that could profitably be applied outside the northern lands where it was developed. It has stood the test of time, and is still used today.

The third important development, similarly thought out in the first half of the nineteenth century, was Charles Darwin's theory of evolution, which he published in *On the Origin of Species* in 1859. Darwin's explanation of the diversity of the living world as a result of a long process of natural selection was to be the subject of impassioned debate, particularly because it was seen to contradict the biblical account of the simultaneous creation of each animal and plant. Moreover, the idea that man was descended from the apes rather than

being made in God's image and placed on earth as the master of all creation was seen as dangerously radical, undermining not only the God-given order of nature, but also the social status quo, and therefore threatening the traditionally powerful groups in society. Despite this, the theory increasingly gained adherents, and by the second half of the century it was becoming an accepted basis for scientific thought.

This created a climate in which the cultural history of man was increasingly seen as an evolutionary progression – through, as it were, the successive ages of stone, bronze and iron to the triumphant stage of late nineteenth-century development and beyond. It was this 'beyond' that separated the nineteenth-century idea of progress from that of the ancient world, in that evolution was seen as the operation of a natural law, an ongoing process with no fixed end and certainly no Platonically inspired ideal or God-given perfect form to limit it. It was essentially an amoral process: the Darwinian model saw species becoming better adapted, and therefore more successful, or failing and dying away, but there was no implication that the successful were morally 'better'. All the same, the cultural process was widely per-ceived as one of improvement. In historical terms, the idea of retro-gression had to be accommodated, as it was clear that societies and nations had suffered waning fortunes at various periods in the past, and equally it had to be recognised that cultural change could be brought to certain areas by invaders or by influence from more advanced lands. In terms of prehistory, however, the underlying assumption that the natural tendency of things was to progress partly shaped, and was itself partly shaped by, interpretations of the newly discovered geological and archaeological sequences. The typological analysis of artefacts was also given a powerful new impetus by the acceptance of the principle of evolution in the biological world.

How, then, did this affect attitudes to the Greek Bronze Age, the early exploration of which coincided with the gradual assimilation and acceptance of the theory of evolution? While Darwin had changed man's view of nature, the old schemes for ordering art would not on the surface be necessarily much altered: after all, the same phenomena were being described and the chronological progression from, say, the art of Egypt to that of Assyria and of Greece was becoming increas-ingly well known. Evolutionary thinking may have introduced the underlying idea of a process, and of progressive development, re-placing what had previously been just an ordering into a static sequence, but this would have little apparent effect. The Parthenon sculptures would not fall from artistic grace because of Charles Darwin, and the problems Charles Newton had in fitting Bronze Age artefacts into the early history of Greek art might be said to have been made worse, since he was already too prone to see a direct develop-ment from them to the art of later Greece, and thus had them chained in concepts of primitiveness and earliness. Nonetheless, the broad effect of post-Darwinian thought could be said to undermine the 'ideal'

or teleological status of the Parthenon sculptures. They might represent the high point of a process, but perhaps such processes could now be seen to lead in various directions, and the various products to which they led could be seen and assessed on their own merits.

Not all Classical scholars viewed this as a good thing. 'Darwinism' could be seen to encourage a search for origins, and therefore an interest in the early world of Bronze Age Greece, which would be perceived as a threat to the Classical ideal. Thus in 1908 Percy Gardner, Lincoln and Merton Professor of Classical Archaeology in the University of Oxford, lamented, 'It is a Darwinian age, when the search for origins seems to fascinate men more than the search for what is good in itself.' He returned to the theme in 1911, in his retirement speech from the presidency of the Society for the Promotion of Hellenic Studies, when he said:

> A strong tendency towards a research into origins set in with the rise of Darwinism in the mid-Victorian age . . . Students have dug through successive strata of Greek custom and belief, as they have dug through the successive strata of remains buried in the soil: it would almost seem in the hope of tracing the very first germination of Greek ideas. The pursuit of what is primitive has led them on from point to point, until they are inclined perhaps somewhat to overvalue mere antiquity, to care more for the root than for the leaves and the fruit.

He concludes magisterially, 'I care more . . . for the products of the full maturity of the Greek spirit than for its immature struggles.'

His successor robustly began his first presidential speech the following year with the cheerful riposte:

> I intend to take advantage of my position here today to say something in favour of roots, and even of germs. These are the days of origins, and what is true of the higher forms of animal life and functional activities is equally true of many of the vital principles that inspired the mature civilisation of Greece – they cannot be adequately studied without constant reference to their anterior stages of evolution.

He has his own magisterial conclusion, 'Whether they like it or not, classical students must consider origins.' Gardner could not have been surprised: he presumably did not expect much sympathy for his viewpoint from the new president, who was Arthur Evans. Perhaps, though, Charles Darwin would have been disconcerted to find himself blamed for an unhealthy fascination with the Greek Bronze Age.

Developments in Near Eastern Archaeology

In northern Europe and particularly in Scandinavia, to which the Roman Empire did not extend, the age of written history began quite late, and it was clear that only archaeological techniques could recover information from prehistoric times. Glyn Daniel suggests that it was for just this reason that developments in archaeology such as the

institution of the Three Age system were northern contributions. It is also true that careful stratigraphic excavation and the typological analysis of finds were not only first applied, but for some time were most rigorously applied, in northern Europe, perhaps again because this was the only way in which information could be extracted here. During the nineteenth century the ancient civilisations of Egypt and Mesopotamia, with their extensive use of writing, became the focus of intense archaeological interest, and their rich sites and monuments were explored. Yet they were widely regarded as being something quite separate from Europe. Certainly the relative chronology of the two areas was not much considered at this early time. The general assumption seems to have been that the European tradition, which after all had started with the stratigraphic excavation in Britain and France of very early Stone Age remains, was concerned with a much more remote past than that of the Near Eastern civilisations.

Greek Bronze Age culture fell between these two extremes, not only geographically but also, as it turned out, in the question of writing. Writing was used for administration in the Greek Bronze Age but not apparently for historical records. Nonetheless, historical deductions of a sort can be made from the Linear B archives, so that the term 'protohistoric' is sometimes used for this stage of development. The contemporary civilisations of the East used writing much more extensively, and for records of a genuinely historical nature, while Europe at this time was prehistoric and would remain so for many centuries.

Much research was necessary then before the chronological relationships between these areas could be clarified. Except in mythology, the Greek Bronze Age world had been forgotten. It had not been historically recorded, except for passing references in the writings of Egypt and Near Eastern neighbours, and these would themselves pose problems of interpretation. Essentially, archaeology was necessary for its recovery, and on this technical ground it had much in common with Europe. In fact, though, it soon became apparent that the Greek Bronze Age world had from an early stage been in contact with other areas of the eastern Mediterranean and only in this context could the newly appearing picture be interpreted. It is therefore appropriate here briefly to mention major developments in Egyptian and Near Eastern archaeology in the eighteenth and nineteenth centuries.

Egypt, with its very noticeable standing monuments, was visited in the eighteenth century by travellers and scholars, who described its antiquities with varying degrees of accuracy, and theorised about the meaning of the ubiquitous hieroglyphs. In 1798, with the expedition of Napoleon Bonaparte, Egyptology entered a new era. Napoleon took with him a group of scholars who were to collect and record all that they could of Egyptian history. Moreover, it was a group of French soldiers who in 1799 accidentally discovered the Rosetta Stone, bearing the inscription that would provide the key for the

decipherment of Egyptian hieroglyphs. The decipherment was communicated to the Academy of Inscriptions in Paris by Jean François Champollion in 1822.

The ability to read Egyptian texts was naturally to revolutionise the understanding of Egyptian history and enabled archaeologists to fix accurately the date of various monuments and objects against written records. The fact that many Egyptian objects were closely datable made them the major tool in the establishment of an absolute chronology for the Aegean Bronze Age, with imports from and exports to Egypt assuming great importance.

Research in Egypt in the first half of the nineteenth century continued to be carried on in a generally haphazard way, though some order was brought to the situation by the appointment in 1858 of Auguste Mariette as Conservator of Egyptian Monuments to the khedive (viceroy of Egypt). His job was to protect ancient sites from plundering and to regulate the work done on them. While his own methods of excavation left much to be desired, he worked hard to establish an orderly situation and has been called the 'father of Egyptology'. However, it was not until the arrival on the scene of W.M. Flinders Petrie that controlled excavation really began on Egyptian soil.

Petrie has been criticised by some modern Egyptologists for his haste and carelessness and it is true that, impelled by an obsessive desire to stay ahead of the looters, he rushed from site to site and worked at what now seems to have been extraordinary speed. His aims were laudable, though, and in some respects his standards were high. He took seriously his obligation to publish promptly and insisted that pottery and small objects should be studied as carefully as the more dramatic sculpture and monuments. His use of 'sequence dating' – a refinement of typological analysis that he applied to his pre-dynastic material – was ahead of its time in the attempt to arrive at an objective chronological framework. Most significantly from our point of view, he had an eye for the foreign in Egypt and his finds were to be of the utmost importance for the absolute dating of the Greek Bronze Age, as well as illuminating the nature of the relationship between the two areas. As he remarked, 'The main light on the chronology of the civilisations of the Aegean comes from Egypt; and it is the Egyptian sources that must be thanked by classical scholars for revealing the real standing of the antiquities of Greece.' But this is to anticipate: Petrie's excavations were contemporary with those of Schliemann and Evans, and thus ran in parallel with the first great age of discovery in Greek lands.

In the Near East, excavations of the Mesopotamian civilisations also began in the first half of the nineteenth century, though naturally travellers had earlier taken a great deal of interest in visiting visible remains and, in particular, in trying to identify the sites named in the Bible. Paul-Emile Botta excavated at what would later prove to be

the site of Nineveh in 1842 and at Khorsabad in 1843, and made remarkable finds, though the identification of the sites was difficult when the texts were undeciphered, and he mistakenly thought the latter was really Nineveh. This problem was also faced by Austen Henry Layard who dug at Nimrud, which he wrongly identified as Nineveh, in 1845–7, and who found he had an archaeological best-seller on his hands when he published *Nineveh and its remains* (1848–9). The world became fascinated by these 'heroic' excavations and Layard, who went on to excavate a number of other sites, became a household name. The interest he generated paved the way for the great public interest which would also greet Schliemann's excavations at Troy and Mycenae.

The eventual firm identification of Nineveh – in part of which Botta had begun to work in 1842 – was to be accomplished only when the cuneiform inscriptions that were frequent everywhere could be read, and this was achieved largely by Henry Creswicke Rawlinson, working on the huge rock-cut cuneiform inscriptions at Behistun. These had been cut on the orders of the Persian king, Darius the Great, in 516 BC to record his victories, and were in three languages. They were on a sheer rock-face some 400 feet above the ground and the act of transcribing them was hard enough, requiring the taking of paper 'squeezes', or impressions, of the inscriptions from a painter's cradle swinging down the rock-face. It was adding insult to injury that they then needed translating, but Rawlinson and other scholars achieved this, and by 1857 it was accepted that the key to Old Persian, Babylonian and Assyrian had been found.

The relative chronologies of these eastern civilisations could only slowly be worked out. In particular, it was some time before it was recognised that the Sumerian culture was very ancient, predating that of the Babylonians and that of the Assyrians. The site of Ur of the Chaldees was first recognised in 1854–5, but not until well into the twentieth century did the brilliant excavations take place there that would again capture the public imagination with wonderful finds and establish beyond doubt the claim of Mesopotamia to be the cradle of civilisation.

ATTITUDES TO HOMER

While archaeology supplied the means for the exploration of early Greece and the nineteenth-century interest in things Greek provided a generalised motive, it was the continued interest in Greek mythology – particularly in the poems of Homer – that gave rise to research spe-cifically into the 'heroic' age. Greek myths continued to inspire art and literature, but the way in which they were regarded changed continuously with the intellectual spirit of the times. The degree to which they were thought to contain information of historical value also changed. The eighteenth-century interest in comparative studies

of mythology tended not to focus on its historical aspect but in the later part of the eighteenth and the early nineteenth centuries the extracting of information that could be used as history became a common approach both in Germany and, later, in England.

This procedure, which allowed conjectural dates for the Trojan War (and even for the expedition of the Argonauts) to be published in general histories of Greece, was to change completely later in the century with the publication of George Grote's monumental and influential *History of Greece* between 1846 and 1856. Grote stated that Greek mythology contained no reliable historical evidence of any period before the First Olympiad in 776 BC, and said that all the stories that were told of times before that, up to and including the events of the Trojan War, belonged in his 'past that never was present'. As Frank Turner says, it was only with the arrival of Schliemann and the excavation of Greek Bronze Age sites that 'The veil that Grote had so tightly drawn across the prehistoric age of Greece was rent asunder.' In fact Turner classes archaeological pursuit of the Greek Bronze Age with the anthropological work of Jane Ellen Harrison in the early twentieth century, saying, 'Each of these endeavours delved into the substructure of the more familiar Homeric and Classical Greek civilisation.'

It was still, though, a matter for debate as to precisely what historical light had been thrown on Greek mythology. Charles Newton, reviewing Schliemann's discoveries at Mycenae, judiciously observed:

> How much of the story of Agamemnon is really to be accepted as fact, and by what test we may discriminate between that which is merely plausible fiction and that residuum of true history which can be detected under a mythic disguise in this and other Greek legends, are problems as yet unsolved, notwithstanding the immense amount of erudition and subtle criticism which has been expended on them.

In this same essay, Newton refers rather jokingly to those scholars for whom the idea of historical reality behind the Greek myths was irrelevant, since as 'Aryanists' they traced the origin of Greek mythology to Indo-European traditions. 'It is not without violence to deep-rooted associations,' he says, 'that an old-fashioned scholar can train himself to think of Agamemnon . . . as one of the dramatis personae in a solar myth.' In fact, his 'old-fashioned' view was more prevalent. Like Newton, most scholars agreed that Schliemann's archaeological discoveries did have some bearing on the question of the history behind Homer and the Greek myths. Thus W.E. Gladstone used the image of Delos, the floating island, finding its roots and anchoring point in the Aegean, as a comparison for the effect of Schliemann's finds on the Homeric Question.

The Homeric Question was, though, a composite affair. It not only encompassed the problem of historicity and Homer, but also the many related questions about the authorship of the poems and the manner

Roman marble portrait bust of the type established during the Hellenistic period, probably about 200 BC, to represent Homer. The portrait reflects the tradition that the poet was blind. (BM Cat. Sculpture 1825)

in which they were composed. The date of the poet and of the matter of the poems had long been recognised as different, simply because Homer says so: he contrasts his own, non-heroic age with that of the heroes he describes. Was it safe, though, to view Homer as a real individual? The assumption had been inherited from the Greeks themselves, but was questioned in the eighteenth century, particularly by the German scholar August Friedrich Wolf.

Wolf recognised that traditional material was incorporated into the Homeric poems, and this is now generally acknowledged. However, he went on to question the existence of a personal Homer, arguing that a group of traditional 'lays' or poems was put together in the Peisistratid period of sixth-century BC Athens. The tradition of a Peisistratid recension comes from Cicero, who speaks of the formerly con-

fused books of Homer being put into the order in which we now have them, though this does not of course imply that the poems were composed or compiled then, as Wolf believed. Much scholarship, particularly in Germany, was spent on the 'analytical' approach to Homer, and arguments about whether he was a single person, and the poems basically unitary in composition, continue up to the present day.

Wolf's *Prolegomena ad Homerum* was published in 1794, and after that anyone who questioned the unitary nature of the poems tended to be described as 'Wolfian', usually disparagingly. In fact it was possible to take a fairly moderate stance, as did George Grote, who saw the poems as essentially unitary and the product of a single hand, though he felt some passages could be recognised as having been added. But Grote was a radical, and the world was at first reluctant to accept such views because it was felt that they might, by extension, undermine the authority of the Bible. Here, too, there was a problem of unitary authorship. Tradition attributed the first five books of the Bible, the Pentateuch, to the hand of Moses, but some scholars had questioned whether this could be true. The initial reluctance to face this problem was largely overcome by the spirit of scientific enquiry later in the nineteenth century, when it was recognised that the same sort of textual criticism should be applied to both the Bible and the Homeric poems.

The Darwinian spirit also affected views of Homer. As Frank Turner says, 'The eager acceptance of the theory of evolution that was characteristic of late-nineteenth-century thought favoured the developmental approach to the composition of the Bible and of the Homeric epics.' For example, Gilbert Murray thought the poems had been constantly revised, with what he called the 'Homeric Spirit' improving them morally, and largely – though not completely – excising references to such abominations as the practice of human sacrifice. In a way, Homer could be viewed as a secular bible, celebrating man's human achievements.

This parallel between the Bible and Homer was important to William Ewart Gladstone, a keen Homerist who found time and energy during his busy political career to publish an astonishing number of scholarly works on the poems, remarking that 'No exertion spent upon the great classics of the world, and attended with any amount of real result, is really thrown away. It is better to write one word upon the rock, than a thousand on the water or the sand.'

Gladstone was concerned with the reform of Classical education at Oxford, and was keen to show that the study of Homer was not inconsistent with a Christian education. He not only took a thoroughly 'realist' and historical view of the poems, advocating thorough consideration of every aspect of the society that they represented, but also felt that external proof would one day emerge of the historical nature of Homeric society. For this reason he was a natural supporter of

Schliemann, delighting in his discoveries at Troy and happily supplying the Preface for *Mycenae*.

Gladstone did not simply take the romantic view that the Homeric poems could be read as an allegory of the Christian condition – incorporating the notion of a simple, noble, uncorrupted race at the beginning of the world – but actually, by some very complex pieces of reasoning, claimed that Homeric religion included Christian elements. He argued that God had communicated with peoples other than the Jews before the covenant with Abraham, and that the promise of a Messiah was present in Greek religion, though eventually the Jewish people had been chosen for the fulfilment of the promise. Gladstone felt that ultimately what was found in Homer was 'a true theology falsified': in spite of his love of the poems, and his enthusiasm for the world they portrayed, he had to see Homeric religion as decayed or incomplete because he felt humanity needed a Redeemer, which the Greeks patently had lacked. The argument eventually rather rebounded against him. His defence of secular occupations, and his use of the Greek experience as an example to be followed, came to be seen, in the increasing secularity of the age, as the perfect rationalisation for that secularity: the contention that Homer and the Greek experience showed what mankind could do for itself, without the intervention of God, left the way wide open for the acceptance of such purely secular experience and achievement as laudable in itself. As Turner remarks, 'Gladstone had portrayed the Greeks of Homer's age as representative of humanity emerging towards civilisation under its own direction, and by the turn of the century that was the only way British intellectuals thought civilisation could emerge.'

It is neither possible nor appropriate to trace all the long and complex history of Homeric scholarship, but one further advance is best described at this point, though it was in fact a development of the early 1930s. This was Milman Parry's recognition of the oral character of the Homeric poems. By comparing the Homeric epics with contemporary oral traditions Parry showed that the repeated use of groups of words is typical of poetry that is designed to be recited and listened to, not written down and read. Examples in Homer include such things as the name of a hero with an adjective to describe him, or words describing a stock situation that happens repeatedly, such as a warrior arming, or dawn breaking. The repeated groups of words arise because they help the bard to recite long passages of poetry from memory. Some are like 'building blocks', allowing him to find a form of the name of a city or hero that will fit metrically wherever they fall in the hexameter line. Others allow him a respite for a few words or lines while he mentally marshals the next part of the plot. This fact, fascinating as an insight into the structure of the Homeric poems, also has major implications for their historic significance. It shows that, potentially at least, not only may basic elements in the stories of Homer be very ancient, as had been recognised, but

also that specific descriptions of, for example, particular objects might also be very old. To what extent the process of transmission would tend to remove archaic vocabulary, or descriptions of things no longer recognisable to the poet's audience, is of course a matter for conjecture. Nonetheless, it is apparent that we may legitimately look in Homer for reminiscences of Greek Bronze Age artefacts, although the date of composition of the poems is very much later.

II

THE HEROIC
AGE OF
EXCAVATION

SCHLIEMANN AT TROY AND MYCENAE

I do suppose that here stood <u>Troy</u>
My Name it is William a jolly boy,
My other Name it is <u>Hudson</u>, and so,
God Bless the Sailors, where ever they do go.

I was here in the Year of our Lord 1631,
and was bound to Old England,
God Bless her.

(Graffito recorded in the Troad in the
late seventeenth century, scratched on a slab
of stone supposed to cover 'Hector's Tomb')

TRAVELLERS IN SEARCH OF TROY

OPPOSITE Map of the Troad (the area around Troy) from Schliemann's *Ilios* (1880).

The story of the discovery of the Greek Bronze Age can be seen as a patchwork of events: chance finds, purposeful excavations, painstaking analysis of finds and imaginative leaps leading to better understanding. By definition there could be no orderly plan of campaign into such unknown territory. Nonetheless, the first substantial steps towards discovery arose from the deliberate search for the world of Homer, and particularly the search for Troy.

From antiquity to the present day the lure of the tale of Troy has been such that travellers have sought the place, wanting to imagine the events described by Homer in their natural setting. Homer makes the general position of the citadel quite clear, describing it as near to the Dardanelles, with Mount Ida to the southeast and the islands of Tenedos and Imbros offshore. Further away lies Samothrace, from the heights of which, according to Homer, Troy was visible. In the immediate vicinity he mentions the rivers Scamander and Simois, the beach where the Greeks drew up their ships and made camp, and the plain where the great armies met and fought throughout the gruelling campaign. Early travellers found the generalities of Homer's description well matched by the real topography of the Troad – the name given to the northwest corner of Anatolia, below the Dardanelles, because the fact that ancient Troy had been in this area was

48

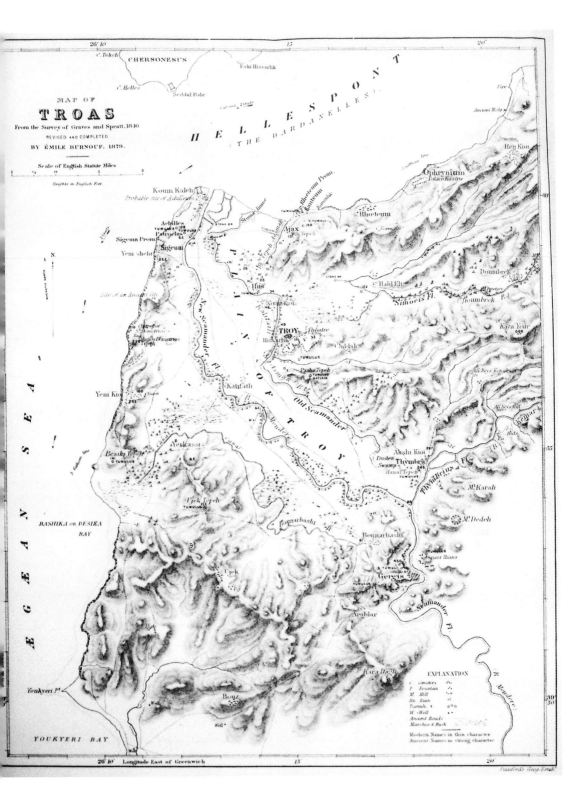

generally accepted. Yet the specific location of the ancient citadel was more difficult to establish, and became a matter of some controversy.

This is perhaps rather surprising when we reflect that the Hellenistic and Roman names of the place now recognised as Troy were Ilion and Ilium Novum (New Ilium). (The names 'Troy' and 'Ilion' seem to be interchangeable in Homer.) Apparently the tradition that here was Homer's Troy had survived the Dark Ages, when the site was probably abandoned, and the inhabitants of the small town that stood there in Classical times did not doubt that they were living on the site of old Troy. Ancient visitors shared this belief. Among them, we are told, were Xerxes, King of Persia, and Alexander the Great, King of Macedon and leader of the Greeks, military commanders who, although one was campaigning westwards and the other towards the East, both thought it appropriate to pay their respects to the heroes and values of the Homeric past. In the same spirit Lysimachus (301–280 BC), a successor of Alexander, rebuilt the city and constructed the fine Temple of Athena there.

In the Roman period the idea that Aeneas had escaped from Troy to found Rome led both Julius Caesar and Augustus to revere Ilium Novum as the site of former greatness. The possibility of founding the new capital of the Roman empire there was mooted – the strategic position of the site between East and West made this a reasonable idea – but it was not acted upon until much later, when in the fourth century AD Constantine the Great actually began building in the Troad, before changing his mind and going on to Constantinople.

Renaissance travellers equally felt the attraction of Troy, both because of the pre-eminent position of the poems of Homer in European literature and because, with the Renaissance enthusiasm for Rome and things Roman, it again seemed important that Troy was Rome's ancestor. Moreover, the fall of the once-great city was felt from antiquity onwards to be a suitable subject for poetic musings, whether as a cautionary tale of pride's ruin, an illustration of the turnings of the wheel of fortune, or simply a melancholy commentary on the evanescence of human affairs: in Ovid's phrase 'Iam seges est ubi Troia fuit' (Now corn grows where Troy once stood).

Arriving by ship, travellers visiting the Troad in the sixteenth and seventeenth centuries were shown extensive ruins that the locals said were Troy, but these were usually a good deal nearer to the coast than the remains of Ilium Novum, which in any case had now lost its ancient name and was too scantily preserved and unimpressive to command much attention. The great arches of the Roman baths at Alexandria Troas, a city founded in the late fourth century BC, were long identified as the remains of Priam's palace though some seventeenth-century sceptics saw this was unlikely. Other visitors, if they happened to put in further north, would be shown the remains at Yenisehir of Constantine's city, begun and then abandoned in the fourth century AD. These equally were claimed as Troy, though this

may not simply be an indication of local mendacity or confusion; instead it seems actually to have been thought that a large area of the Troad was the site of ancient Troy – presumably a huge extent did not seem inappropriate for a place so mighty in legend.

The eighteenth century saw the beginning of that intense scholarly controversy over the precise position of Troy which was to set the scene for Schliemann's activities. The Englishman Robert Wood was among the first travellers to study the Troad in detail, on visits in 1742 and 1750–1. Though he did not identify the location of Troy, or even the position of Ilium Novum, his work was influential because he was the first topographer to study the area systematically and from a 'realist' point of view – in other words, he felt convinced that the story of Troy was the story of an historical place and historical events, even though Troy's very ruins had been lost. Many aspects of the plain of Troy fitted well with the Homeric narrative, but Wood was ahead of his time in the realisation that rivers had changed their courses and that the bay that had once provided Troy with a harbour was extensively silted since antiquity, making the plain larger and the site, whatever its exact location, a good deal further from the sea.

On a non-topographical matter, we might mention that Wood's view that Homer had not used writing, but that the poems were remembered and sung, was equally ahead of his time and deeply influenced Wolf in his view of the composition of the Homeric poems, as discussed above.

Wood's studies were followed by a detailed survey of the northeast Aegean carried out under the auspices of the French ambassador at Constantinople, Choiseul-Gouffier, for whom J.-B. Chevalier was working when he formulated the notion that the site of Troy was to be located at a place called Bunarbashi (Pinarbaşi). An acropolis-like hill looked over an area with natural springs, which he identified with the hot and cold springs described by Homer as the Scamander's source, just outside the walls of Troy. Most scholars still adhered to the Bunarbashi identification in Schliemann's time. More significantly though, it was also as a result of work for Choiseul-Gouffier's survey that the cartographer F. Kauffer was able to put a new ancient site on the map, recognising that ancient remains lay under the grassy and uneven surface of a hill that in modern Turkish was called Hisarlik.

The identification of Hisarlik as the site of Ilium Novum was made by an English traveller, Edward Clarke, on the basis of coins and inscriptions which he was told had been found there or in the neighbourhood, and was first published in 1804 by William Gell in his *Topography of Troy*, which showed the site of 'Ilium Recens' marked at Hisarlik. This seems like a major breakthrough, but it should be remembered that the continuity between ancient Troy and classical Ilium Novum was not considered by this time to be at all obvious, as it had in antiquity. In fact, it still seemed perfectly possible to contend that Troy was elsewhere – or nowhere at all. One of the most famous

negative statements came from the peppery scholar Jacob Bryant, in his monograph of 1796, *A Dissertation concerning the War of Troy, and the Expedition of the Grecians as described by Homer. Showing that No Such Expedition Was Ever Undertaken, and that No Such City of Phrygia Existed.*

The turn of the century, then, saw controversy over the position of ancient Troy raging, with books, pamphlets and monographs fired off in all directions. Armchair archaeologists and students of Homer joined in the debate with topographers and travellers, and feelings ran extraordinarily high. The poet Byron, both seasoned traveller and romantic believer, had little patience with scholarly minutiae, particularly when formulated by those, such as Bryant, who had never been near the Troad. He himself spent time there in 1810 and later wrote in his diary:

> We <u>do</u> care about 'the authenticity of the tale of Troy'. I have
> stood upon the plain <u>daily</u>, for more than a month in 1810; and if
> anything diminished my pleasure, it was that the blackguard
> Bryant impugned its veracity . . . I venerated the grand original
> as the truth of <u>history</u> . . . and of <u>place</u>; otherwise it would have
> given me no delight.

This forceful prose encapsulates the 'realist' viewpoint. His poetic response to the plain of Troy is found elsewhere:

> *High barrows, without marble, or a name,*
> *A vast, untill'd, and mountain-skirted plain,*
> *And Ida, in the distance, still the same,*
> *And old Scamander (if 'tis he), remain;*
> *The situation seems still form'd for fame –*
> *A hundred thousand men might fight again*
> *With ease; but where I sought for Ilion's walls,*
> *The quiet sheep feeds, and the tortoise crawls . . .*
>
> *Don Juan*, Canto IV, 77

The search for Ilion's walls was to be carried on by earnest travellers over the next decades, but with hindsight it is clear that a time was rapidly approaching when rival claims could be tested only by excavation.

Two brothers from a family of English descent, Frank and Frederick Calvert, were pioneers of excavation in the Troad, where they owned land. The Calvert family had been settled for some decades in Turkey, pursuing diplomatic and business careers as well as being landowners and farmers. In the 1850s the brothers excavated at a number of places on their land with considerable success. They discovered ancient remains of various types and periods, gaining considerable archaeological expertise as well as very thorough local knowledge. Both had originally been convinced by Chevalier's identification of Bunarbashi as Troy, but in 1860–1 the draining of marshy ground around Frederick's farmhouse at Akça Koy revealed a hot and a cold spring, reviving, and in the brothers' minds substantiating, an earlier

claim that here was the site of Troy. Frederick seems never to have abandoned this theory, but his brother Frank subsequently turned his attention to Hisarlik.

In 1863 Charles Maclaren published *The Plain of Troy described*, in which he restated his contention, first formulated as early as 1822, that Hisarlik was ancient Troy. This may have spurred Frank Calvert to take more notice of the mound that lay on the edge of his fields and he decided to act. He began by carrying out a series of test excavations at Bunarbashi, finding so little there that he concluded it was not a serious contender as Troy, in spite of the widespread acceptance of the identification. He then made a small sounding at Hisarlik, where he owned land lying to the east of the mound, at the same time beginning to negotiate for the purchase of the whole. He wrote to Charles Newton, Keeper of Greek and Roman Antiquities at the British Museum and an old acquaintance, to suggest a collaboration. Newton had visited the Troad in 1853 and had seen Hisarlik, which he certainly recognised as a potentially interesting ancient site, though only one of many in the area – in the published account of his travels he describes it briefly, saying, 'the remains above ground are very trifling'. Now Calvert suggested that if the Museum would fund the excavations at Hisarlik, they should take all the finds, and excavate any part of his land. Calvert's only stipulation was that he should direct the excavations and that his name should be connected with any finds made.

Disappointingly, the Museum felt unable to collaborate, though Calvert succeeded in buying the northern part of the mound and in 1865 made trial excavations there. These revealed part of the Hellenistic temple and city wall, as well perhaps as Bronze Age remains which could not at that stage be recognised. Without funds for a major campaign of excavations, Calvert was forced to come to a frustrating halt. The mound of Hisarlik, full of promise and established as a likely candidate for Homer's Troy, lay awaiting someone with the means, as well as the will, to excavate. Enter Heinrich Schliemann.

HEINRICH SCHLIEMANN

Heinrich Schliemann was forty-eight years old when he first visited Troy. He had made his fortune in business, and came onto the scene not only as a wealthy man, but as a man looking for a new direction and a second career. A philhellene and lover of Homer, he wanted to turn to scholarly pursuits, so it is not surprising that his intentions became focused around the search for Homer's Troy and the excavation of the Hisarlik hill.

Its problems would occupy him, at intervals, for the rest of his life. His excavations were to wrest some of the secrets from the mound, though its complexities could not be quickly or easily unravelled, and indeed he paid a high price for a too-hasty attack. Nonetheless his is

rightly one of the most famous names in archaeology. His finds, both at Troy and at sites on the Greek mainland, were arguably the most dramatic and significant ever made by any individual – in archaeology, as in business, he had a golden touch. He truly claimed to have found a new world and was without doubt one of the discipline's most remarkable pioneers.

Heinrich Schliemann was born on 6 January 1822 in the little town of Neubuckow, Mecklenburg-Schwerin, in eastern Germany. His father was elected that year to the position of Lutheran pastor in the village of Ankershagen. Here Schliemann spent his early youth and, by his own account, developed a passion for local legends that was to shape his distant future. His father also fired his imagination with stories of Pompeii and Herculaneum, then being recovered from their mantle of lava, as well as recounting for him stories of the Trojan War and the great deeds of the Homeric heroes. When he was nearly eight, Schliemann tells us, he was given a copy of Jerrer's *Universal History for Children*, containing an illustration of Aeneas escaping from the burning city of Troy, carrying his father Anchises and holding the chubby child Ascanius by the hand. The pathos of the foreground figures seems to have been as nothing to the young Schliemann compared with the excitement of seeing large city walls shown in flames behind them. When his father explained that this was only an artistic reconstruction, and that Troy had been totally destroyed, young Heinrich disagreed, instead maintaining that buried remains of the city must survive. 'At last we both agreed,' claims Schliemann, 'that I should one day excavate Troy.'

The rest of the story continues to read like a fairy-tale: determinedly Schliemann threw himself into business pursuits in order to make the money to fund his quest; determinedly, too, he filled every spare minute with learning foreign languages, including ancient Greek so that he could read Homer in the original. A lifetime of effort was crowned with success when this self-made man astonished learned society with the revelation of the world of Homer's heroes. The fairy-tale was complete: it included the improving moral message that effort and determination bring their own reward and coupled this most satisfactorily with the romantic idea that unwavering belief could overcome all obstacles. Schliemann's faith in the noble world of Homer and his heroes could be seen as quasi-religious, with echoes of a Parsifal-like quest in which the naive believer is protected by his innocence and enabled to move mountains – in Schliemann's case, quite literally.

Such stories are rarely exactly what they seem, and the facts of Schliemann's life and activities, where these can accurately be ascertained, are more complex and indeed more extraordinary than the 'stylised' version of his life that has widely been reproduced in the literature. This is based on his own autobiography, which appears in its fullest form in his preface to *Ilios*, and has often been reproduced

uncritically, though it is full of romanticism and inaccuracy. Critics would say that it owes too much to Schliemann's boastfulness and tendency to self-aggrandisement, though it is also true that he viewed his life in retrospect as having had a meaningful pattern, and emphasised this at the expense of random or unhappy events, the better to present a moral tale. One therefore looks in vain, for example, for evidence that his early years must have become very unhappy. He tells of his childhood sweetheart and their mutual pursuit of local legend, but says nothing of his mother's death when he was barely nine, which was soon followed by disgrace falling upon the family when his father – already notorious for a far too public affair with his maid – was wrongly accused of misappropriating church funds. Scandal and near-ruin separated the large family (Schliemann had six brothers and sisters). He was sent to relatives, but money for his education soon ran out. When eventually he returned to his father's home at the age of fourteen he ended his youth with an apprenticeship lasting five and a half years in a grocer's shop.

Modern critics can perhaps scarcely blame Schliemann for glossing over his family scandal – and after all, although censorious of his father, he did keep in touch with him and support him financially for the rest of his life. They have, though, poured scorn on Schliemann's claims for his boyhood 'dream of Troy', asserting that he never thought of the place until he was middle-aged and looking for a change of direction. A letter written by Heinrich to his 88-year-old father in 1868 explains that he is about to publish an account of his long obsession; this has been interpreted, perhaps cynically, as a covert request to his father to back up the story. Whatever the truth, Schliemann does not seem to have mentioned Troy in his letters or diaries before he visited the site. The 'obsession' is a feature only in retrospective accounts and may therefore have been exaggerated, if not necessarily invented, by Schliemann's older self.

There is not room here to mention all Schliemann's remarkable adventures before the archaeological phase of his life, still less the controversies about how truthful his accounts of these adventures were. He seems always to have been the sort of person to whom extraordinary things happened. When he first left home to seek his fortune he was shipwrecked and washed ashore on the Dutch coast, quite literally clinging to a spar. He became a clerk in Amsterdam and later went to St Petersburg, where he became a successful indigo merchant. Indigo was the basis of his rapidly accumulated wealth, but he speculated in other commodities too. He went to America and dealt in gold bought from prospectors in the California gold rush, then returned to St Petersburg and profited hugely from buying saltpetre, an ingredient of gunpowder, just at the outbreak of the Crimean War. Indeed, speculations throughout the war gave him some of the busiest, and most profitable, years of his trading life.

Certain inaccuracies in his diaries have been highlighted recently.

He describes, for example, a meeting with President Fillmore of the United States that is unlikely to have taken place, and gives an eye-witness account of the great fire of San Francisco in 1851, though he was not there at the time. The diaries were not for publication, but these fabrications perhaps show Schliemann trying his hand as a writer. Dissatisfied with his life, he certainly entertained the notion of becoming a travel writer before his ideas finally focused on the scholarly and archaeological world, and in fact his first published work was *La Chine et le Japon au temps present*, which appeared in 1867 and was based on his travels to those countries. We might also bear in mind that the relevant diary entries are in English, and that Schliemann, who tried always to write his diary in the language of the country he was visiting, advocated the writing of such descriptive passages as language exercises. He was a passionate linguist, learning some eighteen ancient and modern languages in his lifetime. At first, he concentrated on languages that would be useful for business – his mastery of Russian was one of the foundations of his success in St Petersburg – and he claims to have postponed learning ancient Greek, the language of his beloved Homer, until a period of his life when he could spend some time on it, since he feared it would distract him too much from work when he still had his fortune to make.

Again there is a colourful story to accompany Schliemann's account of his early love for Homer, this time of a drunken miller, a youth of good education who had fallen into bad ways, and who used to come into the grocer's shop where Schliemann worked. Schliemann bribed him with tots of whisky that he could ill afford to recite long passages of Homer from memory, and was much moved by the sound of the poetry, though he understood not one word.

Whether or not that particular story would stand up to detailed scrutiny, there seems every reason to believe that Schliemann was deeply enthusiastic about Homer and so when, during his restless middle years, he felt the need for a change of direction, it is not surprising to find a latent philhellenism coming strongly to the fore. Since he wanted to leave Russia – and his unsuccessful marriage – behind, he decided to take a two-year trip round the world and, to fill the gaps in his education, he enrolled as a mature student in a series of courses at the Sorbonne, including French language and literature, Greek philosophy and Egyptian archaeology. He wanted, above all, to find a niche in the world of learning. His intention at first seems simply to have been to pursue and develop his travel writing, but Homer was in his mind when his steps were directed, or drawn, towards Greece.

SCHLIEMANN THE ARCHAEOLOGIST

The year 1868 was a turning-point for Schliemann. His Greek travels took him first to Corfu, Cephallonia and Ithaca, and he spent most

of his time seeking out places significant in Homer's poems. With naive enthusiasm he noted that on Corfu, which is identified with the Phaeacia of the *Odyssey*, he saw the washing-troughs of Nausicaa and her maidens. On Ithaca, too, he believed without hesitation all stories that linked specific locations to the Homeric accounts. These identifications were made by local guides and by the standard guidebook which Schliemann carried, but his extremely uncritical tendency to relate every place and every thing to Homer made him the object of some ridicule when he published his own account of his travels.

A more positive element of his approach, though, that emerged at this time, was his instant recourse to the spade to answer archaeological problems. Having found what he thought was the location of Odysseus' palace, he immediately hired four workmen and returned there to dig – his first excavation, though not his most successful. This is the practical side of Schliemann, attacking a problem with energy and purpose, brushing difficulties aside. In spite of his avowed desire to write and the possibility that he greatly exaggerated his early determination to discover Troy, it does seem that excavation came completely naturally to him. He may have picked up the idea when seeing the excavations at Pompeii, which he had visited earlier the same year, but he seems not to have felt any need to boast that digging was his own particular contribution to Homeric studies, although it did not occur to most travellers and writers of his time. Archaeology was still a relatively new science, and Schliemann was far from the most careful exponent of excavation in its early years, but still it seems that Schliemann 'became' an archaeologist unselfconsciously: the discipline claimed him as her own.

Schliemann went on to the Peloponnese, where his first visit to Mycenae prompted his airy statement that, although the tombs of Agamemnon and his companions mentioned by Pausanias are no longer visible, 'No doubt excavations could recover them.' He saw Tiryns, too, on this part of his journey. Then came a sojourn in Athens, where his old friend and Greek teacher from St Petersburg, Theokletos Vimpos, was now an archbishop. From Athens in August 1868, Schliemann set sail for the Dardanelles.

He headed at once for Bunarbashi, then widely identified as Homer's Troy, but claimed in his account of his travels – *Ithaque, le Peloponnese et Troie* (1869) – that he instantly realised the identification was wrong. This was partly because almost no fragments of pottery appeared on the surface in the area, but mainly because of Homeric considerations. Thus, for example, there were far more springs than the two mentioned by Homer at the foot of the hill there; it was unlikely that Hector and Achilles could ever have run three times round Bunarbashi; and to cap it all Mount Ida was not visible from the summit, though it was from Ida that Zeus viewed the progress of the war. This was 'realist' reasoning carried to an extreme, but whether these really were Schliemann's first impressions of the site,

or were written later in a library in Paris, and however flawed the reasoning, they led to the right conclusion.

Schliemann did not rely entirely on these arguments, however. He carried out trial excavations at Bunarbashi, claiming – with a degree of showmanship – that he had done so merely to prove a negative, since he himself was entirely convinced. The negative was duly proved when, like Frank Calvert before him, he found nothing of interest. Bunarbashi rapidly faded into the background, for by the end of his short visit to the Troad Schliemann was completely convinced that Hisarlik was the site of Troy.

In his book he claimed that this conviction instantly overwhelmed him when he visited Hisarlik. In fact, it is clear from his letters that after leaving the Troad he had only the haziest memory of the site. It is quite possible that he did not actually go there, or perhaps saw the mound only from a distance. Certainly he can have paid it only scant attention. He did, though, meet Frank Calvert at the very end of his trip, and it is to this meeting that we must attribute Schliemann's certainty about the identification of Troy. It would be quite in charac-ter for Schliemann both to rush into print to espouse the Troy/Hisarlik theory entirely on Frank Calvert's word, and at the same time to conceal the fact that he had not himself properly examined the site. He confessed himself that he had no painstaking regard for truth: as he once wrote to his brother, 'My biggest fault, being a braggart and a bluffer, yielded me . . . countless advantages.' In print, he simply said that, having viewed Hisarlik, he dismissed his workmen. 'Con-trary to my expectation, I had had no occasion to use them at Hisarlik, for even without any trial digs I had become fully convinced that it was here that ancient Troy had stood.'

It has been a matter of some crusading zeal in recent scholarship to restore to Calvert his proper position in the discovery of Troy, and to picture him as something of a victim of the 'Schliemann effect', cruelly plundered of his information, then discarded, and robbed of his place in history. This is not quite accurate. Undoubtedly Calvert was generous with information and put Schliemann on the right track, which the latter acknowledges in *Ithaque, le Peloponnese et Troie*, where he writes:

> The peak of the hill of Hissarlik consists of a square, flat plateau of some 233 metres in length and width. The ingenious Frank Calvert, by exploring the hill, has established that it was, in the main, raised artificially from ruins and rubble of temples and palaces which through the course of the centuries were successively built on its ground . . . After having twice thoroughly examined the entire plain of Troy, I completely shared Frank Calvert's conviction that the plateau of Hissarlik marks the site of ancient Troy and that on this very hill stood its Pergamus fortress.

Schliemann was not always to acknowledge so openly his debt to

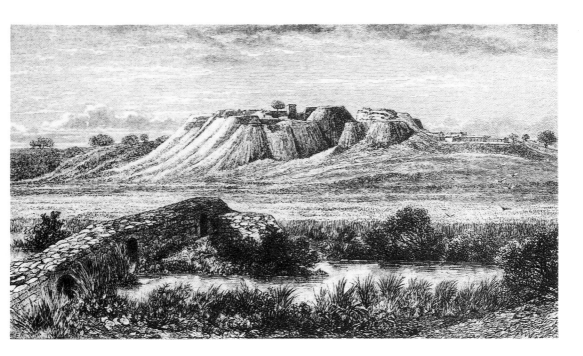

An early view of the mound of Hisarlik from the north-west, from Schliemann's *Ilios* (1880).

Calvert, and relations between them were sometimes to reach a very low ebb, with scholarly disputes that, as so often, led Schliemann to excesses of verbal abuse that seem now almost comic in their vehemence, though they must have been trying to the recipient. He spoke at one point, for instance, of Calvert's 'foul and ignominious accusations' on a matter that now seems the mildest of academic disputes. Even so, the arrival on the scene of a wealthy and enthusiastic amateur who was keen to test some of the theories dear to Calvert's heart must surely have been a source of excitement and satisfaction. Moreover, the collaboration between them was not all one way: Calvert was enabled not only to share in excavations that he could not have afforded to finance himself, but also to use Schliemann's contacts to help sell antiquities abroad.

By the end of 1868, Schliemann's mind was made up. He wrote to Frank Calvert with the ruthlessly expressed intention, 'I am now quite decided to dig away the whole artificial mount of Hissarlik.' He went on to ask a barrage of questions, from the sensible – concerning climate, conditions, availability of local labour and the like, to the bizarrely detailed: 'Have I to take a tent and iron bedstead and pillow with me from Marseilles?'; or again, 'Please give me an <u>exact</u> statement of <u>all the implements</u> of whatever kind and of <u>all the necessaries</u> which you advise me to take with me.'

These preparations had to be put aside for a while, however, as in 1869 personal matters took centre stage in Schliemann's life. His estrangement from his Russian wife, and her successful attempt to keep their children aloof from him, had made his home life an insup-

portable misery, and he decided to sue for divorce. He went to America, on the understanding that this could be arranged more quickly there. Citizenship was a prerequisite, and had not been acquired by Schliemann on his earlier sojourn in spite of his intentions in the first flush of pro-American enthusiasm. Five years residence was required, but Schliemann found friends in New York who were willing to perjure themselves and testify that he had been resident for this time; within three days of his arrival citizenship was granted. He then went to Indianapolis, learning that the divorce laws were less strict in Indiana, though it still took him more than three months – and the outlay of considerable sums of money in the right quarters – before the divorce was finally granted.

Already his thoughts had turned to remarriage, and he had hit upon an idea so unusual that its eventual success must surely also be attributed to his luck. He asked his friend, Archbishop Vimpos, to find him an Athenian wife, and was sent photographs and descriptions of several candidates, from whom he made his choice. This course of action was presumably suggested by his newly awakened philhellenism, and his decision to devote the rest of his life to the pursuit of Homer. It was perhaps the emotional gap left in his life by the loss not just of his wife but also of his children that led him to choose a Greek wife scarcely out of the schoolroom, and some thirty years his junior. Sophia Engastromenos seemed to him both beautiful and intelligent. Her grace and her knowledge of Homer endeared her to him, though her family, who perhaps could be forgiven for seeing the whole matter in an unromantic and predominantly financial light, misjudged their man, and by betraying their greed very nearly put him off completely. Yet who can understand Schliemann's mind? The arrangement seems impersonal, and indeed he made his choice from a photograph, but before meeting Sophia he wrote to Vimpos, 'Already have I fallen in love with Sophia Engastromenos . . . so that I swear she is the only woman who shall be my wife.' And to his father he wrote he had chosen her 'as the most lovable' – though this seems the quality least likely to be assessable from a photograph.

The marriage was, however, destined to be a great success. After early tribulations – such as Schliemann trying too hard to force-feed Sophia with languages and learning so that she, not unnaturally, began to buckle under the strain – they achieved a happier coexistence. Indeed, Sophia eventually became not only a source of support and comfort but also a collaborator and partner with Schliemann in his archaeological pursuits.

It was in February 1870 that Schliemann made his first excavations at Troy. With typical impatience he had begun before Frank Calvert had been able to negotiate a *firman*, or permit to excavate, from the Turkish authorities; after only twelve days it became apparent that without official backing his position was weak, so he was forced to give up until this was achieved. Still, he was pleased with the results

of his efforts and even more convinced, if that were possible, that here indeed, under his grasp, lay ancient Troy.

THE FIRST CAMPAIGN AT TROY

The *firman* was finally granted, after irksome delays, in the autumn of the following year, and Schliemann's first real season of excavation took place between 11 October and 24 November, when winter set in and he was forced to stop. His approach to the site was simple – actually far too simple, in view of its complexities. He was faced with:

> ... a plateau lying on an average about 80 feet above the plain, and descending very abruptly on the north side. Its northwestern corner is formed by a hill about 26 feet higher still, which is about 705 feet in breadth and 984 in length, and from its imposing situation and natural fortifications this hill of Hissarlik seems specially suited to be the acropolis of the town. Ever since my first visit, I never doubted that I should find the Pergamus of Priam in the depths of this hill.

He laid his plans accordingly and, with his usual directness, began to drive a huge trench from north to south right across the middle of the mound.

It was not that he failed to appreciate the nature of a 'tell'; after all, he himself wrote, 'Hills on which, in the course of thousands of years, new buildings have been continually erected on the site of former buildings, gain very considerably in circumference and height.' The problem was rather that he was fully and unquestioningly convinced that Homeric Troy must be the lowest city within the mound, founded on virgin soil. It just did not occur to him that there could have been predecessors to Priam's Troy; indeed after his earliest visit to the Troad he had written that 'to reach the ruins of the palaces of Priam and his sons . . . it will be necessary to remove the entire artificial part of the hill.' This single misapprehension was to cost him very dear. It was perhaps not all that surprising for, while he knew perfectly well that Priam's Troy had long-lived successors, there was little in the tradition to alert him to the possibility of predecessors on the site. Homeric studies had not afforded anything more than the vaguest chronological peg for the world of Homer. Essentially Schliemann viewed his first job at Troy as a huge earth-moving exercise. It is true that he excavated also in the area of the Hellenistic temple of Athena on the east side of the mound but in the main, during his first excavation seasons, he employed men and machinery with the sole aim of digging his huge north–south cutting across the mound as rapidly as possible.

Tales of the frustrations of this process bring tears to archaeological eyes.

> The numbers of immense blocks of stone also, which we continually come upon, cause great trouble and have to be got

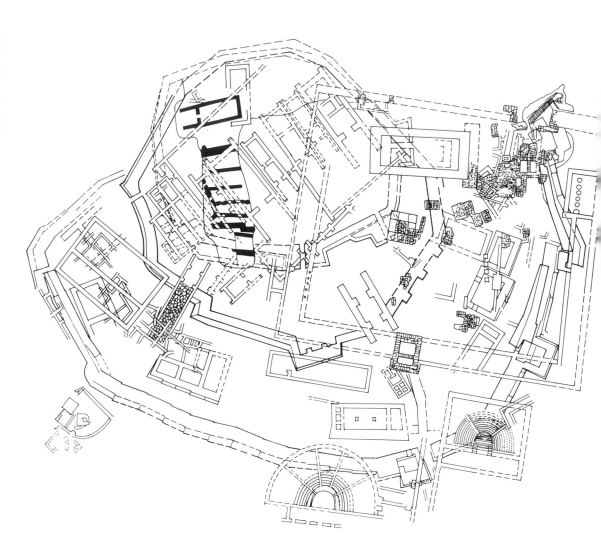

Plan of Troy (*above*) showing the complex superimposed ruins of all periods of the city. The simplified plan (*above right*) shows just Troy II and Troy VI. The Early Bronze Age Troy II (unshaded), Schliemann's 'Priam's Troy', was strongly fortified and had long thin buildings of 'megaron' type within. Troy VI (shaded), the much larger Late Bronze Age city, had huge fortification walls and bastions at intervals. The schematic section (*opposite*) shows the way in which the successive layers lie within the mound. The effect has been likened to a series of upturned pudding basins, stacked within each other and broken off so that only the rims – that is, the fortification walls – remain. Something of this effect can be seen in the aerial view of Troy (plate IV).

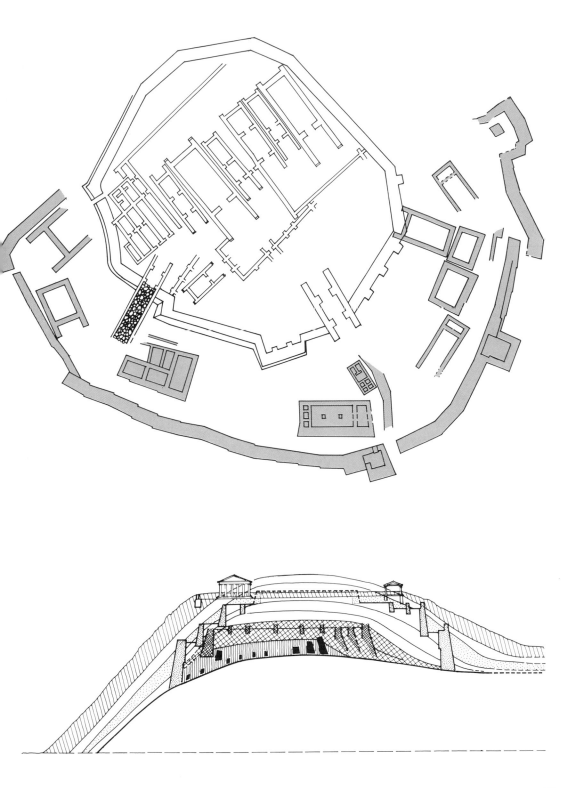

die trojanische Ebene & der Hellespont von Iliums Thurm ausgesehen

Schliemann's 'Great Trench' at Troy, looking from the heart of the mound to the north. The plain of Troy can be seen in the background, and the huge scale of the cutting is shown by the foreground figures. (Schliemann, *Atlas Trojanische Alterthümer*, Leipzig, 1874, pl. 111)

out and removed, which takes up a great deal of time, for at the moment when a large block of this kind is rolled to the edge of the slope, all of my workmen leave their own work and hurry on to see the enormous weight roll down its steep path with a thundering noise and settle itself at some distance in the plain.

These blocks must often have been of Bronze Age date: Schliemann was casting away the evidence he had come to find. To make matters worse not only were the workmen, between about eighty and one hundred and sixty in number, insufficiently supervised, but Schliemann himself became very confused both by the stratigraphy and structures and by the quantities of finds that were unearthed, mostly of types previously unknown. It was probably as well for his sanity that the first season was short, so that he could leave Troy to regroup, to consider his finds, to seek advice, and to plan his next campaign.

The season from April to October 1872 saw Schliemann, by his own lights, better organised – that is, he had more equipment and the help of an engineer to assist with the earth-moving operation. On his fifth day back at Troy he wrote, 'It is above all things necessary for me to reach the primary soil, in order to make accurate investigations', and he stepped up his efforts to do so. His accounts are littered with fearful stories of falling rocks and collapsing walls as he

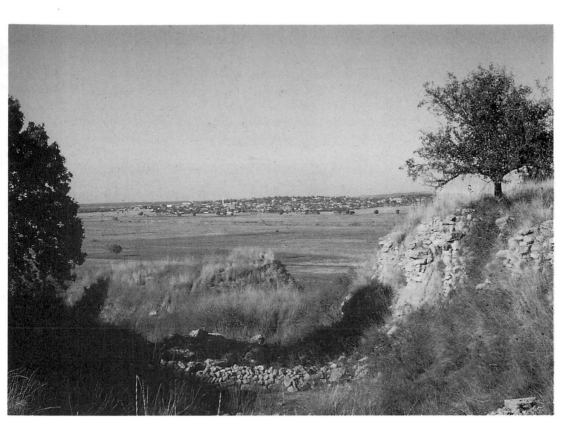

A more recent view of the 'Great Trench' at Troy.

penetrated deep into the heart of the mound, and he ended each day with heartfelt thanks to God for preserving himself and his workmen from serious injury. He also liked to calculate the amount of earth removed, boasting for example that 8,500 cubic metres had gone in the first seventeen days.

Schliemann continued, as he had from the start, to describe his finds in considerable detail, as well as making an attempt to record their location within the excavation. To this end he noted the depth at which each object was found, though his indications of where he was digging were often rather generalised. He concentrated upon certain objects with particular enthusiasm. Vases and figurines with a certain type of face, either applied in clay or incised into stone, exerted a particular fascination. He described them as 'owl-headed', though in fact their tendency to prominent eyebrows and beaky noses had misled him, and there is no reason to suppose their makers had owls in mind. Schliemann wanted them to be owls because he saw in them representations of 'thea glaukopis Athene', the tutelary deity of Troy, according to Homer. His translation of the Greek was idiosyncratic: the lexicographers tell us she is the 'bright-eyed' goddess Athena, but Schliemann derived the epithet 'glaukopis' from 'glaux', the owl – the bird itself so-called because owls have bright, glaring eyes – and there-

ABOVE A pottery vase with a human face from Troy II. The type is common at Troy in the Early and Middle Bronze Age. Such vases were thought by Schliemann to be owl-headed, and to represent 'Athena Glaukopis'.

fore claimed that the deity should be called 'the goddess Athena with the owl's face', believing that she was shown thus in her earliest representations, such as he assumed he was finding at Troy. The owl was, of course, Athena's sacred bird in Classical times, but this piece of contorted reasoning was simply pure Schliemann, and was not taken seriously by anyone in his time or since.

The decorative motif of the swastika was another focus for Schliemann's obsessive attention. It was interpreted by scholars of the day as an Aryan sun-symbol, and Schliemann was interested because he thought it showed the race of his Trojan people. Fascination with the races represented in ancient finds was common in Schliemann's day, and human remains, particularly skulls, were expected to bear a quite unrealistic burden of evidence about the races they represented. The reason for this seems to have been mainly a desire to claim common ancestry with the peoples of the past who achieved high levels of civilisation, though the approach seems outmoded today.

By the end of the 1872 season Schliemann had uncovered part of the fortification walls of the city, and a structure that he described as the Great Tower of Ilium – actually just a part of the walls. He began to refer to the site as the Pergamus of Troy, claiming that he had proved, by the discovery of 'a high civilisation and immense buildings

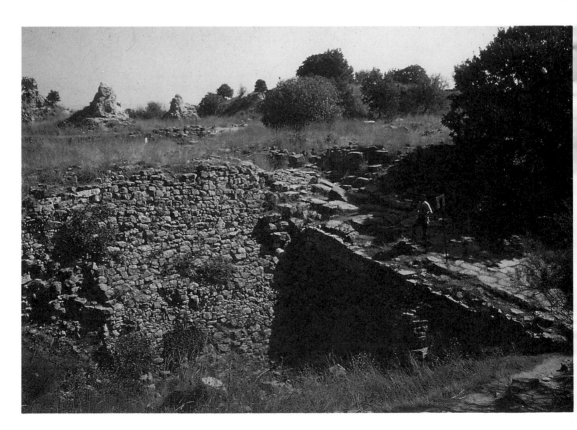

upon the primary soil', that this was the city immortalised in the poems of Homer.

In spite of his concern about the great expense of the excavations, which led him into desultory attempts to find some archaeological society or organisation to take them on, Schliemann decided on another campaign at Troy to try to uncover the complete circuit of the walls, as well as the rest of the Great Tower. This season, in 1873, was particularly successful. A paved ramp was found leading to an entrance within the walls – instantly called by Schliemann the Scaean Gate – while the emerging rooms of a fairly substantial building near to the gate had to belong to Priam's Palace. Such Homeric identifications allowed Schliemann to conclude that he had fulfilled the purpose of his Trojan excavations, while evidence for extensive burning on many parts of the site fitted well with the story of the sack of Troy. He was, though, forced to rethink some of his general chronological conclusions. He had previously thought that he could recognise four main layers of ruins before the foundation of the Greek city in about 700 BC, and that the lowest of these was the Troy of the Trojan War. He now recognised that the so-called Great Tower and Scaean Gate actually belonged to the second level. His willingness to change his mind on this point stands to his credit as a serious seeker of the truth, as indeed does his rueful admission that he had destroyed structures of this second city in his headlong rush for the lowest level.

Although problems remained, Schliemann was impatient to find new sites to conquer, and decided that he had essentially completed his work at Troy. He planned to finish the excavations for good in the middle of June. Remarkably, it was just about two weeks before this that he made the find that was perhaps the most significant, and certainly the best known of all his finds at Troy. Near to the Scaean Gate and, according to him, 'on' but probably in fact just outside the remains of the great circuit wall, he found a magnificent cache of precious objects that was to become famous as the Treasure of Priam.

The treasure consisted of a large copper bowl and a copper cauldron, below which were smaller vessels of various forms, made of gold, silver, electrum (a natural alloy of gold and silver) and bronze. There were bronze weapons and silver ingots and, perhaps most impressive of all, a quantity of gold jewellery. This included beads, rings, bracelets and ear-rings, and two elaborate head-dresses, made from hundreds of small gold ornaments, threaded together with gold links. The jewellery became known as the Jewels of Helen, and Sophia was photographed wearing some of it – a photograph that has become a very well-known image. It was published as a fashion-plate in a German magazine: unique ancient jewellery becoming an example *par excellence* of the 'archaeological jewellery' that was very much in vogue at the time.

The discovery of a golden treasure was wonderfully lucky for Schliemann, as it made both the learned world and indeed the public

OPPOSITE The ramp leading to the small, fortified city of Troy II, and part of the walls. It was in the foreground area to the left that the 'Treasure of Priam' was found.

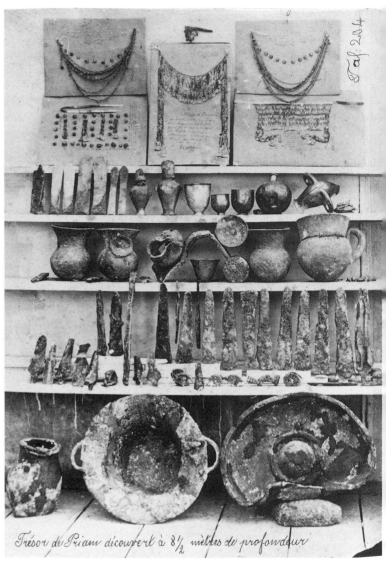

Trésor de Priam découvert à 8½ mètres de profondeur

Schliemann's photograph of the
'Treasure of Priam'. (*Atlas
Trojanische Alterthümer*, Leipzig,
1874, pl. 204)

at large take notice of his finds, and substantiated his claim that he
had indeed found remains of a rich and princely civilisation. His
second city of Troy at last could be made to seem a home fit for
heroes. Though privately he was still worried about the small size of
the citadel within the fortification walls (he regretfully reported to
Charles Newton that it was only about 140 × 90 metres, 'hardly larger
than Trafalgar Square'), publicly he admitted no such doubts. Troy
was found, the treasure was hastily smuggled off the site, and with
Turkish wrath about to explode behind them it was time for the
Schliemanns to leave.

Controversy surrounded the treasure in two ways. Most noticeable,

ABOVE Sophia Schliemann
wearing the 'Jewels of Helen'.

ABOVE Letter sent by
Schliemann to Charles Newton
in December 1872, in which he
admits that Sophia Schliemann
was not present when the
'Treasure of Priam' was found.

of course, was the anger of the Turkish authorities when they discovered that Schliemann had broken the terms of his agreement with them, which stipulated an equal division of finds between him and the Turkish state. A lengthy lawsuit ensued and was settled only in 1875, when Schliemann paid a large indemnity. Before then, and for some time after, Schliemann was *persona non grata* on Turkish soil. The eventual out-of-court agreement stipulated that the excavations at Troy should not continue, and it would take Schliemann much diplomatic effort before he could get round this problem. Of course, it should not have been a problem, had he really been so sure that his work at Troy was done. The other controversy, though, lay in doubts about Schliemann's discovery of the treasure, some of which have reawakened of late. Was it really a single find, or had Schliemann gradually gathered it from various places on the site, saving it up to make a big splash and escape with it intact at the end of the season? Worse, had he bought pieces locally on the market to add to his genuine finds – or even manufactured fake pieces for the same purpose?

The waters have been muddied by the recent recognition of the fact that in one respect, at least, Schliemann's dramatic account of his discovery of the Treasure of Priam is inaccurate. Having spotted the copper vessel in the trench, he claims to have called an early meal-break for the workmen, and got to work himself.

> I cut out the treasure with a large knife, which it was impossible
> to do without the very greatest exertion and the most fearful risk
> of my life, for the great fortification wall, beneath which I had to
> dig, threatened every moment to fall down upon me. But the
> sight of so many objects, every one of which is of inestimable
> value to archaeology, made me foolhardy, and I never thought of
> any danger. It would, however, have been impossible for me to
> have removed the treasure without the help of my dear wife, who
> stood by me ready to pack the things which I cut out in her
> shawl and to carry them away.

In fact, Sophia Schliemann had gone to Athens at the beginning of May and was still there at the end of the month, when the treasure was found. She was not present to help with its recovery, and Schliemann explains as much in a letter to Charles Newton, where he says,

> On acct. of her father's sudden death Mrs Schliemann left me in
> the beginning of May. The treasure was found end of May; but,
> since I am endeavouring to make an archaeologist of her, I wrote
> in my book that she had been present and assisted me in taking
> out the treasure. I merely did so to stimulate and encourage her,
> for she has great capacities.

The inclusion in a published work of such a fabrication is typical Schliemann who, as noticed before, had no scruples about adding all possible glamour to the story of his life. While this may be viewed as a peccadillo, it is of course important for archaeologists following in

his footsteps to know whether his cavalier treatment of facts extended also to his archaeological reporting. His accounts of his excavations have been scrutinised for demonstrable instances of falsehoods. Happily, none have been found: while mistakes and confusions naturally occur on occasion, it seems his finds were sufficiently extraordinary to satisfy even his appetite for the dramatic, and needed no elaboration.

With regard specifically to the Treasure of Priam, we can now see that it cannot have been bought or faked – it is homogeneous in style, and generally right for the Early Bronze Age context in which it was found. It fits well with other material of late Troy II date and, as Donald Easton has recently shown, came from an area between two successive fortification walls, probably both of Troy II. Schliemann could not have known this, and certainly could not by chance have concocted a treasure which later research would so thoroughly vindicate. Indeed, his were the problems of the pioneer: it was difficult for the learned world to evaluate his finds – or even, in some cases, to accept them at face value – since parallels were not then known. From a modern perspective, we can see that Schliemann himself was wrong about the dating: the treasure, and his Priam's Troy, date to about 2500–2200 BC, and thus belong to a period some six hundred years earlier than the rise of the Mycenaean civilisation of the Greek mainland. They are therefore much earlier than the earliest Greek period that could provide a plausible background for the legendary expedition against Troy, and a thousand years earlier than the traditional date.

As soon as he had left Turkish soil Schliemann wrote extensively about his finds, particularly the treasure, as well as travelling and lecturing on the subject. The learned world, and the public at large, were naturally interested, and Schliemann and Troy became household names. The academic establishment, especially in Germany, was suspicious of Schliemann and his Homeric discoveries, and he was the subject of some ridicule for his apparently naive belief in the truth of Homer. He was, though, given a very warm reception when he lectured in England, partly because of Charles Newton's support and partly because for that energetic Homeric scholar and arch-realist, Gladstone, the excavations had proved the reality behind the Homeric poems, in which he had long believed.

All of this was of course a source of great satisfaction to Schliemann, but it was not enough. He wanted passionately to be accepted by the learned world, and was always driven to try to convince doubters, whether or not they were worthy critics, that he was right. Even more significant, though, were his own inner doubts about Troy that were to drive him back again and again to the site. In spite of his published optimism, he was still worried by certain problems, in particular the small compass of his Homeric Troy. Could so small a city, however rich, have been the worthy opponent of the massed Greek forces, and could so small a city, however well defended, really have

held out against a ten-year siege? Schliemann was the first 'realist' thinker to have material remains about which to think. The difficulty of matching his finds to the world described by Homer meant that many critics did not accept the identification of his site as Troy. There was still a long way to go.

MYCENAE

Facing criticism of his interpretation of the Trojan finds, Schliemann was to become increasingly frustrated with the ban from Turkish soil. It would, though, take some time before he could get back onto the sort of terms with the Turkish authorities that would enable him to begin his second major campaign of excavations there. In the meanwhile, he decided to go back again to the famous site of Mycenae, home of the legendary Agamemnon, and described by Homer as 'rich in gold'. Here, too, his belief in Homer and his combination of energy, skill and luck, were to bring magnificent rewards. Schliemann's finds from Mycenae remain one of the most impressive sights that we have inherited from the ancient world. The massed effect of them in the

Gold from Shaft Grave III at Mycenae, including two large and elaborate diadems. About 1550–1500 BC. (Athens, National Museum)

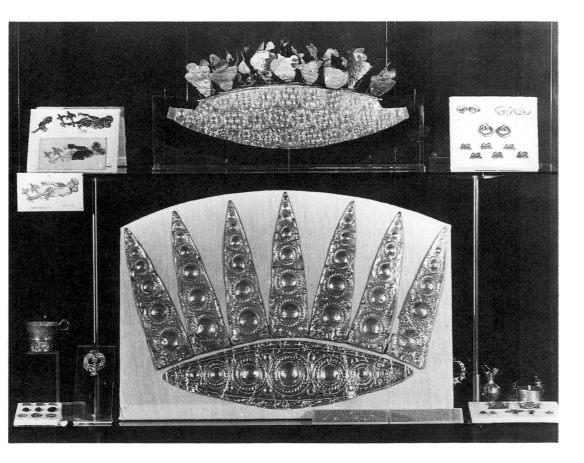

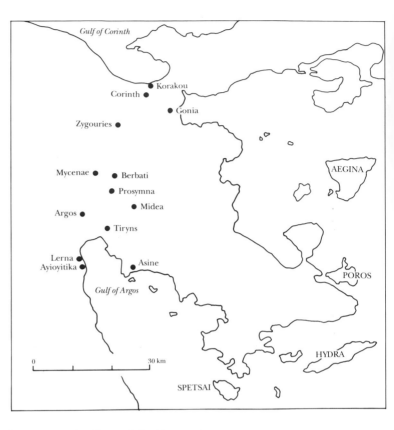

Map of the Argolid.

large central gallery of the National Museum in Athens is extraordinarily rich: the predominant impression is one of gold. Close examination reveals that much of the gold is wafer-thin – there is maximum area for minimum weight. But closer inspection also shows that among the plethora of vessels, weapons, ornaments and jewellery are pieces in a variety of styles, all interesting, many beautiful, and some showing exquisite detail and fine workmanship. The Mycenaean world could hardly have been more dramatically brought to light.

Schliemann conceived the idea of excavating at Mycenae on his first visit in 1868 and began negotiating for permission from the Greek government as early as 1870. The response had seemed quite positive, but when he renewed his application in 1873, it was rejected. The Greeks may have felt that Schliemann would not accept and adhere to the principle that all finds made on Greek soil had to belong to the Greek state. Such caution must have seemed amply justified when his behaviour over the Trojan treasure, and the lawsuit brought against him in Athens, became a local *cause célèbre*. Impatient with the delay, and apparently unconcerned at the possible undermining of his position, Schliemann carried out unauthorised excavations at Mycenae in February 1874, working for five days with twenty workmen, until he was stopped by the local authorities. A permit was nonetheless

granted the following month but, frustratingly, Schliemann had to stay in Athens because of the Turkish lawsuit and could not take it up. It was rescinded in July.

By April 1875 the lawsuit was over and Schliemann had paid the compensation to the Turks that freed him from further obligation to them. The whole Trojan collection was officially his and could be brought out of hiding. Able again to travel, he lectured abroad to various institutions about his Trojan finds and visited European museums to look for comparable material. It may seem strange that he did not immediately return to his plans for Mycenae, but he was annoyed with the Greek government for allowing Ernst Curtius and his German team permission to excavate at Olympia, a site that he would have liked for himself. In a fit of pique he travelled in Italy, looking there for a promising place to excavate. He felt that Greece had been ungrateful and so threatened to remove his excavations, his collections and indeed his potential bequests to another nation. This was typically volatile, not to say unreasonable, behaviour but, as so often, the threats came to nothing. No site in Italy satisfied him, so he returned in early 1876 to Constantinople where, surprisingly, he managed to negotiate a new permit for Troy. Yet although the Turkish authorities seem to have been remarkably forgiving, he was not able to organise the details as he wanted them, so he gave up and returned to Greece. Now at last he was able to obtain, and to act on, permission to dig at Mycenae. Thus it was in August 1876 that he set off for the second great triumph of his career.

Certain conditions were attached to the permit. All finds were to belong to the Greek nation, while all expenses were to be Schliemann's responsibility and he was to have the right of first publication of his discoveries. It was intended that there should be certain limitations on his activities, in particular to prevent his destroying existing or newly discovered structures. Excavation was supposed to be limited to a reasonable number of areas and to a reasonable number of work-men, so that progress could be supervised by a representative of the Greek Archaeological Society, Panayiotis Stamatakis. Seldom can anyone have been given a more thankless task. Schliemann was deter-mined to do everything his own way and treated Stamatakis with scant respect, so that it is not surprising that the latter should, in one of his reports to his superiors, ask to be removed from the site, saying plaintively, 'I remain here at the expense of my health'. With little or no real authority, he was constantly undermined by Schliemann's threats to pack up and leave if he were thwarted. Fate gave Stamatakis some small revenge, however – when Schliemann did eventually leave, thinking that he had finished excavating the Grave Circle at Mycenae, Stamatakis carried on and found a sixth rich grave.

Unlike Troy, the site of Mycenae had never been lost. The mighty citadel walls, constructed from large blocks of stone in a style of masonry known as Cyclopean (since tradition ascribed their construc-

tion to the Cyclopes, a mythical race of giants), had always been visible, as had the famous lions in the gateway. They had guarded the comings and goings beneath them from the Bronze Age, the time of Mycenae's greatness, through the Classical and Hellenistic periods when Mycenae was a small but flourishing town, until its eventual late Hellenistic abandonment, when the ruins became only a haunt of shepherds and their sheep. The lions had been visited, admired and drawn by travellers before Schliemann, but happily their sheer size prevented them from being taken away. Only their heads, which

Drawing made by the artist Sebastiano Ittar for Lord Elgin, showing the Lion Gate at Mycenae in 1803. (British Museum)

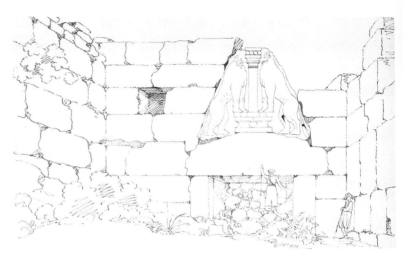

used probably to look outwards, were lost. Their identification as lions, rather than griffins or sphinxes with lions' bodies, is in fact not certain, depending partly on Pausanias' description (though the heads may already have been lost when he saw them) and partly on the fact that lions are important in Mycenaean art. Such noble beasts, standing with their forepaws on altars and heraldically flanking a sacred pillar, seem to make a suitable symbol for the might of Mycenae, and though now they hear not the clatter of armed men but only the click of cameras they are impressive still. Indeed, it is hard to stand in their gateway without thinking of the troops pouring through as they mustered for the expedition against Troy, or of the chill and lonely vigil of the watchman of Aeschylus' *Agamemnon* as he patiently waited for the moment when, after ten years, he would see from Mycenae's walls the beacon announcing Troy's fall. Perhaps it was here, too, that the purple cloth was strewn on the rocky ground for victorious Agamemnon to trample on as he re-entered his citadel – a presage of his own blood, spilt in Mycenae as the curse of the House of Atreus worked through to the bitter end.

With such stories attached to it, and impressive standing remains, the attraction of Mycenae for Schliemann is not hard to understand: perhaps more remarkable is the fact that no one had attempted large-

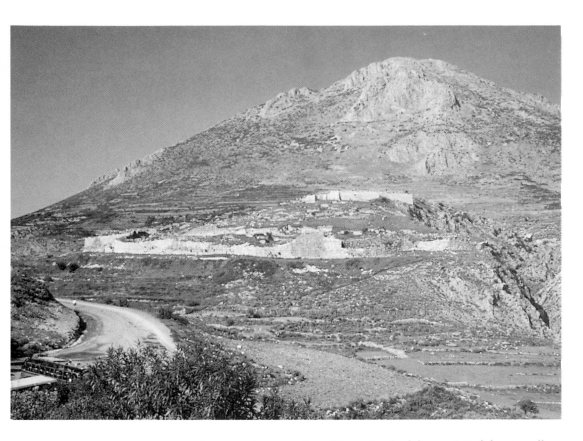

The citadel of Mycenae from the south-west.

scale excavations earlier. The ruins had been visited by travellers from the late eighteenth century onwards; one of the earliest, John Morritt, who was there in 1795, concluded – no doubt rightly – that it had not changed much since Pausanias' day. Lord Elgin arrived in 1802, and took away some of the decorative carvings from the façade of the domed tomb known as the Treasury of Atreus, including parts of the columns that flanked the doorway. These are now exhibited in the British Museum, along with other fragments of the columns that were at first removed to Westport House in County Mayo by the Marquis of Sligo in 1810.

Other topographers and scholars who visited Mycenae and drew, measured and studied its monuments included Edward Clarke, William Leake, Charles Cockerell, Edward Dodwell and William Gell. Their drawings and descriptions provided a basis for Schliemann to work on. Cockerell had actually conducted a small excavation in the mound covering the roof of the Treasury of Atreus, to check the nature of its construction, while Dodwell had discussed Cyclopean masonry and published the first illustrations of Mycenae. Thomas Burgon, the great collector, had picked up sherds that he illustrated in 1847 as 'An attempt to point out the Vases of Greece proper which belong to the Heroic and Homeric Age.' This was an early and perceptive

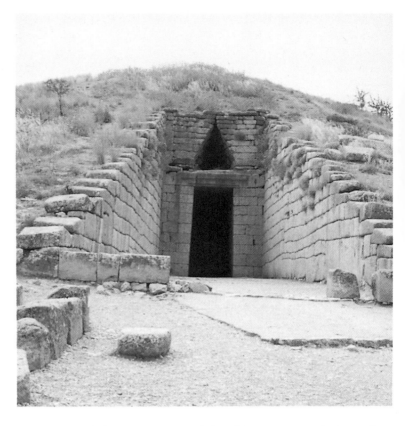

The so-called 'Treasury of Atreus' at Mycenae, largest and most elaborate of known tholos tombs as well as the best preserved. It dates from about 1350–1250 BC.

realisation of the importance of humble pottery picked up from amongst more impressive remains. The legends surrounding Mycenae meant that just about everyone accepted that the ruins were 'heroic' in date, but only by study of the pottery could this 'heroic' age eventually be defined and dated.

Schliemann, then, had distinguished predecessors at Mycenae. The fact that no one had previously excavated there in a systematic way perhaps gives some idea of the difficulties, as well as the expense, of excavating in what were then fairly remote parts of Greece. Quite apart from the discomforts of life in the field there could be real danger: Schliemann had earlier abandoned a planned trip to Mycenae because of reports of brigands in the vicinity.

With Homer in one hand and Pausanias in the other, Schliemann decided to dig an area inside the citadel which lay just through the Lion Gate and on the right. His well-nigh immediate success showed that his intuition had not failed him, and his idiosyncratic interpretation of Pausanias was also a help: scholars and previous visitors to the site had generally felt that the graves his guidebook describes as 'inside the city wall' must have been inside the outer, sparsely preserved, Hellenistic walls of Mycenae, not inside the Cyclopean walls of the citadel itself. This view might have been supported by the

Section through the 'Treasury of Atreus', drawn by Thomas Hope in 1800. The side chamber was an unusual elaboration, found also in the so-called 'Treasury of Minyas' at Orchomenos. (Athens, Benaki Museum)

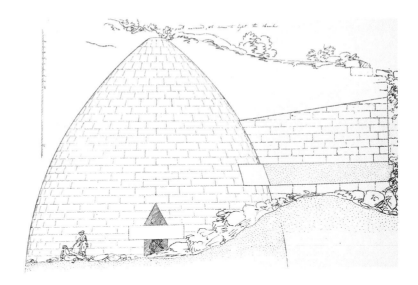

BELOW Drawing by Thomas Hope of the doorway of the 'Treasury of Atreus' in 1800, before the dromos (entrance passageway) was cleared. (Athens, Benaki Museum)

RIGHT The interior of the 'Treasury of Atreus', drawn by Edward Dodwell in 1805. He remarked in his notes, 'There is every reason to believe that this is the identical edifice denominated the Treasury of Atreus by Pausanias. Sixteen centuries ago that traveller was not less bewildered in the dark labyrinth of Mycenaean antiquities than we are at the present day: history throws no light upon their construction, and all that we can know for certain is that the architects of those distant days were possessed of science and of genius that have not been surpassed in later times.' (*Pelasgic Remains*, 1834, p. 8, pl. 10)

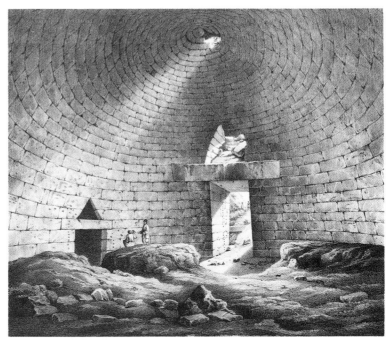

existence outside the citadel of a number of 'tholos' tombs. Tholos is the Greek word for a circular building, and the tombs are circular, domed structures, of which the largest and best-preserved example is the so-called Treasury of Atreus. However, the fact that Pausanias calls these buildings treasuries, although illogical (for who would keep their treasure *outside* the huge walls of a citadel that they had taken such pains to build?), was nonetheless influential, and in Schliemann's day only a few scholars recognised that they were more probably

Plan of the citadel of Mycenae. Originally the settlement covered only the top of the hill, and the area of Grave Circle A (1) was outside the citadel walls. When the walls were extended and the Lion Gate (2) built, in the thirteenth century BC, the Grave Circle was enclosed by a double wall of upright slabs. The palace (3) occupied the summit of the hill.

tombs. Schliemann, still using the term 'treasury', actually excavated the second most elaborate of the tholos tombs, which became known as the Tomb of Clytemnaestra. He also finished clearing the Lion Gate itself, a job which had been begun by the Greek Archaeological Service. Previously the Gate had become choked with earth and rubble so that the lions were almost at ground level. Most importantly, though, believing that Pausanias referred to the graves of Agamemnon and his entourage lying inside the citadel, he excavated the area within the walls, quite close to the Lion Gate, where he found Grave Circle A and the Shaft Graves of Mycenae.

Looking for graves there flew in the face of the general rule that cemeteries lie outside the settlement they serve. In fact, the Shaft Graves at Mycenae were no exception. Schliemann was successful

simply because the citadel had expanded at a period after the graves were in use, and the walls had been extended to encompass an area that was previously outside. He should, though, be given credit in purely archaeological terms for his decision about where to dig. There is no doubt that he had developed a very keen eye for promising spots, and took account of surface sherds, as well as odds and ends thrown up by the casual diggings of local treasure hunters within the ruins.

The excavations bore almost instant fruit. It seemed that no spade could be dug into the soil without revealing antiquities. At first these were of the later periods, but within a very few days Schliemann was

finding Bronze Age buildings and objects, including a large number of terracottas that he described as 'Hera Boopis' – cow-headed Hera – the counterpart of his 'Athena Glaukopis' at Troy, and pursued by him with just as much misplaced enthusiasm. The building later known as the Granary began to come to light, and near it 'large unpolished tablets of white chalkstone', thought by Schliemann to be gravestones. It subsequently emerged, however, that these slabs had originally been arranged in a double row to form a circular enclosure. Moreover, they originally had slabs placed horizontally across them, leading him to identify the enclosure as the 'agora' or meeting-place of Mycenae, with a circular bench all around it. Within this enclosure, real gravestones began to appear. At least, Schliemann had no hesitation in so describing the slabs decorated in low relief, some with spirals

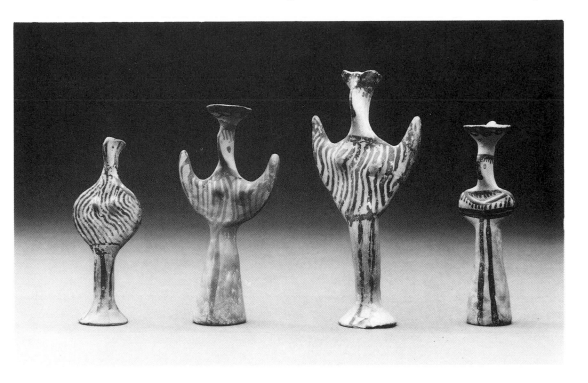

Mycenaean terracotta figurines of about 1400–1200 BC. The upraised arms of some examples suggested cow's horns to Schliemann, who therefore identified such figurines as 'Hera Boopis' (ox-eyed Hera). (BM Cat. Terracottas B5, B7, B11, B12)

and others with scenes of men and chariots, that came to light. These sculptures, with their neatly achieved spirals but undeniably sketchy (and, in the terminology of Schliemann's time, 'primitive') representations of men and animals, became a focus of much attention, not least because they could be classed as sculpture, which, with later Greek achievements in mind, was widely regarded as the foremost and noblest of the arts.

Schliemann, confident ahead of events, was indeed right to call them gravestones, but the graves themselves took quite a bit more digging before they came to light. They were deep below the surface,

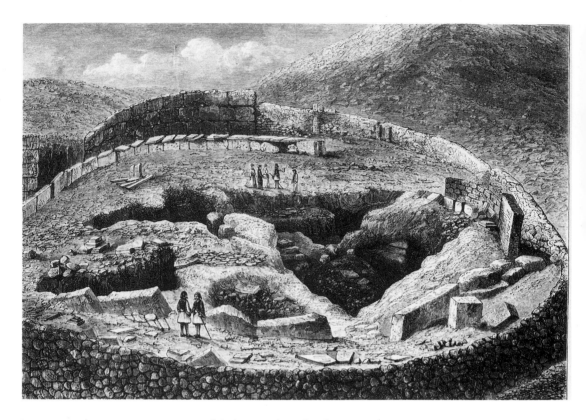

Schliemann's excavations in Grave Circle A at Mycenae. (*Mycenae*, 1878, pl. VI)

and it is now thought that some of the grave stelai (the Greek term for stone grave markers) were replaced at a higher level to mark the position of the graves when the area was terraced and the circular wall erected, which took place in the thirteenth century BC when the citadel wall was extended and the Lion Gate built. Other stelai were found much lower down, and these were presumably in their original positions. The graves must, though, always have been deep, and the appropriate term Shaft Graves was coined for them shortly after Schliemann's time, because the burials lay at the bottom of deep rectangular shafts.

While downward progress within the Grave Circle continued, other finds continued to emerge elsewhere – in spite of Stamatakis, Schliemann continued his old ways of excavating energetically in several places at once. The treasury, where work was mainly supervised by Sophia Schliemann, was perhaps rather disappointing. Tholos tombs in general are too noticeable to escape plundering, and the Tomb of Clytemnaestra was no exception. However, its architecture was revealed, and it could be seen closely to resemble the Treasury of Atreus, though with rather less elaborate decoration.

While Schliemann adhered to the treasury interpretation, Charles Newton followed Curtius and others in taking the view that the tholoi were tombs and this, though correct in itself, shaped a significant

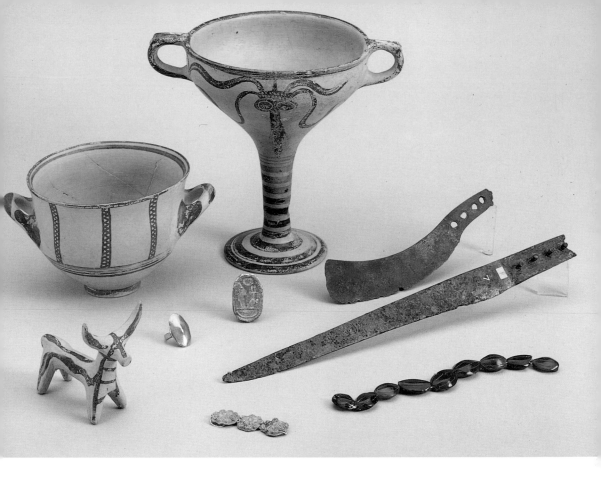

I ABOVE A group of Mycenaean finds from
Ialysos on Rhodes which were amongst those
that allowed Charles Newton to begin to
describe and characterise Mycenaean pottery,
bronzes, jewellery and terracottas. The Egyptian
scarab of Amenhotep III (1390–1352 BC) was
one of the earliest pieces of evidence to be
found that linked Mycenaean products with
Egyptian chronology. (BM GR 1870.10-8.130;
BM Cat. Bronzes 7, 15; BM Cat. Vases A870;
GR 1959.11-4.10; BM Cat. Tc. B3; BM Cat. Rings
873; GR 1868.10-25.57; GR 1872.3-15.5)

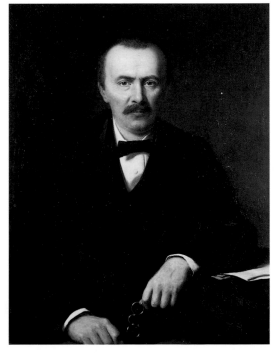

II RIGHT Portrait of Schliemann by Sydney
Hodges, London, 1877. (Museum für Vor- und
Frühgeschichte, Berlin)

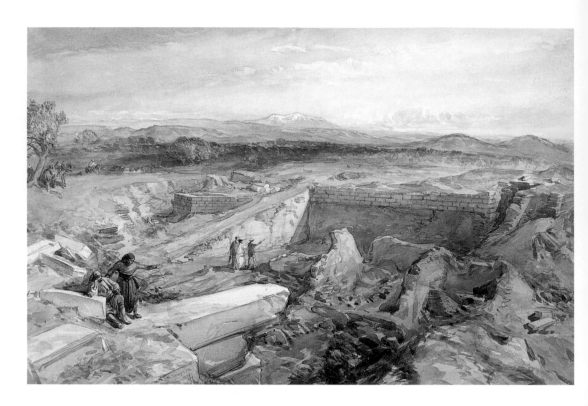

III ABOVE Watercolour by William Simpson of Troy, 1877, with Schliemann showing visitors some of the Hellenistic and Roman remains on the site. Simpson was himself sceptical about Schliemann's early (and subsequently abandoned) identification of 'Priam's palace' in the mound of Hisarlik. He felt the building in question was too small and unimpressive to fit the Homeric description and remarked, 'If I had been told it was the palace of Priam's pig I could have believed it.' (BM PD 18543)

IV RIGHT Aerial view of Troy.

V ABOVE Watercolour by William Simpson showing a distant view of Mycenae in 1877. The dumps from Schliemann's excavations can be seen in the foreground. (BM PD R36365/1)

VI RIGHT A view from within the citadel of Mycenae showing the back of the Lion Gate.

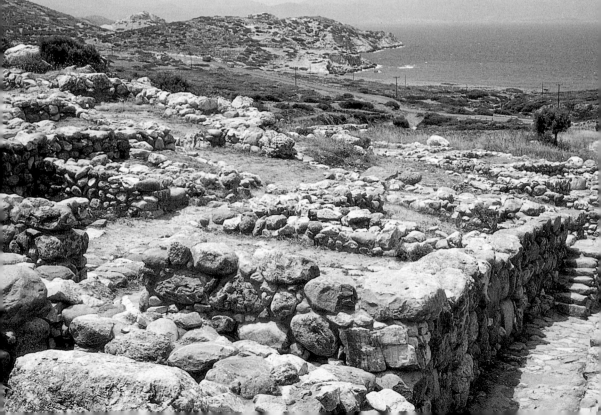

chronological mistake about Mycenae. Newton perceived a difficulty
about accepting both the tholoi and the Shaft Graves as princely
burials, unless each had a different period of use. Unfortunately, he
got these periods the wrong way round. He felt that the massively built
and architecturally sophisticated tholos tombs must have belonged to
the greatest period of Mycenae's history, when manpower and
resources existed to produce such huge monuments in stone. By con-
trast the Shaft Graves, representing a much simpler form of burial,
and dug within the citadel, seemed more probably to belong to a time
of retrenchment, when large-scale architectural tombs could no longer
be built and it was safer to put rich burials behind the citadel walls.
Schliemann accepted and published Newton's chronological conclu-
sion. Only a fuller understanding of the finds within the Shaft Graves,
and the architectural history of the citadel itself, could correct this
misapprehension. It may be said that the tholos tombs were, and are,
difficult to date precisely, because of the lack of finds made in clear
association with them.

A 'Cyclopean house', as Schliemann called it, came to light to the
south of the Grave Circle, and this became known as the House of
the Warrior Vase, for found within it were the fragments of probably
the most famous of all Mycenaean painted pottery vases. The depic-
tion of warriors in full armour, wearing tunics, greaves and helmets
and armed with spears, would always have been of interest and
importance, and was described by Schliemann. What he could not

know, however, is that this vase probably dates from just after
1200 BC, close to the traditional date given for the Trojan War, and
arguably quite close to the most likely date for any real event that
might lie behind the tale. The warriors are therefore perhaps – with
a bit of Schliemann-like faith – as near as we are likely to get to a
picture of the Achaean forces that set out for Troy.

The Shaft Graves

It was the Shaft Graves that produced the most dramatic finds. As
work in the Grave Circle progressed downwards many objects were
found within the shafts, and it seems that some of these were stray

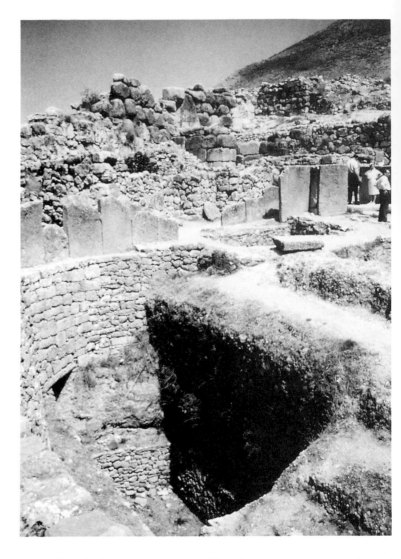

One of the Shaft Graves within Grave Circle A at Mycenae as it looks today. The stones lining the bottom of the shaft can be seen, as can part of the double row of upright limestone slabs that encircle the graves.

pieces disturbed from the graves, while others were either from funeral ceremonies or indeed from later burials. Schliemann's contemporary reports are muted in tone, and rather confusing to follow – not least because until he had begun to uncover the burials he did not himself know what was what. Further confusion arises for us because the numbering that he gave to the graves was subsequently altered. Thus Schliemann's Grave I became v, his II became I, his III and IV remained the same, and his v became II. In what follows the revised numbers have been used, as these have become standard, but with Schliemann's numbering in parentheses where it differs.

First, then, Schliemann began to penetrate the shaft of Grave v (Schl. I), and a hint of the rich finds to come was given by a number of small objects in gold amongst the plentiful pottery. Before reaching

the bottom, though, he was forced by heavy rain to switch his attention to Grave I (Schl. II). Here he got right to the bottom of the shaft, where he discovered the remains of three bodies, and the first examples of the remarkable Shaft Grave gold.

The bodies lay on a floor of pebbles separating them from the virgin rock within what resembled a chamber, created by the lining of all four sides of the shaft with a stone wall. Later researchers established that a wooden roof existed at the level of the top of this wall, protecting the bodies and allowing the grave to be reopened and thus to be used for more than one burial. It would have been quite a job to remove the earth from the shaft for subsequent burials, but it must be remembered that the depth of the grave – which according to Schliemann was 25 feet – included the large amount of earth brought into the area when it was terraced. The original shaft would have been about 15 feet deep.

The three bodies in the grave were all men, and all laid with their heads to the east. This was by no means the richest of the graves, but still the men were accompanied by fifteen diadems of beaten gold as well as large, indeed rather ungainly, flimsy gold ornaments in the shapes of leaves and crosses. Pieces of badly decayed glass, terracotta figurines, pottery vases and a silver vessel were also found.

Schliemann thought the bodies were covered with the ashes from a funeral pyre, though he had to admit that this could not have been large, but 'merely intended to consume the flesh of the bodies because the bones and even the skulls had been preserved . . .' This insistence on cremation has all the appearance of a foregone conclusion and indeed it is clear that Schliemann could not bring himself to admit, or even allow the possibility, that the bodies in the Shaft Graves had not been cremated, as they always were in the Homeric poems. As further graves were cleared, there was less and less evidence for cremation. The traces of burning were too slight, and were much more likely to have resulted from sacrifices burnt as part of the funerary ritual. Schliemann became very touchy on this point, protesting too much as often seems to have been the case when he was suppressing his own doubts.

He turned his attention next to Shaft Grave III, of similar construction, this time containing three female bodies oriented in the same east–west position. The grave also contained what seemed to be gold coverings for the bodies of two children. The women were, says Schliemann, 'literally laden with jewels', and indeed a staggering quantity and variety of rich finds came from this grave. There were no fewer than 701 discs of gold, mainly decorated with elaborate incised spiral designs, but also sometimes with rosettes, butterflies or cuttle-fish. Some may have been sewn onto clothes and have holes presumably for this purpose, while others are not pierced, and may simply have been tucked into the drapery of the corpse.

A group of about seventy-five more elaborate cut out gold plaques

were found, of double thickness, with repoussé decoration on the front and a flat surface attached to the back. Almost all were pierced so that they could be sewn onto clothes. They are in the form of human figures, perhaps goddesses, and animals, including cuttle-fish, stags, leopards, dogs, lions, birds, butterflies and mythical griffins and sphinxes. We can now see, though of course Schliemann could not, that the subjects of these cut-outs are at home in Minoan Crete. They may have been imported to Mycenae sewn onto fine textiles.

Two of the bodies had elaborate golden diadems still in position around the skulls, again made of thin beaten gold and decorated with repoussé work. Five further diadems were found, along with several large flimsy ornaments made up from leaf-shapes which are fastened together to form crosses or clumsy flowers. These may have been made specifically for burial: they create an ostentatious display, but are probably too thin to have stood the wear and tear of use.

Solid and serviceable gold jewellery was, though, also abundant. Numerous spiral ornaments, made from curled wire, represent local workmanship, but the finest pieces are undoubtedly the large gold brooch on a silver pin, in the form of a goddess with outstretched arms under an arching pattern of plants or branches, and the large hoop ear-rings of elaborate design, both of which are probably from Minoan Crete. So too, presumably, are the three gold seals, shaped like flattened cylinders and decorated with fine miniature work-manship. They show a kneeling lion, a warrior slaying a lion, and a combat between two warriors. Whether they were imported or made by an immigrant Minoan craftsman to mainland taste remains prob-lematical. They seem, though, to have been buried with the women in grave III as jewellery: there is no evidence for the use of seals on the Greek mainland at this time.

Gold and silver plate were represented by six golden vessels of different shapes and four of silver. Schliemann was very puzzled by what seemed to be four copper boxes filled with traces of wood. It was later suggested that these were the housings for the ends of the beams that had formed the roof above the burials, though they may have been casings for the feet of a bier or chest.

Beads and seals of semiprecious stones, pottery, bone and ivory – all sorts of minor objects complete the catalogue of finds from this rich grave, which certainly bore out Homer's epithet for Mycenae, 'rich in gold'. Schliemann's contemporary accounts of his discovery are very matter-of-fact, betraying little emotion. But even more excit-ing finds and rich treasures were to come.

In Grave IV were found the first of the famous gold face-masks. The grave contained the bodies of what Schliemann thought were five men, though the finds made with them have led later researchers to conclude that at least one, perhaps two, of the bodies in this grave were actually female. Three of the skulls were certainly male, as they were covered with masks, clumsily shaped of beaten gold. One was

badly crushed, but the other two were reasonably well preserved. Facial features are roughly worked on them, and the three masks seemed sufficiently different for Schliemann to think that some attempt had been made at individual characterisation. A fourth 'mask', described by Schliemann as representing a lion, was subsequently restored in the form of a vessel shaped like a lion's head. Another such vessel in this grave was the silver bull's head with gold muzzle, gold-plated wooden horns, and a gold rosette in the middle of the forehead.

Like the three women of Grave III, the five bodies in this grave were accompanied by any number of gold discs of various types and sizes, and cut out plaques, amongst which were three interesting models of tripartite shrines. These clothing ornaments may be further indications that female bodies were interred here. Funerary diadems were also found, as well as long decorated strips of gold which Schliemann described as shoulder belts. Amongst the more solid pieces of jewellery was a massive armlet with a central rosette, probably Minoan, made of gold covered with silver and plated with more gold, in a clever sandwich-like technique. Two oval gold signet rings were decorated with scenes of hunting and of warriors in combat, both themes that seem appropriate to the warrior aristocracy of the Shaft Graves.

Perhaps even more appropriate was the huge cache of weapons found in this grave. No fewer than forty-six swords were found, some beautifully decorated, as well as many gold ornaments from the pommels of swords. Here, too, were found two of the three famous inlaid daggers, one with running lions and the other with a lion hunt – though the decoration was obscured when they were found and only later revealed by cleaning.

Finally, Grave IV was notable for the extraordinary number of fine gold and silver vessels it contained. Many of these were cups and goblets of various forms, with more or less elaborate decoration. They included the gold goblet compared by Schliemann to the cup of Nestor as described by Homer, with its double handles and doves at the rim (Schliemann rather unromantically refers to them as pigeons), and a cup of electrum with inlaid floral decoration in a technique like that of the daggers – though again this was not visible before cleaning. The silver vessels included fragments of two fine vases with scenes of battle, one of which, the so-called seige rhyton, showed an attack on a walled city – an interesting indication that this theme was already to be found in Aegean Bronze Age art. An unusual silver vessel shaped like a stag is thought to be of Anatolian origin, a further example of the range of influences and possible imports that the Shaft Grave treasures include.

While the gold and silver vessels from the graves look magnificent now, it is instructive to compare them with Schliemann's original photographs of their crushed and dirty state when first excavated.

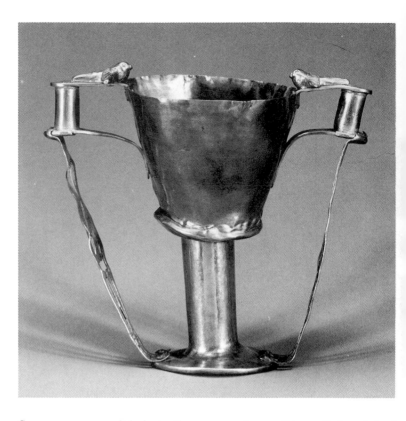

Some are very solid, but others were always thin-walled and had suffered badly. In many cases the decoration was not visible before cleaning, and therefore escaped Schliemann's eye, making it difficult now to identify the actual objects in his early descriptions.

By Shaft Grave standards, Grave II (Schl. V) was relatively sparsely furnished. A single occupant, wearing a golden diadem, was provided with a gold cup, swords, knives and fine pottery. Grave V (Schl. I), however, the excavation of which had been postponed by Schliemann, was to provide a fitting climax to his campaign.

The preservation of the bodies in the graves had previously been disappointing, the bones and skulls, being badly affected by damp, generally disintegrating before they could be taken out and preserved. The three male bodies in Grave V, though, were not only remarkably large but also remarkably well preserved. All lay with their heads to the east. The southernmost of the three wore the mask which is often, though wrongly, referred to as the Mask of Agamemnon: to our eyes the most handsome of the Shaft Grave masks, and certainly the most neatly made and best preserved. When the mask was removed, Schliemann says, 'His skull crumbled away on being exposed to the air, and only a few bones could be saved besides those of the legs.' The same was true of the second body. 'But of the third body, which lay at the north end of the tomb, the round face, with all its flesh, had

A golden goblet, called by Schliemann the 'cup of Nestor', in the squashed condition in which it was found (*below*) and after restoration (*left*). About 1550–1500 BC. (Athens, National Museum)

been wonderfully preserved under its ponderous golden mask; there was no vestige of hair, but both eyes were perfectly visible, also the mouth, which, owing to the enormous weight that had pressed upon it, was wide open, and showed thirty-two beautiful teeth.' It was this body, with its relatively unimpressive mask, that Schliemann liked to think was that of Agamemnon, though he did not say so in his official publication. Nor did he ever send the 'Today I have gazed upon the face of Agamemnon' telegram that has entered the literature from some apocryphal source. The nearest equivalent – and it is nothing like so dramatic or romantic – seems to be his comment in a telegram to the Greek press: 'This corpse very much resembles the image which my imagination formed long ago of wide-ruling Agamemnon.'

The body created quite a stir. 'The news that the tolerably well preserved body of a man of the mythic heroic age had been found, covered with gold ornaments, spread like wildfire through the Argolid, and people came by thousands from Argos, Nauplia, and the villages to see the wonder.' A pharmacist from Argos solidified the body by pouring over it alcohol with gum dissolved in it, and with great difficulty it was cut out from the bottom of the grave, along with a couple of inches of solid rock underneath it, and transported to Athens. Its eventual fate is unclear – the preservative may not have stood up to the test of time – but a painting that Schliemann commissioned when it was still in the ground has survived. Like all very ancient human remains it has a melancholy aspect.

The body was found beneath a plain breast-cover of beaten gold, and a band of thin and fragile gold was found lying across it. To this was attached part of a sword but, as Schliemann said, the 'belt' was far too flimsy for real use and must again have been part of the funerary panoply. A breastplate of similar type, but with spiral decoration, was found on the body at the south of the grave.

Further rich treasures emerged, including gold and silver vessels, gold ornaments, amber beads, bronze swords with golden ornamentation, and so on. The body in the middle, though, showed signs of having been disturbed. It had lost its gold ornaments, and the normal layer of white clay and pebbles which overlay the burials and which, though Schliemann did not know it, actually represented remains of the roof of the grave, had been disturbed at this spot.

We now recognise that the Shaft Graves were used for successive burials for more than a hundred years, throughout the sixteenth century BC and into the fifteenth. Schliemann did not know this, for he failed to pick up the evidence for the roofs that made such reuse possible and could not, in those early days, discern any chronological differences amongst the finds. Perhaps most significantly, though, he was predisposed to see the burials in the tombs as simultaneous because this was one of the main planks in his argument that the twelve men, three women and two or three children in the graves were Agamemnon and his entourage, who were all murdered, and

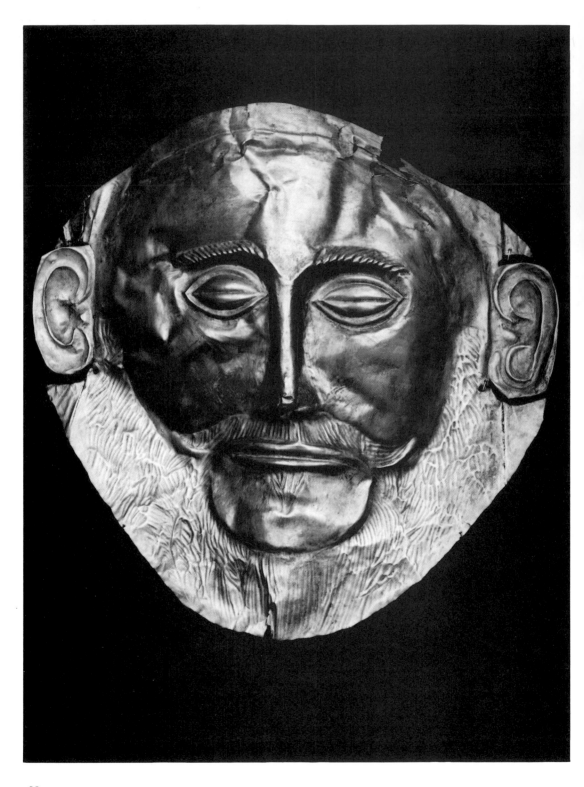

RIGHT The gold face-mask from Shaft Grave v that actually covered the face of the well-preserved corpse that Schliemann liked to think could have been Agamemnon. About 1550–1500 BC. (Athens, National Museum)

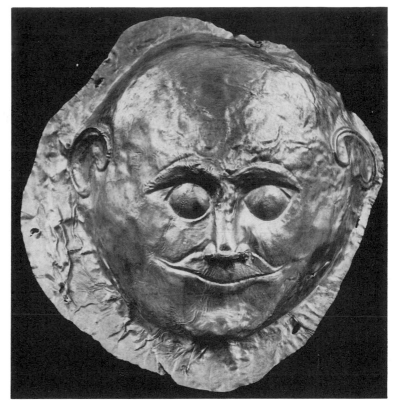

ABOVE Schliemann's engraving of the well-preserved corpse from Shaft Grave v.

OPPOSITE The gold face-mask from Shaft Grave v that became known as the 'Mask of Agamemnon'. About 1550–1500 BC. (Athens, National Museum)

therefore presumably all buried, at the same time. He expresses this cautiously: 'I have not the slightest objection to admit that the tradition which assigns the tombs in the Acropolis to Agamemnon and his companions, who on their return from Ilium were treacherously murdered by Clytemnestra or her paramour Aegisthus, may be perfectly correct and faithful.' He explains away the slightly awkward thought that the murderers were hardly likely to have buried their victims in a place of honour and with such riches by adducing Homeric and Classical parallels for the generous treatment by victors of the corpses they have created – though since this is usually in war, rather than by underhand and treacherous murder, the comparisons are not really exact.

While making every effort to appear duly cautious, Schliemann musters all possible arguments to support his identifications, sometimes coming perilously close to arguing in two directions at once. Thus, having explained the rich finds in the graves, he nonetheless suggests that the mode of burial, with the bodies simply laid in earth-filled pits, is due to the fact that the murderers were in charge of their victims' interment, and chose a simple, even squalid, type of grave. In spite of this, though, he has to argue that the graves were revered continuously from the time they were made right through to the histor-

ical period, in order to explain the fact that Pausanias must have been shown their position – otherwise how could he accurately record that they were inside the citadel walls, when in his time they were deeply buried and there was nothing to see? To a certain extent Schliemann was right: we can now see that the re-erection of the grave stelai at a higher level, together with the creation of the double wall of the grave circle, does indeed show later remembrance of and reverence for the graves below. However, while not impossible, it is very unlikely that this tradition could have survived until the time of Pausanias' visit in the second century AD. Schliemann's interpretation of his words must really be seen as illogical, though lucky. His contention that the enclosure wall of the Grave Circle formed a circular bench for the agora at Mycenae, attractive to him because this could also be seen as a Homeric feature, was later also seen as a red herring, if only on the practical grounds that to sit comfortably there the members of the assembly would have to be about nine feet tall. The discovery in the 1950s of an older Grave Circle outside the citadel walls also now shows that such circles were an established funerary form.

Perhaps the most frustrating problem for Schliemann was the obstinate refusal of the finds at Mycenae to tie in with those from Troy in an obviously meaningful way. He needed to link the two to make his Homeric interpretation of the sites stand firm. While some general comparisons could be made, he recognised that the material culture of Troy seemed older than that of Mycenae. He toyed with chronological ideas such as the notion that Homer might have been contemporary with Agamemnon and included him in an older tale of Troy, but he was clearly on shaky ground. Schliemann's publication of *Mycenae*, like all his published works, followed the excavations themselves with commendable swiftness, but he wrote it so quickly that he did not give himself time to marshal all the evidence and come to a considered opinion. It was in any case inevitable that the process of assimilation of his finds would take time; indeed, it is not yet complete.

It may also have been partly due to speed bordering on impatience that Schliemann finished his excavations at Mycenae so abruptly. It is usually assumed that he left the site because he thought that Pausanias recorded only five tombs, and that having found five his job was done. With part of the Grave Circle unexcavated this was a bold assumption to make: perhaps Schliemann also felt he should hasten away to prepare the publication of his finds, since he wanted to consult learned colleagues, but naturally did not want other scholars to steal his thunder by referring to them before the official publication could be prepared. The discovery by Stamatakis of Shaft Grave VI shows that his departure was premature. Schliemann reveals no particular chagrin about this, but is keen to point out that the discovery of a sixth grave does not undermine the identification with the burials of Agamemnon and the others, claiming – rightly – that Pausanias is not specific about the number of graves in which the bodies were laid.

Whether he really always thought this, or whether it was simply a piece of agile footwork after the event, is open to conjecture.

His mind was full of such matters as possible links with Troy, or the reality behind the Homeric poems, and perhaps he did not linger because he was still driven by the problems that remained. The year following his triumph at Mycenae was spent in finishing the publication and in lecturing in Paris and London. He arranged the exhibition of his Trojan material at the South Kensington (later the Victoria and Albert) Museum, finding again amongst the British archaeological establishment some of his most interested supporters, as well as becoming a lionised guest in London society. Nevertheless, he soon returned to the field: 1878 saw him excavating again, first in Ithaca, with indifferent success, then back – it seems inevitably – at Troy.

RETURN TO TROY

It was a changed Schliemann who in 1878 began on the second Trojan campaign, with greatly increased excavation experience and a more restrained approach. He had from the beginning solicited the opinions of other archaeologists and scholars. At times he had been almost pathetically grateful to those who had taken him seriously – reflecting the insecurity this self-made man felt on entering the academic world, which had often treated him unkindly. He had also habitually consulted specialists, particularly scientists, for analyses of the metals that he found, for example, and was in this respect something of a pioneer of today's team approach to excavation. Now, though, in his campaigns of 1878 and 1879, two particular friends were to help, and to influence Schliemann greatly – the many-talented French archaeologist Emile Burnouf and the distinguished German pathologist and polymath Rudolf Virchow.

The former had long been a friend, while Virchow was a new acquaintance. He was to prove, however, to have much in common with Schliemann, not least because he, too, had achieved his eminence from relatively humble beginnings and was to a great extent self-taught. These two, then, were to help Schliemann both with further excavations at Troy and with a broadly based study of Troy and the Troad, including not only archaeology but also geology, geography and natural history.

The results were published in 1881 in *Ilios*, perhaps the most considered of Schliemann's works, which took him a year and a half to write and which benefited considerably from the collaboration of his two friends, as well as of other scholars who contributed sections or chapters. These included the distinguished Oxford orientalists Max Müller and A.H. Sayce, the Dublin classicist J.P. Mahaffy and Schliemann's old friend Frank Calvert, who contributed a description of his excavation of one of the tumuli on the Trojan plain.

The book has an air of finality, but in truth the excavations threw up

a host of new problems and sometimes made further confusion of the old. Many previous identifications of structures were jettisoned. The Great Tower was recognised as simply part of the circuit walls and in a new spirit of detachment Priam's Palace, though it still continued to produce a series of 'treasures', was now referred to in less romantic terms as the 'royal residence' or 'chieftain's house'. Even the Scaean Gate became simply 'the Gate', as the finds continually failed to make explicit any Homeric connection. Burnouf helped Schliemann to recognise seven successive strata in the mound, at last beginning to create a framework for comprehension of the site. Unfortunately he and Schliemann now attributed the finds from their Priam's Troy to the third city, a confusion that we can now see arose because Troy II had a long history, and the layer of burning that separated its middle and late phases could easily be confused with the burned layer that sealed its remains. Even so, Schliemann did not waver in his conviction that this site of Hisarlik was Priam's Troy, and argued the case as firmly as ever in *Ilios*, though he had been persuaded to adopt more neutral terms. He was, however, forced by the results of his own and Virchow's researches to recognise that Homer may never have seen Troy. 'I wish I could have proved Homer to have been an eyewitness of the Trojan War. Alas I cannot do it . . . Homer gives us the legend of Ilium's tragic fate, as it was handed down to him by preceding bards, clothing the traditional facts of the war and destruction of Troy in the garb of his own day.' This admission that Homer could have lived later than the events he describes was very important.

The contents of the seven strata were described by Schliemann, and he paid particular attention to those coming from the third (he would later go back to recognising this as the second) – the 'burnt city' that he thought was Priam's Troy. To this belong the 'chieftain's house' and the second stage of the Gate, the series of golden treasures, smaller than the Treasure of Priam but still of great interest, and other characteristic finds such as the huge storage jars or pithoi, some over six feet tall.

The fourth city showed much continuity from the third, apparently indicating that the Achaean destruction of Troy was not permanent, while the fifth city contained greater quantities of wheel-made pottery and more sophisticated metalwork. Between it and the seventh city – the Greek Ilion – was a thin layer with grey pottery that Schliemann described as Lydian. It was later called Minyan ware and was to prove to be of great importance. Since he could find no architecture to go with this pottery, he rightly surmised that the top of the hill had been levelled for later building. His work at Troy was dogged by this, among other factors, with the result that he missed very significant remains, as we shall shortly see.

Questions such as why Troy was so small, why its level of culture seemed earlier than that revealed at Mycenae, and why no links between the two could be found still remained. He tried again to draw

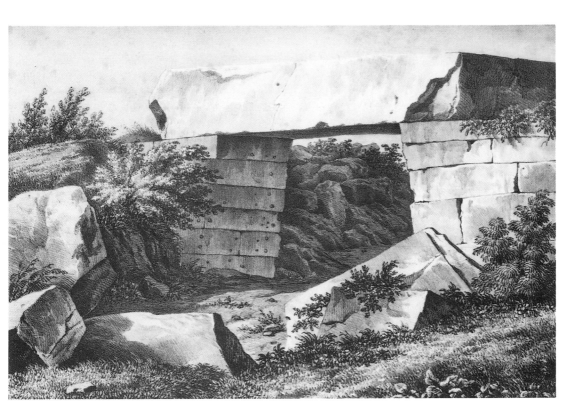

The tholos tomb at Orchomenos known as the 'Treasury of Minyas', by Edward Dodwell, 1805. (*Pelasgic Remains*, 1834, pl. 13)

a line under his work there but the site was to draw him back, siren-like, though it was to be two years before he was again on Trojan soil. In the interim he excavated at Orchomenos in northern Boeotia, a site again described by Homer as 'rich in gold', where Pausanias had described a monument that he called the Treasury of Minyas, attributing it to the city's legendary king.

The large and elaborate tholos tomb identified as this treasury had come to light when the dome collapsed dramatically and noisily, revealing its presence to the surprised local inhabitants. Lord Elgin had considered excavating it, but was put off by the vast amount of fallen masonry filling the interior. Schliemann, ever positive in his attitude, had high hopes that rich finds would be made both in the tholos (as at Mycenae, he persisted in describing it as a treasury not a tomb) and in the vicinity. He was to be disappointed, though the side chamber of the tomb proved to contain slabs of green schist that had decorated the walls and ceiling, carved with an intricate pattern of spirals and rosettes. These must be regarded as some of the finest examples of Bronze Age stonework, of themselves making the excavations worth while. Schliemann returned to Orchomenos six years later, but his finds were not sufficient for him to publish the site as a book. He did, though, recognise there a class of grey wheel-made pottery with characteristically angular profiles that he called Minyan ware.

Strangely, he failed to recognise that this was almost indistinguishable from his so-called Lydian pottery at Troy. Though later researchers did make the connection, coming to see the Minyan ware as a potential indication of newcomers to Greek lands, perhaps linked with the arrival of the first speakers of Greek, there are problems about the origin or origins of this type of pottery, and the interpretation of its significance is not entirely straightforward.

In the winter of 1880 Schliemann went to London to close the South Kensington exhibition of his Trojan finds. The following spring he visited Olympia, where he admired the technique of the German excavations and met the young architect Wilhelm Dörpfeld, who was to become his assistant in his last campaign at Troy. Dörpfeld was memorably described by Arthur Evans as 'Schliemann's greatest find' though it is not clear whether he originated the phrase, or simply thought it worth repeating. It certainly contained some truth: Dörpfeld was to make outstanding contributions both during the last years of Schliemann's life and after his death.

June 1881 found Schliemann in Berlin, to which city he presented his Trojan collection, receiving honours, including honorary citizenship, in return. This was largely due to the influence of Virchow, who had long felt that Schliemann should give the collection to the land of his birth, working assiduously to reawaken in him the patriotic feelings that would bring this about. It was no easy task. Schliemann had always viewed the Trojan collection as a bargaining counter, to be exchanged for such things as honours, decorations or excavation permits. Having dangled it as a carrot at the end of many a stick, he was loath finally to part with it. Moreover, Sophia felt strongly that the collection should remain in Greece, Schliemann's adopted home, where in Athens the architect Ziller was even then constructing for the Schliemanns an impressive house. The Iliou Melathron (Hall of Ilium), of neo-Classical design and richly decorated with paintings and mosaics recording Schliemann's achievements, may have seemed an appropriate home for the collection: it is indeed impressive, though its chilly splendours may always have felt rather more museum-like than domestic. However that may be, Virchow succeeded in persuading Schliemann that the treasure should find a German home, even petitioning Chancellor Bismarck, from whom he differed politically, to help. Eventually all was settled. The treasure was to be donated to the German nation. A museum wing bearing Schliemann's name would be dedicated to it, while Schliemann would have the right to arrange the collection himself. Moreover, he would be heaped with honours, amongst which the citizenship of Berlin ranked very highly.

History subsequently made the decision seem an unlucky one, since the Treasure of Priam was lost at the end of the Second World War. However, the recent Russian announcement that the treasure survives in Moscow means that this story will have a happy ending, with the finds from Troy once more on public display.

With typical enthusiasm Schliemann – an exile, and surely with his Russian, American, French and Greek connections the complete *citoyen du monde* – suddenly became the most patriotic German alive, espousing Bismarck as a new hero and never ceasing to remind all and sundry what great sacrifices he had made on Germany's behalf. There was an element of ruthless self-interest in this, as he tried to use all possible influence from the powerful Prussian Empire to get the excavation permits and the terms that he wanted from the Turkish authorities. He had set his sights once more on Troy and the Troad, planning a campaign of excavations that, if he had his way, would encompass other sites in the region and not just the mound of Hisarlik itself. Whether by discovering larger-scale remains of Troy surrounding the Hisarlik mound, or by proving that no other local site could possibly be a contender for the city made famous by Homer, he was determined to have yet another try at 'proving' his Homeric identification.

Disappointingly, the permit he eventually obtained for 1882 covered only the mound itself. He therefore embarked on a new survey of the stratigraphy, which, with the help of the architects Dörpfeld and Hofler, he managed to sort out much more clearly than before. He reverted to the view that the Treasure of Priam, and the other finds that he associated with Priam's Troy, did after all belong to the second city on the site. The circuit of walls of this city was further revealed, as, for the first time, was the ground-plan of buildings in the centre of the fortified citadel. These included three solidly built and roughly parallel structures, each in plan a long rectangle with just one internal division to form an inner hall. These, at first described as temples, were later recognised as belonging to a type of hall known as a 'megaron' – the term was borrowed from Homer. The old chieftain's house could now be seen, in spite of the treasures found in its vicinity, as a peripheral structure, partly overlying an older and larger building that Schliemann now called the royal palace – though the megaron-type halls in the centre of the site were later regarded as the most important structures and the most likely to have had palatial functions.

Much remained to be worked out, but with the help of his architects Schliemann for the first time began to create a cogent picture of Troy II. He argued again – though with little supporting evidence – for its being a 'pergamos', a central fortified place around which a much larger town once lay. This was a view he had previously discarded, though evidence from recent excavations has indeed shown that, at least in the Late Bronze Age, there was an extensive 'lower town' at Troy. Of more immediate and lasting significance was Dörpfeld's recognition of nine major strata in the mound. This scheme has stood the test of time, though the American team re-excavating the site in the 1930s were to distinguish forty-nine lesser sub-strata.

At the end of this campaign Schliemann again tried to draw a halt,

'Nauplia from Tiryns March 30 1849', a drawing by Edward Lear.

saying in the publication *Troia*, 'My work at Troy is now ended for ever, after extending over more than the period of ten years, which has a fated connection with the legend of the city. How many tens of years a new controversy may rage around it, I leave to the critics: that is their work, mine is done.'

For the next five years Schliemann stuck to this resolution, turning his attention again to the Greek mainland. He excavated at Thermopylae, in an excursion into historical Greece, before returning to the Argive plain and to Mycenae's neighbour, Tiryns.

The massively built citadel of Tiryns, whose beetling Cyclopean walls are perhaps even more impressive than those of Mycenae, presented a natural lure for Schliemann. Some eight miles south of Mycenae, without neighbouring high ground to detract from the enormous walls, Tiryns was situated on a rocky promontory that had originally been right by the sea, though is now about a mile inland. The citadel had retained its ancient name throughout the ages. Legend called it the home of Heracles, thus connecting it to a generation of mythical heroes earlier than those of the Trojan War, while according to Homer the later warrior Diomedes led a contingent from Tiryns amongst the troops mustered for the assault on Troy. Certainly the fortifications are on a heroic scale, while the corbelled galleries within the great walls of the citadel are a marvel to behold. (Pausanias makes the comment that they are quite as impressive as the pyramids

of Egypt, though the Greeks have a terrible habit of admiring the exotic at the expense of wonders in their own homeland.) The challenge to Schliemann's excavation techniques, though, lay inside the walls. Here, in 1884 and 1885, he and Dörpfeld uncovered for the first time the remains of a Mycenaean palace.

These lay at no great depth and the old Schliemann would probably have made a complete mess of their excavation. Now, with the advantage not only of many years experience but also of the practised eye of Dörpfeld to make sense of the remains and guide their recovery, he did a workmanlike job. Tiryns revealed no great treasures or royal tombs but comparisons could be made, in a general way at least, between the palace there and the descriptions in Homer – particularly that of the palace of Alcinous in Phaeacia. The pursuit of Homer's heroic world would therefore be seen by others as well as Schliemann to have received a boost from these Tirynthian discoveries.

The palace centred round a main hall, approached from a large courtyard through a porch and a vestibule. This arrangement, where the visitor comes first through the columned entrance of a porch and then through a triple door into an ante-room before entering the throne-room itself, was to prove typical of mainland palaces. So, for that matter, was the arrangement within the hall, where a large central hearth was surrounded by bases for four columns. These must have supported a higher central section of the roof, to allow smoke out and light in. This type of hall, more elaborate than the earlier examples from Troy, was seized upon as the real Homeric megaron. Its lavish decoration helped with the comparison, including such features as a carved stone frieze of the triglyph and metope type already known from Mycenae, though here retaining traces of blue glass inlays that could be identified with the Homeric 'kyanos', and a floor elaborately decorated with squares of differently painted plaster.

A smaller hall was designated by Dörpfeld, under Homeric influence, as a Women's Hall, though the identification is not certain. Refinements in the palace also included a paved room with a drain that had clearly been a bathroom. Of particular interest, too, was the discovery of several fragments of painted wall-plaster. Some had decorative patterns such as rosettes, spirals and the like while others had figured scenes, including a scene of two women in a chariot, one of hunting dogs attacking a boar, and a depiction of an acrobat performing a feat on the back of a bull – an exciting link with the legendary tale of Theseus and the Minotaur and a taste of Cretan things to come.

The publication of Tiryns, appearing, with Schliemann's customary speed, in 1885, was a collaborative effort, showing how content Schliemann was to trust Dörpfeld both to dig and to publish the results of their joint works. Schliemann by now was achieving 'grand old man' status in Homeric archaeology, but although he was mellowing, he was far from tiring. He had his eye on Crete, where he felt

that Knossos would be worth excavating – a feeling with which many of his learned colleagues agreed. Legendary associations and the potential ancient importance of the large island of Crete gave generally hopeful indications, while small-scale excavations at Knossos by an Herakleion antiquary, the aptly named Minos Kalokairinos, had revealed interesting finds. It was Kalokairinos whom Schliemann sought out when he visited Crete in 1886.

Once he had seen the finds from the Kephala hill, which would later prove to be the site of the Palace of Minos, he tried to negotiate a price for a tract of land in which the hill was included. The attempt to buy the site was drawn out over some three years, but was not ultimately successful. Problems arose over the description of the land, particularly the acreage, and the number of olive trees for which compensation would have to be paid. Schliemann feared that his intermediary in Herakleion was not entirely honest, but remarked in a letter that such difficulties could no doubt have been overcome: he had not, after all, needed the estate to bring him an income and as long as the Kephala hill were included his excavations could have gone ahead. The real problem, as he explained, was a political one: the Cretans did not want archaeological excavations to take place while the island was under Ottoman rule, fearing that any finds would be taken away to Constantinople. The stage would be set for excavations in Crete only when the island had gained its independence.

Unable to conquer Crete, in 1890 Schliemann went back to Troy. His decision to reopen the excavations there was in part provoked by the extraordinary attacks of one Ernst Bötticher. Claiming that the remains Schliemann had found at Hisarlik were not of a habitation site at all, but rather of a great 'fire necropolis', or burial ground for cremated bodies, Bötticher produced a series of pamphlets and articles attacking Schliemann in vehement, indeed positively unbalanced, terms. It has always seemed surprising that Schliemann took these attacks as seriously as he did. Perhaps, as Leo Deuel suggests, he recognised in Bötticher a ghost of his old self, becoming obsessed by the need to refute him in order to dissociate himself from his own amateurish and over-obsessive past. Perhaps, too, Bötticher was given far more exposure in learned journals than his crackpot theories deserved. Whatever the reason, he was quite disproportionately influential in causing Schliemann to return to Troy. The excavations that took place between March and August 1890 were, however, of great significance.

Success at Mycenae had awakened in Schliemann a desire to hunt for the 'royal' graves at Troy. He felt that they, too, might lie near one of the city gates – and there could be no better refutation of the necropolis theory than the discovery of real graves. Thus it was that, while Dörpfeld worked on refining the stratigraphy within Troy II, Schliemann began work outside, to the southwest of the Troy II walls.

Here he was to be given the key to the connection between Troy

and Mycenae, though fate did not, so to speak, give him the chance to turn it. Working (thanks to Dörpfeld) methodically downwards, he found two large buildings of what one might call sophisticated megaron type – in other words, more like the megaron at Tiryns than the earlier and simpler Trojan examples. They were in the level of Troy VI, and contained examples of the smooth grey Minyan pottery that Schliemann had called Lydian. They also, quite unmistakably, contained typically Mycenaean pottery.

Here, then, was the long-sought connection. Troy VI, not Troy II, would prove to be contemporary with Mycenae's centuries of greatness. A much bigger citadel, with massive encircling walls, it had largely been missed by Schliemann because he had worked in the middle of the mound, and therefore mostly inside its great walls. Moreover, remains on the top of the hill had been swept away by later Greek and Roman levelling operations on the site, so that little of Troy VI remained. Sadly, too, when he did come across parts of its solidly constructed and large-scale walls he had generally ignored and destroyed them, mistaking them for Hellenistic Greek structures. Now, in his last season, potentially all was being revealed, so that the two major problems haunting him – why Troy was so small, and where the connection with Mycenae lay – could be solved.

In fact, assimilation of the significance of the new finds did not work as quickly as that. Dörpfeld was initially cautious, though it would be left to him, in excavations after Schliemann's death, to reveal the extensive remains of Troy VI. Schliemann himself seems to have recognised that he now had the key, but he was not able to pursue the import of his new finds. His death in December 1890, caused by complications after an ear operation – and compounded by his inability to relax the hectic pace of his life – might seem rather melancholy in this respect, as though he had missed by a whisker the culmination of his life's work, but perhaps it was better so. He would have had not only to make enormous adjustments to all his previously published opinions about Troy but also to start again on a great deal more research on the site. Though the adjustments would have been hard, the research would have been meat and drink to him. He died planning two further seasons of excavation on the site that had been his life's work, keen to sort out all the problems, old and new. It was not to be, but Heinrich Schliemann had already done enough – more than enough – to earn himself an unrivalled place in the annals of archaeological history.

CHRISTOS TSOUNTAS
AND OTHER PIONEERS

*'A dateless era and a nameless race . . . are facts
to be accepted only in the last resort.'*

C. TSOUNTAS, *Mycenae and the Mycenaean Age*, 1897

In 1893 Sophia Schliemann financed a campaign of excavations at
Troy to continue her husband's work, while in the following year the
German Kaiser paid the bills, but both left to Dörpfeld, Schliemann's
natural successor, the job of actually conducting the excavations. Thus
it was that within only a few years of Schliemann's death a scheme
was worked out by Dörpfeld for the Trojan finds that is still the basis
of the way we view them today. Identifying nine layers within the
mound, he estimated the date of Troy II as 'about 2500–2000 BC,' and
described it as a rich fortified citadel destroyed by fire. Troy VI,
although lacking evidence for destruction by fire, was firmly pro-
claimed not only as the citadel of Mycenaean times, as indicated by
the imported Mycenaean pottery, but also as 'The Pergamus of Troy
sung about by Homer', and dated to about 1500–1000 BC. Though
the dates needed refinement, they were in the right general area, so
that a firm foundation was set for further researches at Troy.

At Mycenae, too, further campaigns continued Schliemann's
efforts. The Greek archaeologist Christos Tsountas discovered the
badly eroded remains of the palace on the summit of the acropolis,
demonstrating that here also the main room had been of the megaron
type already known from Tiryns, with a porch, ante-room and large
hall, in the centre of which four column bases surrounded a circular
hearth. Excavation around the huge fortifications of the site revealed,
on the eastern side, the impressive hidden passageway that led down
ninety-nine steps to an underground cistern: a remarkable feat of
engineering that astounds the modern visitor, and would have secured
the water-supply in times of attack.

It might be mentioned in passing that further evidence of
Mycenaean engineering skills came to light in the 1890s during the
drainage of the marshy Lake Copaïs in northern Boeotia. It was disco-
vered that the Mycenaeans had already dug great drainage canals
there, presumably, like the modern scheme, to release fertile land.
The nearby fortifications set on the rocky promontory of Gla proved,

on examination by the French archaeologist A. de Ridder in 1893, to be a third Mycenaean citadel, similar to Mycenae and Tiryns, though with significant differences. Here the walls enclosed a much larger area, but the buildings within were considerably less extensive, perhaps indicating that this was some kind of fortified outpost.

Tsountas, who excavated a number of Mycenaean tombs, made considerable progress in describing Mycenaean burial customs in his important work of synthesis *Mycenae and the Mycenaean Age*. He dug about sixty chamber tombs at Mycenae, recognising that, like the tholos tombs, they were used for multiple burials. He also put the record straight by assigning to the Shaft Graves a date earlier than that of the tholos tombs, though since he based this on rather vague, general reasoning rather than on an analysis of the pottery, it could still be described as a lucky guess.

Tholos tombs were discovered elsewhere on the Greek mainland, and though by far the greatest concentration was in the neighbourhood of Mycenae, a picture was emerging of Mycenaean occupation over a wide area. Mostly their contents were disturbed and plundered, but Tsountas himself excavated a notable exception, namely the tholos at Vapheio, near Sparta. Scattered finds on the floor of this tomb included engraved gems and some small gold objects, but it was in an undisturbed pit let into the floor that the most remarkable discoveries were made. Here was a burial accompanied by rich grave-goods, amongst them a fine inlaid dagger and, most famously, the two wonderful golden cups with relief decoration showing the capture of bulls.

Tsountas thus already had a large number of Mycenaean objects from a variety of Mycenaean sites on which to draw for the general conclusions in his book. The topics he covered included dress and personal appearance, religion, literacy, the race to which the Mycenaeans belonged, and the relationship of the Mycenaean age to that of Homer. Some aspects emerged more cogently than others. The chronological position of the Mycenaean world was remarkably well established by an increasingly complex series of links with the recorded chronology of Egypt; Tsountas lists the occurrences of Mycenaean objects in Egypt and of Egyptian objects in the Aegean that make up this framework. Flinders Petrie's excavations of the 1880s and 1890s, particularly those at Tell el-Amarna, were of the utmost importance in giving well-dated Egyptian contexts for Mycenaean vases, and the period from the sixteenth to the twelfth centuries is quoted as the floruit of Mycenaean culture: a remarkably accurate estimate.

Equally reasonable was Tsountas' view of the world of Homer. He is typical of his period in the importance which he attaches to the possible Homeric significance of Mycenaean finds – it would be some time before a book could be written about the Greek Bronze Age that did not have Homer at its heart – but he does not make a direct equation between Homer's world and Mycenaean Greece. Instead,

he is content to see potential origins for the Homeric stories in Mycenaean times, while recognising that other factors have resulted in the formation of the poems.

As to the question of whether or not the Mycenaeans could write, Tsountas answered this in the negative, in spite of Arthur Evans' preliminary conclusions, published in 1894 and 1895 after his earliest travels in Crete, that two scripts could be distinguished 'within the limits of the Mycenaean world'. Tsountas believed that the Cretan situation might be a thing apart, concluding that the few inscriptions known from the Mycenaean mainland were imports, though he was not able satisfactorily to answer the question of why the otherwise sophisticated Mycenaeans did not feel the need to write.

One typically nineteenth-century preoccupation exhibited in the book was the attempt to identify the race of the Mycenaeans, and specifically to prove them to be of Nordic or Aryan extraction. This now seems strange, and there really was not the information available to make even reasoned suppositions about the matter. It arose, however, because it was a major theme in nineteenth-century thinking that the ancient Greeks represented a branch of the original Aryan or Indo-European race.

In spite of such weaknesses, Tsountas' book was a masterly synthesis of what was then known, showing how swiftly evidence had accumulated since Schliemann's initial excavations. First published in 1893, it was translated into English and extended in collaboration with the American scholar J.I. Manatt, to be republished in 1897. It is a tribute to the importance of the work that the need was quickly felt to make it available to a wider public in this way.

After his work at Mycenae, Tsountas turned his attention to the islands of the Cyclades, which were beginning to emerge as an important centre of Early Bronze Age culture, and in 1889–90 carried out extensive excavations there. He was the first to recognise and begin to classify the Cycladic civilisation.

Cycladic figurines – the characteristic white marble female figures with folded arms – had been picked up as more or less unconsidered trifles by early travellers in the islands, and had aroused some passing interest. With their apparently 'primitive', simple forms they were felt to be early. In 1878 Charles Newton, commenting that they were 'ruder, and perhaps even more ancient' than the seal-stones in his collection, remarked, 'These figures . . . remind us at once of the rude carvings of savage races, such as may be seen in ethnographical collections.' It seems a great leap from this dismissive appraisal to Tsountas' rather optimistic use, only some twenty years later, of the term 'civilisation' to describe the culture of the islands. By then, though, there was a great deal more material, mostly from his own excavations, but also from the earlier work of the Englishman James Theodore Bent.

Bent deserves the credit for the very earliest attempts at scientific exploration in the Cyclades. A traveller rather than an archaeologist,

he and his equally adventurous wife became thoroughly familiar with the islands during intensive visits in 1883 and 1884, when foreign visitors were a rarity. They stayed in island homes and were treated with great hospitality by the inhabitants, who also gave them much valuable information. Bent's publication *The Cyclades, or Life Among the Insular Greeks* is as much an account of contemporary customs and folklore as it is of island history. Nevertheless, he was interested in the past, commenting, 'In every island . . . on almost every barren rock, I might say . . . are found abundant traces of a vast, prehistoric empire' – a slightly surprising statement, since Early Cycladic sites are in fact often remote and unobtrusive. Presumably the insight provided by local informants allowed Bent to be very aware of what traces there were. It was certainly with local help that he was able to undertake the excavation of two Early Cycladic cemeteries on the island of Antiparos.

His methods, particularly his recording, were lacking by modern standards, so that it is not now possible to establish which of his finds came from which cemetery, still less from which grave. The fact that he lacked the requisite patience to be an archaeologist is shown by his comment, 'I had been opening the graves of the prehistoric inhabitants of Antiparos for some days, and was getting weary of this sexton-like kind of life.' Still, his intentions were certainly scholarly: he published his researches with commendable speed in the *Journal of Hellenic Studies*, while his finds, which included pottery, marble vessels and other minor objects as well as figurines, formed the basis of the Cycladic collection of the British Museum.

When Tsountas turned his attention to the islands, he conducted an altogether more rigorous campaign there. A professional archaeologist *par excellence*, and an extremely hard worker, he set to and opened several hundred graves on Syros, Paros, Siphnos, Despotiko and Amorgos, as well as undertaking the first excavation of an Early Cycladic settlement, the fortified site of Kastri, near Chalandriani, on Syros. These energetic campaigns were published in two important articles in *Archaeologiki Ephemeris* for 1898–9. While again inadequately recorded by modern standards, the excavations were nonetheless of great significance, since they enabled Tsountas to recognise that what we now call the Early Bronze Age culture of the islands was homogeneous, distinctive and influential. We might avoid the use of the word 'civilisation', with its implications of a more complex society than is represented in the islands at this stage, but the importance of Early Cycladic culture cannot be doubted. Tsountas' work foreshadowed one abiding factor in Cycladic research: he excavated far more graves than settlement remains, and the greater part of our evidence in this field still comes from the realm of the dead rather than from the land of the living.

Christos Tsountas was a giant among the archaeologists of his time, but from the turn of the century onwards the field became

increasingly full of excavators earnestly and patiently uncovering the prehistoric secrets hidden beneath the soil of Greece. Those who came from abroad worked as members of the various foreign archaeological schools established in Athens during the nineteenth century.

These foreign schools were created as centres from which students and scholars could conduct fieldwork and research, with residential premises and academic libraries. They represented a formal channel for communication with the Greek archaeological authorities, becoming the official bodies to whom excavation permits were granted. The earliest was the Ecole Française d'Athènes, founded in 1846, amongst whose most significant achievements were the excavations at Delphi and at the palace of Mallia in Crete. In 1874 the Prussian 'Imperial Institute' (later the Deutsches Archäologisches Institut) was formed, becoming the headquarters from which the excavation of Olympia and later Tiryns took place. The Italian school came into being in 1910, though the Italian mission in Crete was founded in 1899 – excavations there would include Phaistos, Gortyn and Ayia Triadha. In 1881 the American School of Classical Studies appeared on the scene, soon to be involved in excavations in Corinth and its vicinity, as well as in Athens itself. Its next-door neighbour, the British School of Archaeology, was founded in 1886. British activity has centred particularly on Knossos in Crete, and on Sparta. Amongst the School's earliest excavations, though, was a series of sites in Cyprus, which, together with excavations conducted there by the British Museum in this period, put Cyprus firmly on the map as one of the most active and interesting areas of archaeological research in the last years of the nineteenth century.

Cyprus had long been known as a rich source of antiquities. As in Athens and elsewhere during the nineteenth century, members of the diplomatic community there collected objects gathered in a more or less haphazard way. Most active amongst these was General Luigi Palma di Cesnola, Italian by birth, but a career soldier who as a young man had emigrated to America, where he had fought in the Civil War. At the end of the war he began his diplomatic activities in Cyprus, becoming in 1865 both American and Russian consul. Over the next ten years he amassed large numbers of antiquities from purchases and excavations. The bulk of his collection is now in the Metropolitan Museum of Art in New York.

Cesnola wanted to be taken seriously as an archaeologist and, as his letters show, emulated Heinrich Schliemann, with whom he corresponded and whom he much admired. Olivier Masson has recently suggested that it was Schliemann's discovery of the Treasure of Priam in 1873 that led Cesnola, two years later, to invent his own Treasure of Curium – a group of jewellery that had patently come from a number of different tombs, as was recognised even at the time. This 'treasure', and the results of Cesnola's researches, were published in his *Cyprus, its ancient Cities, Tombs and Temples* in 1877. The scholarly

reception of this work speaks volumes about Cesnola's operations, and fully explains why so little is known about the origins of the pieces in his collection. Thus D.G. Hogarth wrote in 1889:

> So much has been written and said since the publication of General Cesnola's book as to numerous inaccuracies and mis-statements contained therein, that I almost owe an apology for flogging a dead horse . . . The truth of the matter seems to be that the General seldom directed his excavations in person . . . he undertook some rapid tours about the island, stopping for instance one day only at Old Paphos (cf. his book p 206 'I superintended excavations there in 1869 for several months'), but his collection was amassed by the labours of his dragoman . . .'

As an archaeologist, then, Cesnola was found sadly wanting by his peers; one feels that whereas Cyprus was unlucky to have a Cesnola, by contrast, Troy and Mycenae were lucky to have a Schliemann, who was always there, on the spot, enduring whatever hardships were necessary to complete the job. John Linton Myres, who later worked on Cyprus and has been described by Elizabeth Goring as the first 'modern' archaeologist on the island, summed up Cesnola firmly, but quite kindly, in 1914, when he wrote:

> In 1865 . . . the moment clearly was near when Cyprus must be won for archaeology, and 'digging' be transformed from a mischievous pastime into a weapon of historical science. With Cesnola's opportunities, an archaeological genius had the chance to anticipate modern work by a generation; it was a pity – but no fault of Cesnola – that the United States Consul was not an archaeological genius.

The age of systematic exploration in Cyprus perhaps began in 1878, the year when British administration was established there, with the arrival of the archaeologist Max Ohnefalsch-Richter. He conducted excavations on behalf of the British Government on many sites, over many years. In 1887 the foundation of the Cyprus Exploration Fund, supported by the British School at Athens and other academic institutions, contributed to the establishment of Cypriot archaeology on a firm footing. Thereafter it was mainly official bodies who conducted excavations in Cyprus, though the standards of excavation and recording were still variable, indeed on some sites disappointingly low.

The British School worked first at the famous Sanctuary of Aphrodite at Old Paphos, revealing in those early years only the post-Bronze Age remains there, as well as excavating other post-Bronze Age sites. Of more interest for present purposes were the excavations carried out by the British Museum between 1896 and 1899 in the Late Bronze Age tombs at Enkomi, Maroni, Klavdhia and Hala Sultan Tekke. Rich finds were made, showing how prosperous the island had been in this period. It is perhaps not surprising, in view of the excitement caused by the discovery of the Mycenaean culture in Greece, that the

Mycenaean elements in the finds were seized on with great enthusiasm and given far more attention than the native products. Indeed, at first the interest of Cyprus in the Late Bronze Age was felt to lie in the fact that it could be seen as an outpost of the Mycenaean world. Much further research would be needed before a more balanced view could be taken of the various elements in the mixed culture of the island, and a fuller understanding of the chronology and connections of the various classes of finds could be established. It was always clear that influences from both East and West were present in Cyprus, as was to be expected in view of its geographical position. Nonetheless, the presence of large quantities of Mycenaean pottery, together with Mycenaean influences visible on other types of object, initially led to the conclusion that the island was a Mycenaean colony in the four-teenth and thirteenth centuries BC. It is now recognised that this is unlikely, the presence of Mycenaean objects being more probably due to extensive trading links between Cyprus and mainland Greece.

From the fourteenth to the twelfth centuries BC Cypriot workshops produced luxury objects in materials such as gold and ivory. Examples were found in the Enkomi tombs, finds from which were shared between Cyprus and the British Museum. Mycenaean influence can clearly be seen on many of these objects; in the past they were widely considered to be truly Mycenaean, either imported or produced by immigrant craftsmen. In the case of the twelfth-century material, it was suggested that the craftsmen may have come to Cyprus having escaped the destructions on the Greek mainland that saw the end of the Mycenaean world in about 1200 BC. Such views have now been modified: although it is possible that some Mycenaean craftsmen were working on Cyprus, the products in many cases should be described as Cypriot, resulting from mixed influences but unique to the island. It is not until the eleventh century that there is evidence for a substantial Hellenic element in the Cypriot population.

Returning to Greece proper, and the early excavations of the Brit-ish School, we come to the important site of Phylakopi on the island of Melos. Phylakopi, which was excavated between 1896 and 1899, was a Bronze Age town, significant not only because it was a settle-ment – and therefore a helpful counterbalance to the prevalence of known cemeteries in the Cyclades – but also because it had a long history and provided stratigraphic evidence for the whole of the Bronze Age. A typically Cycladic town, with houses grouped round winding streets, for much of its history it must have looked rather like towns in the islands today. The earliest finds belonged to the last phase of the Early Cycladic culture, which was characterised by the island populations grouping together into larger settlements that were often by the sea, and unfortified. In the Middle Bronze Age the site was walled. It continued to produce distinctively local pottery – Melian jars decorated with birds were imported to Knossos – but Minoan and mainland wares were also found there. The Late Cycladic

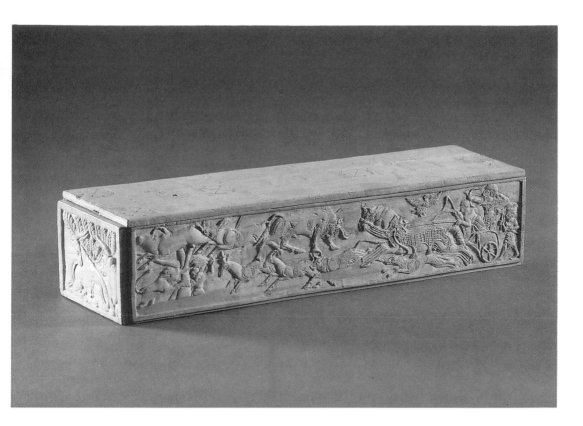

Ivory gaming box decorated with animals and scenes of hunting. The top and bottom are laid out for the Egyptian games of Tjau and Senet. The drawer presumably held the gaming pieces. Found at Enkomi. 12th century BC. (BM GR 1897.4–1.996)

city felt Minoan influence increasingly strongly. A fresco showing flying fish – one of the most exciting finds from this early excavation – may well have been painted by a Minoan hand. This conclusion could not, of course, be reached before Minoan Crete had been discovered, but as soon as excavation there began Phylakopi provided a ready-made yardstick for parallel developments in the Cyclades. At the same time, British School personnel became experienced in the excavation of a Bronze Age site, which would be important when the age of excavation began on Crete.

Crete, the 'megalo nisi' or 'great island', was indeed, archaeologically speaking, rather like a slumbering giant at this time, caught in the torpor of the last years of Turkish rule. As Schliemann had found, the impulse towards excavation was stifled by fear that finds would be taken away to Constantinople. It was, however, becoming increasingly clear that archaeologically the island would prove to be very rich.

The legendary associations of Crete, and the extensive traces of early remains, ensured that it was an object of antiquarian interest more or less continuously from antiquity onwards. Indeed, in the Roman period a great earthquake in the time of Nero was supposed, according to the prologue of a Latin work, the *Ephemeris Belli Troiani* (Chronicles of the Trojan War), to have broken open a 'tin chest' at Knossos within which were writings on 'lime bark' in Phoenician

characters. The entirely spurious chronicles pretended to be a translation of these writings, which were supposed to be by one 'Diktys of Crete', who had taken part in the Trojan War. Their real origin is obscure, but they may have been written in response to Nero's demand for a translation of documents genuinely found at Knossos during the earthquake. This incident can therefore probably be identified as the first find of Linear B tablets in Crete.

Early interest in the archaeology of Crete had focused upon the myth of the Minotaur and the labyrinth said to have been built by Daedalus for King Minos. The labyrinth had been mistakenly identified by Cristoforo Buondelmonti, who surveyed Crete in 1415, though the workings that he saw were in fact the stone quarries for Gortyn, the later Greek and Roman capital of the island. This same 'labyrinth' was shown in 1632 to William Lithgow, who trustingly accepted the identification – a misguided tradition that was to survive into the nineteenth century, even though the quarry had been recognised as such as early as 1553. In any case, a position for the labyrinth in the centre of the island should perhaps have seemed unlikely, since the name of Knossos had never been lost from the locality some six kilometres south of the old fortified town of Candia (modern Herakleion), where early remains were known to abound. Richard Pococke published an account of these in 1745 which specifically mentions an 'eminence to the South' of the area of Knossos that was probably the site where the Palace of Minos would later be found. In 1834 Robert Pashley was sufficiently impressed with the quantity and complexity of traces of walls and pieces of ancient masonry at Knossos to say that the place 'calls to mind the well-known ancient legend concerning the Cretan labyrinth' – though it was presumably mainly remains of the later Greek and Roman cities of Knossos that he saw.

Pashley's account of his travels was published in two volumes in *Travels in Crete* in 1837. This work was later joined by that of Captain Thomas Spratt, a naval surveyor whose *Travels and Observations in Crete* was published in 1865. Spratt identified many of the ancient sites throughout the island with great accuracy, and though most of these were of the historical period, a foundation was laid that would also be of use in the pursuit of the island's prehistory.

The distinguished Italian scholar Federico Halbherr, though not primarily a prehistorian, became a pioneer of prehistoric research in Crete. He was to be a good friend to Arthur Evans. Halbherr, who cut a dashing figure as he galloped over the island on his black horse, made his first visit in 1884. Within four months of his arrival he made the remarkable discovery of the fifth-century BC Law Code of Gortyn, one of the most important inscriptions ever found in the Greek world.

Halbherr became thoroughly committed to the recovery of Crete's past, broadening his interests from the purely epigraphical to the archaeological. He travelled extensively in search of ancient sites, often with his Cretan friend and colleague Joseph Hazzidakis. As early

as 1885 the two of them collected Minoan objects from the Psychro Cave on the Lasithi Plain. The list of sites that Halbherr explored, excavated or encouraged others to explore is very long, including Gortyn, Axos, the Idaean Cave, Lebena and Prinias. Most notable in Bronze Age terms – and perhaps the two most important sites dug by Italian archaeologists on Crete – were the Minoan palace of Phaistos and the neighbouring Minoan villa of Ayia Triadha. The excavation of Phaistos, like that of Knossos, began in 1900.

Joseph Hazzidakis also deserves credit as a pioneer who, in spite of the difficulties of archaeological life in Crete during the last two decades of the nineteenth century, worked hard to lay what foundations he could in the island, with the result that the excavations of the early years of the twentieth century got off to a flying start. In 1878 he founded the Cretan 'Syllogos', or 'Society for the Promotion of Learning', with aims that included both the study and preservation of ancient monuments and the foundation of a museum in Herakleion. To this museum in its early years came chance finds and gifts from collectors. Its founder could scarcely have imagined how it would be enriched by finds from archaeological excavations all over Crete that would give it its present status as one of the most important archaeological museums of the world. After Crete's liberation from Turkish rule Hazzidakis and his colleague, Stephanos Xanthoudides, were recognised as the first Cretan Ephors (Directors) of Antiquities.

It was to the still relatively new Candia museum that peasants in 1893 brought examples of well-made and brightly coloured pottery that they had found in the Kamares Cave on the slopes of Mount Ida. The vessels were decorated in red, orange, yellow and white paint on a shiny black background. The significance of this ware could not then be known, but the excavations at Knossos and Phaistos would later show that it was the characteristic pottery produced in the palatial workshops in the First Palace Period. It was called 'Kamares Ware' after the cave where it was found. Remarkably enough, though, the discovery in the Kamares Cave was not the first time that such pottery had come to light. For that we have to look some hundreds of miles to the southeast, to a town at the entrance to the Fayum in Egypt, called 'Kahun' by its excavator, Flinders Petrie, though now more correctly referred to as Lahun.

Petrie excavated the site in 1889–90. While he was working in rubbish heaps that he thought dated exclusively to the Twelfth Dynasty (about 1985–1795 BC), he found a few scrappy sherds of pottery that stood out from the bulk of his finds. Finely made from well-levigated clay, the sherds were thin-walled with bright paint on a dark background. They were clearly not Egyptian, and their motifs, particularly dotted rosettes and spirals, instantly led Petrie to identify them as 'Aegean'. For this reason, they eventually ended up in the Greek and Roman Department of the British Museum. The fact that these were Kamares sherds – the first ever found – would later become

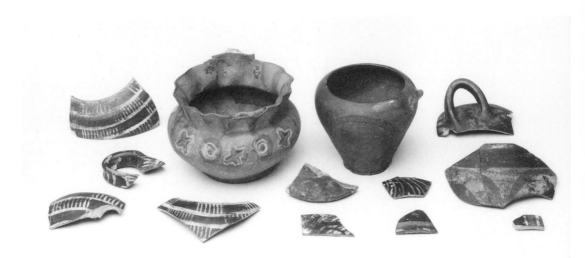

Some of the first sherds of Kamares pottery ever to be found in excavation, and two restored vases made in Egypt in imitation of the Kamares style. Found at Lahun ('Kahun') by Flinders Petrie in 1889. About 1900–1700 BC. (Selection from BM Cat. Vases A548–67)

apparent, but the perspicacity of Petrie's identification cannot be underestimated. His comment on the nature of the decoration, made in a letter to A.S. Murray at the British Museum in February 1890, strikes a familiar note. 'The style of the painting is much more savage than anything you have in Greek pottery, looking more like the savage neatness of Polynesian ornament.' Like Charles Newton before him, Petrie still exhibits here a view of art that equates 'savagery' and 'primitiveness' around the world, placing it at the same level of relatively undeveloped culture. The discovery of the Minoan palaces would show Kamares pottery in a completely different light, and it is to the story of Arthur Evans' excavations at Knossos that we must now turn.

ARTHUR EVANS AND MINOAN CRETE

For us, then, . . . Minos was waiting when we rode out from Candia.
Over the very site of his buried throne a desolate donkey drooped,
the only living thing in view. He was driven off
and the digging of Knossos began.

D.G. HOGARTH, *Accidents of an Antiquary's Life*, 1910

Did Arthur Evans simply discover the world of Minoan Crete, or did he to some degree invent it? Consider the impressions likely to be retained by the visitor to Knossos. What could be more typically Minoan than the Grand Staircase or the North Portico, both dominated by warmly coloured downward-tapering columns and decorated with frescoes? What could be more postcard-worthy than the painting of three Minoan court ladies dressed in blue, with their elaborate coiffures and air of animated conversation, or the fresco showing the 'priest-king', or the famous bull-jumping scene? The Throne of Minos, flanked by griffins, the Queen's Megaron, with her terracotta bathtub – the palace is full of memorable sights. But who really built these

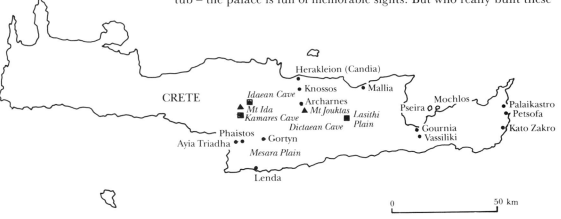

Map of Crete.

rooms, porticoes and staircases, and who really painted the frescoes? Are they truly Minoan, or do they reflect too much the vision of the man who discovered their fragments and decided to reconstruct them, pouring in the concrete and lashing on the paint, before presenting them to the world?

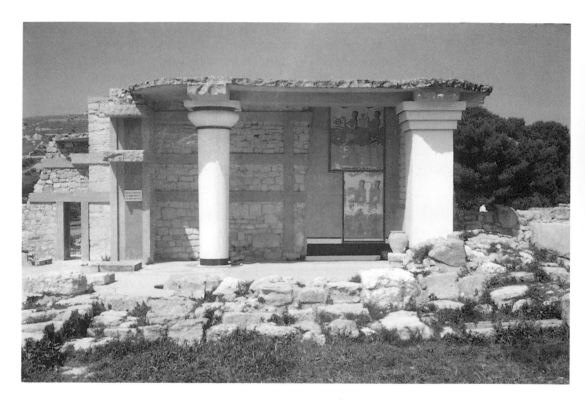

The South Propylaion at
Knossos as restored by Evans,
who also placed copies of
wall-paintings, in this case
processional figures, on to
the walls near which their
fragments were found
(see also page 126).

From Evans' time onwards the degree of reconstruction at Knossos
has been controversial. Visitors to the Palace of Minos should be
wary, for the site is a beguiling mixture of the real and the restored.
With the eye dazzled by the light and shade of its courts and inner
recesses, and the mind filled with the warm earth colours of the fading
paintings, it is indeed difficult to keep a firm hold on where fact ends
and fantasy begins.

Many visitors who are enchanted with Knossos and the Minoan
world and have good cause to be grateful to Evans may feel criticism
is disloyal. Notwithstanding, there can be no doubt that Arthur Evans
was not a dispassionate chronicler of his finds. He came to love 'his'
Minoans. He was their champion, and it is hard to find a negative
statement about them in his works. He claims for them many things
which now seem unlikely or sometimes just wrong. Such claims are,
however, counterbalanced by the many respects in which later
research has confirmed his views, even those visions based on a 'feel-
ing' for the Minoans rather than on the hard evidence of the finds.
With the benefit of hindsight, though, we must beware of Evans'
tendency to interpret the Minoan world in a way that fulfilled his
preconceived notions. Perhaps the most noticeable example of this is
found in Evans' consciously 'anti-Classical' stance. Here we find again
the difficulties encountered by the learned world when trying to fit
Greek Bronze Age finds into its concept of the development of Greek

art and culture. By the turn of the century, as we have seen, a great deal more was known about Mycenaean culture than had been the case when Charles Newton tried to put Schliemann's finds into some sort of context. It was beginning to be untenable to dismiss Mycenaean objects as the first fumblings towards Greek art proper. However, since their relationship with the art of later Greece was unknown, it became possible to view them as something apart – a separate, unrelated phenomenon. Arguments about the extent to which Mycenaean art was 'Greek' would continue, but in principle a separatist view was helpful, as it allowed an objective view of Mycenaean culture.

Evans, however, took up cudgels against both the Classically inspired ordering of art lying behind much nineteenth-century thought and the British Classical establishment which he felt still, in its espousal of this ideal, suppressed research in other areas. He consciously sought a non-Classical area of research, first in Illyria (one of the Balkan states) and later in Crete. After the discovery of the Minoan civilisation, he fought long and hard for a true appreciation of its pre-Classical and non-Classical merits. Not content with this, he eventually claimed that the Minoans had had all the best Classical Greek ideas first; that their art foreshadowed that of the fifth century BC; that their poetry was later adopted and translated and became what we know as Homer, and so on. In other words, although he had claimed that the Minoans were non-Classical, he himself failed to allow their art and architecture simply to set their own standards. Instead he was keen to 'take on' the Classical establishment, 'épater Messieurs les Hellenistes' as he put it. Evans had from his youth rebelled against the prevailing views of the academic establishment of his time; even as a schoolboy he had spoken in debate in support of the motion 'that the present system of Classical education is carried to excess.'

This is not to deny Evans the credit for his very deep knowledge and understanding of the extraordinary civilisation that he brought to light: we perhaps live in an age when worms are too prone to creep round the feet of great men to see if they are made of clay. Still, as Evans' character and personal history certainly informed his interpretation of his finds, we should look briefly at his life and background before he discovered the world of Minoan Crete.

ARTHUR EVANS

Arthur Evans came from academic stock. His great-grandfather had been an astronomer and mathematician, while his grandfather, a bibliophile and collector, ran a boys' school. There was some money in the family, but it was decided that young John Evans, Arthur's father, should be sent not to Oxford, like his brother, but to work in his uncle's paper mills in Hertfordshire.

This was the beginning of an extraordinary career, which saw John Evans, intelligent, level-headed and extremely hard-working, make a success of everything to which he put his hand. At the age of sixteen his new life seemed austere and rather gloomy. He worked hard, being treated with no great favour. Typically, he made the best of things by immersing himself in the technical aspects of paper-making, determined that, if life were not pleasant, it would at least be interesting. He inherited the paper mills after his uncle's death, thus coming to control a very considerable operation, with seven mills in Hertfordshire and subsidiary factories elsewhere. Although he made a great success of his commercial activities, this was no sinecure, for his uncle had left a heavy burden of debts and responsibilities, and the maintenance of the business was always to demand much time and effort.

In view of this, it is remarkable that John Evans has gone down in history as one of the foremost scholars of his day. He inherited from his father an interest in antiquities, particularly coins, which he collected from an early age. By his early twenties he was presenting papers to archaeological and numismatic societies. Later, when he turned his attention to the new discipline of prehistory, he became an authority of international repute on questions relating to the antiquity of man, one of the most controversial and significant scholarly debates of the time. He continued to collect widely and to publish on a variety of subjects. By the end of his life his academic honours were legion, rivalled only by his civic honours, for he also took an energetic role in county life. All this was achieved in such spare time as the demands of his commercial activities allowed.

John Evans' family life was not without sadness. He and his first wife – his cousin, Harriet Dickinson – had five children, but Arthur, the eldest (born on 8 July 1851), was still only six years old when Harriet died, shortly after the birth of her fifth child.

This was a sad blow to John Evans, since the marriage had been very happy. The effect on the young Arthur can only be surmised, though his half-sister, Joan, wrote in her biography of him that he was devastated, and attributed his reserve in personal relationships to this early loss.

John Evans married again twice, quickly restoring a stable background for his family. He and his eldest son got on well, and they shared many interests. The young Arthur spent his days surrounded by ever-growing collections of antiquities, from which he learned much. He entered as of right into the world of learning, where his father's contacts were distinguished and various. He also entered into considerable family wealth. The contrast with Schliemann needs no elaboration. Nonetheless, Arthur, as the son of so distinguished a father, had much to live up to. He was once pointed out as 'Little Evans, son of John Evans the Great' – a much-quoted saying that sums up the problem. It is not surprising that Arthur, clever and perhaps rather spoiled (Joan remarked that at the age of twenty-four

Arthur Evans standing in the North Entrance of the Palace of Minos at Knossos.

he was 'fantastically conceited'), should perhaps feel the need to be different.

Arthur's school life and undergraduate career at Oxford saw him making various gestures against the status quo – he gained his First in History by the skin of his teeth, because he did not answer the required number of examination questions, but allowed himself to expatiate at length on a single topic – and when he settled down to postgraduate work in Oxford, it was with no very firm sense of direction. He did not rebel against his father: their interests were too alike, though temperamentally Arthur was much more capricious, lacking his father's common sense. Cushioned from many sorts of harsh reality, he was able to take up high-minded, even romantic, stances on, for example, political matters. He became a Whig while his father was a traditional Tory, although the fact that later in life he was to stand (albeit reluctantly) as a Conservative candidate shows that he had no profound political convictions, but wanted rather to be different for difference's sake. He certainly did not rebel against his material position in the world – in fact throughout his life he seems rather coolly to have expected financial support from his father, in a way at which even the latter, though a fond and generous parent, sometimes baulked.

A strange mixture of a man, then, shy in manner, short-sighted and always carrying his favourite stick, non-conforming and against at least some forms of establishment, intelligent, sensitive and sure that he had much to offer – Arthur Evans was a rebel without a cause. He travelled widely, perhaps partly because familiarity with far-flung places was one way in which he could be different from his father. It was in the Balkans that he found both a cause and a second home.

Taking up residence in Ragusa, later renamed Dubrovnik, he lived there from 1877 to 1882. Illyria, then one of the Balkan states, appealed to the romantic side of his nature, so much so that he fervently espoused the cause of Illyrian independence, writing impassioned articles for the *Manchester Guardian* to bring Balkan politics to a larger audience. These were persuasively written and well received. Happy fighting for a cause in which he believed, as well as indulging his love of intrigue, he also found domestic contentment at this time, since it was to Ragusa that he took his new wife, Margaret Freeman, in 1878. Not that Evans was the man to settle down quietly at home: he continued to travel widely, carried out some excavations and began to collect materials for a history of Illyria.

Unfortunately, in 1882 a local insurrection made the Austrian authorities nervous. Evans' known sympathies, together with his characteristically outspoken, indeed rather rash, behaviour, resulted in their having him thrown into jail. On his release, after seven weeks, he was officially declared *persona non grata*, and was forced to return to England. His sister Joan describes this episode under the heading 'Paradise Lost', which seems to sum up Arthur's own view.

Still without an established career, Evans chose not to apply for a couple of posts that became available about then, feeling that both would go to a Classical archaeologist, while he already considered himself to be a prehistorian, with broader interests than the academic establishment's narrow-minded Hellenism as he saw it. This was already becoming a crusade for him, in which he regarded such figures as Charles Newton as 'enemies' – a pity, since Newton inconveniently kept turning up on the selection panels for positions that Evans might otherwise have found interesting. It is clear, however, that, given the opportunity, he would have become as obsessed with Illyria as his 'enemies' were with Greece and it was only his banishment that prevented this, leaving him temporarily aimless once more. As ever, though, he could not bear to settle and used his new home in Oxford mainly as a base for foreign travel. Thus it was that in 1883 he and Margaret set off for a five-month trip to Greece.

This Greek journey was of great significance for Evans' future career, since for the first time he saw the prehistoric remains that Schliemann's excavations had brought to the forefront of scholarly attention. Still an undergraduate when Schliemann began work at Troy, Evans had been part of the enthusiastic English audience that had followed with interest the announcements of his finds in *The Times*, and the reports of his London lecture tours, during which Schliemann and John Evans had become acquainted. Now Arthur and Margaret had the opportunity not only to visit sites such as Mycenae, Orchomenos and Tiryns but also to discuss them with Heinrich and Sophia Schliemann, who entertained them in Athens. Evans seems to have taken to Schliemann. He later agreed to write a preface to Emil Ludwig's biography in which he describes his impressions of the pioneer: a 'spare, slightly built man of sallow complexion and somewhat darkly clad, wearing spectacles of foreign make, and through which – so the fancy took me – he had looked deep into the ground.'

More important, though, was Evans' reaction to Schliemann's finds. Nothing could have pleased him more than to see the remains of this 'heroic' age in Greece, and to know that in the depths of his beloved prehistory, before the arrival of the Classical Greeks, a distinctive and technologically advanced civilisation had flowered. He was intrigued by the nature of this civilisation, particularly by its origins, seeming to have an almost intuitive idea that something earlier remained to be found.

For the present, the excitements of Greece and of such ideas had to be put to one side, and he and Margaret returned to England. There, at last, an opening appeared that gave him a sense of direction. The ailing Keeper of the Ashmolean Museum in Oxford had retired, and Arthur, thanks to a combination of his family connections and his own growing scholarly reputation, was offered the post. It meant an English interlude, when his main work would not take him to the sunny Mediterranean lands that he loved, but he could not resist the

challenge and took the post. He became Keeper of the Ashmolean in 1884.

When Evans took command the Ashmolean had suffered a long period of neglect, during which the University cared little for the collections, allowing them to become dispersed, using some of the Museum's space for other purposes, and not paying for proper staff to maintain it. Evans took up arms on behalf of his new institution, relishing the battle, particularly as one of his 'opponents' was Benjamin Jowett, one of the dreaded Classical school. During the first ten years or so of his Keepership, Evans revolutionised the Museum. He acquired quantities of new material, using his extensive contacts in the archaeological world almost to double the collections. These needed not just arranging but rehousing, in a handsome new building opened in 1894. By the time of the opening Evans had in effect refounded the Museum, turning it from a decaying backwater into a great institution for learning and research, with wide-ranging and important collections exhibited in a logical way. The enterprise now seems a triumph, but it was painfully slow and beset by uncongenial meetings, councils and committees from which he took refuge in continuing to travel as much as was possible.

The first years of the 1890s, which saw many upheavals in Evans' life, constitute a 'transitional' period between one phase and another. Family troubles took much of his attention. His father's second wife died in September 1890, and was greatly missed by her husband and all her stepchildren. The children, worried about their father's solitary state, were greatly relieved when, two years later, he married again. For Arthur, though, this happy news was quickly followed by a great sadness. Margaret, who had for some time been in rather uncertain health, died in Alassio in March 1893. Their life together had been happy, despite Margaret's inability to have children. Joan Evans says of Arthur that 'he felt her loss deeply, but was not overwhelmed'. A man of inner reserve, he took refuge in work and the life of the mind. The arrival of Joan herself, born in June that year, might perhaps have cheered him; he wrote to his father in warm congratulatory terms, though he confided to a friend that the arrival of a half-sister when he himself was nearly forty-two felt rather strange. Even so she was to become a good friend and helper in later life, compiling the index to his great work *The Palace of Minos at Knossos*, as well as writing his biography.

On the more positive side, it was during the early years of this decade that Evans' thoughts began to crystallise around Crete. The reasons for this were various: as Joan Evans put it, 'It seems as if a thousand tiny facts and things had drifted like dust and settled to weigh down the scales of his decision.' In the background was his earlier interest in the origins of Schliemann's Mycenaean civilisation. A visit to Rome in 1892 saw a meeting with Federico Halbherr, the Italian scholar who had already investigated a number of Cretan sites

and who was able to tell Evans that the island held many remains of a hitherto unrecognised kind that seemed to belong to a remote, prehistoric past. Legend, of course, also supported the contention that Crete had a long history. Evans' friend John Myres had visited Knossos and had been enthusiastic about the prospect of excavations on the Kephala hill, though he had been persuaded by Hazzidakis and Halbherr that these should not take place while the Turks were still in power. He brought back seal-stones from Crete for the Ashmolean, knowing that they would interest Arthur Evans in his pursuit of early systems of writing.

The cover of Evans' *Cretan Pictographs* (1895), his earliest substantial publication on Cretan archaeology, predating the excavations at Knossos and clearly showing that scripts were initially the main objects of his interest.

It was specifically this that set Evans off on his Cretan journey. He suspected there were traces of writing on Mycenaean gems and seals that he had seen in the collections of both the Ashmolean and the British Museum, as well as in Athens, in Schliemann's collection and in the hands of dealers there. Indications that such stones often came from Crete gave a concrete reason for his first visit to the island, which he made in 1894. The second phase of his life was due to begin: at a relatively mature age he was on the verge of the discovery that would fully occupy his mind and heart for the rest of his life.

THE 'PALACE OF MINOS' AT KNOSSOS

Evans' trip to Crete in 1894 saw him travelling extensively over the whole of the island, familiarising himself with the terrain and the visible remains and, to his great delight, purchasing many of the engraved stones that had caught his attention. They were known to

the peasants as 'galopetres' (milk stones), the tradition having grown up that they ensured the supply of nursing mothers' milk. Indeed, some peasant mothers were unwilling to give up fine examples, and refused handsome offers, fearing for their babies' future nourishment.

More important, though, was the beginning of negotiations for the site of Knossos, which Evans visited during his first days on the island. He saw the extensive traces of ancient remains noted by early travellers in the broad and fertile valley of the River Kairatos, south of Candia. These were concentrated particularly on the low hill called Kephala just to the west of the river. It was here that Minos Kalokairinos had excavated in 1878 and revealed lines of huge storage jars or 'pithoi', some of which he had sent as gifts to various museums (the one he sent to the British Museum can still be seen exhibited there). Rather like Frank Calvert at Troy, Kalokairinos did not have the resources to pursue excavations on this clearly most promising site, nor would the Cretan authorities allow him to continue, fearing for the future of the finds. His work had, though, proved conclusively that here would be a good place to dig. Indeed this was recognised by Thomas Sandwith, British Consul in Crete, who immediately tried to initiate excavations at Knossos, inviting the co-operation of the British Museum. He was not successful, but the consensus that had arisen some years before Evans' arrival in Crete (following the visits of Schliemann, Dörpfeld and other scholars) that the remains were likely to be of a 'Mycenaean' palace, had become a near-certainty. Unlike Troy, the name had never been lost from the locality, and while Evans was no Schliemann, but placed far greater emphasis on strictly archaeological reasons for digging there, nonetheless the ghosts of Minos, Pasiphae and Ariadne called to the romantic side of his nature.

Schliemann's attempt to buy the site had met with the well-known obstructiveness of the Turkish proprietors, which Evans encountered in his turn. However, more patient in pursuit of his aims and perhaps better versed in the ways of dealing with pashas, he managed to buy a quarter share of the Kephala hill in 1894, and had title to this under Ottoman law. It was not, though, until Crete was liberated from Turkish domination in 1899 that the rest of the land could be bought and arrangements made for its excavation. Evans visited the island again in 1895, but the outbreak of hostilities meant that he could not return after that until 1898 when, with the instinctive sympathy towards the quest for independence that he had shown in his Balkan years, he publicly took the islanders' part against the final atrocities of the departing Turkish troops. This led the new Cretan authorities to view him as a staunch friend, and to look kindly on his long-laid plans for Knossos. At last, on 23 March 1900, he was able to begin work there.

Evans arrived with D.G. Hogarth, Director of the British School at Athens from 1897 to 1900, who helped him to establish the excava-

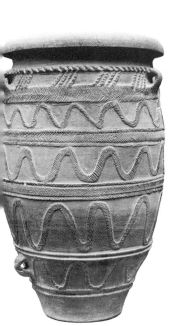

Large 'pithos' or clay storage jar, discovered by Minos Kalokairinos in trial excavations at Knossos in 1878 and sent via Thomas Sandwith to the British Museum. About 1450–1400 BC. (BM Cat. Vases A739)

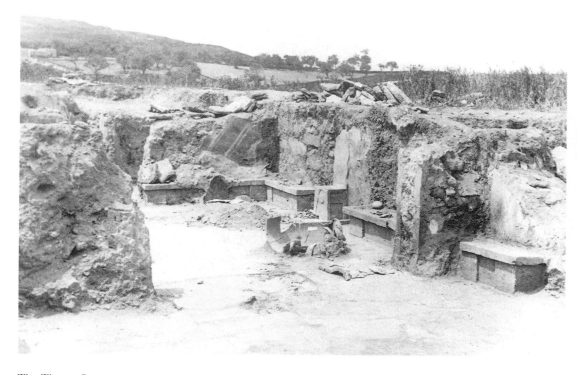

The Throne Room at Knossos in 1900, directly after excavation. Traces of frescoes can be seen adhering to the walls.

tions before leaving to pursue work of his own elsewhere in the island. The expedition's architect was Theodore Fyfe, while Evans' assistant and right-hand man was the tall, quietly spoken, red-headed Scot Duncan Mackenzie, a pottery expert and experienced digger who for the previous four years had been working on the British School excavations at Phylakopi on Melos. Since Evans himself, though brought up on the principles of stratigraphy at his father's knee, had very little field experience, such help was essential. By modern standards, though, the level of supervision in the field was quite inadequate for the great number of workmen and women employed – between 50 and 180 during the first season, working at great speed over what proved to be a large and complex site.

From the very beginning Knossos poured forth wonderful things. Though we now know that the town there had a long later history, the site of the Palace of Minos itself had not been built over in Greek or Roman times. This has been attributed to the remains being held in superstitious awe by later inhabitants, but may in fact have been more a matter of luck or convenience, since recent excavations have revealed a seventh-century road that clips the palace site on its southwest corner. At all events, the remains of the palace lay relatively undisturbed, remarkably close to the surface. Thus the workmen were able to uncover about two acres of the site within the first nine weeks. Very quickly some of the main characteristics of what, thanks to Evans, we now know as the Minoan civilisation emerged. He had

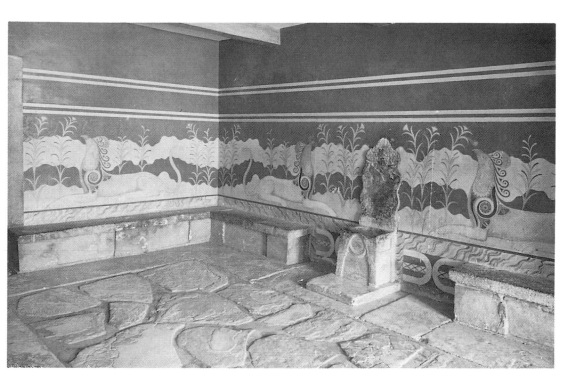

A modern view of the Throne Room as restored by Evans.

suggested the use of the term 'Minoan' as early as 1895, as the Cretan counterpart to the 'Mycenaean' of the Greek mainland. He went on to name his site at Knossos 'The Palace of Minos', speculating that the name Minos may have been hereditary, belonging to all the rulers of Crete, in the manner of 'Pharaoh' in Egypt. It is salutary to remember that we do not know what the Minoans called themselves – though the Egyptians label as 'Keftiu' figures in their tomb-paintings that almost certainly show Bronze Age Cretans, and Crete seems to be called 'Kaphtor' in texts from Ugarit, so these may give some clue.

While the name of Minos was plucked from mythology, the fact that the building could reasonably be described as a palace quickly emerged, at least in the sense that it was large, elaborate and obviously important. Modern self-consciousness requires that the term be used with due caution: after all, we have no real proof that Minoan society was ruled by a king, or that the concept of a 'royal family' would have had any meaning, though such ideas may be propounded on the basis of general probability. Caution could hardly be expected in the excitement of the early days of excavation, however, particularly since by an extraordinary piece of luck almost the first room to be revealed was the so-called Throne Room. Here, quite remarkably, a carved stone throne still stood against one wall. Flanked with benches and originally with wall-paintings of imposing griffins, the throne still had an air of grandeur. Moreover, the whole suite of rooms to which it belonged was elaborately appointed, with benches, wall-paintings and

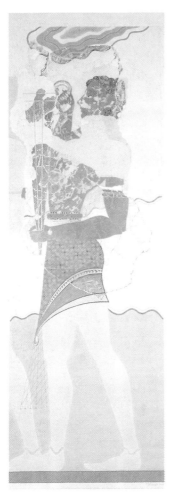

Watercolour restoration of the 'Cup-bearer', the best-preserved figure of a processional fresco originally decorating the South Propylaion at Knossos, dating from about 1450–1375 BC. Arthur Evans encouraged the use of such exact-size copies for exhibition outside Crete. This example belongs to the British Museum.

decoratively paved floors. Opposite the throne was a sunken so-called Lustral Area, separated from the main room by a balustrade and pillars. On the floor of the throne room was an imposing group of stone vessels, which Evans thought might have been in use for a ritual intended to avert disaster at the time of the palace's destruction. More recently the suggestion has been made that this part of the palace may have been a shrine, the throne being occupied by a priest or priestess. This would perhaps not have seemed too unlikely to Evans: he was soon to suggest that the ruler of Knossos was a 'priest-king', combining sacred and secular power. In the first days of excavation, though, since everyone was hoping to find Minos' palace, Minos' throne seemed far from impossible. It was by any standards a wonderful find.

Excavation proceeded apace in the rest of the West Wing of the palace, much of which was taken up by line upon line of 'magazines', or long, narrow storage rooms, in which were found many more pithoi of the sort discovered by Kalokairinos. It was clear that these ground-floor storage areas supported a first storey where rooms of spacious and airy proportions were laid out, called by Evans the 'piano nobile'. To the west these rooms looked out onto the West Court of the palace, which linked it with the surrounding town and with the road to the south of the island that must in part have dictated the palace's position. To the east the façade overlooked the Central Court, a rectangular open space at the heart of the palace, around which all the rooms and areas were grouped. Such courts were later seen to be the central feature of all the Minoan palaces, but at this early stage the Central Court was referred to as the East Court, because it was not obvious that the building extended on its eastern side. Although it was already clear that the palace was large and complex, much more was to be revealed as the work progressed and season followed season.

The frescoes that are amongst the major delights of Minoan art began to come to light from the first days of excavation. By the end of the first season the fragmentary remains that had been recovered included not only the griffins from the Throne Room, but also the Cup-bearer, the miniature Grandstand fresco and the great relief bull's head from the North Portico. Evans employed the Swiss artist Emile Gillieron, then resident in Athens and specialising in archaeological work, to restore the wall-paintings. Gillieron and his son Edouard worked on the Knossos frescoes for some twenty-five years. Their restorations are now amongst the most famous images of Minoan art, much reproduced in postcards and books, but under Evans' guidance they restored very freely. It is instructive – and in some cases rather shocking – to examine the frescoes themselves and see what small fragments of the real compositions were preserved, and how much their present appearance owes to a Gillieron hand.

Pottery, of course, and other small finds were found in plenty, but perhaps the most pleasing thing to Evans was the discovery of quanti-

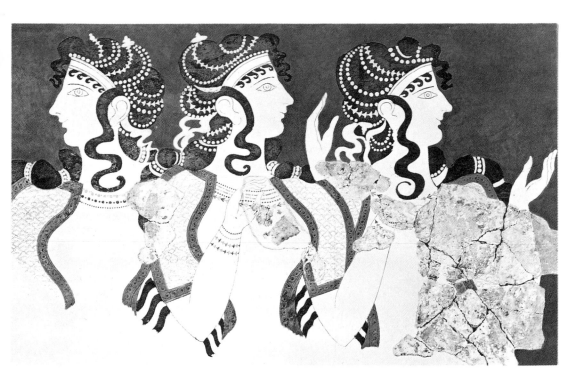

The 'Ladies in Blue' fresco from Knossos. Only a very small part is original: large areas, including all three heads, are restored. (Archaeological Museum, Herakleion)

ties of tablets bearing signs in an unknown script. This, after all, was what he had originally come to Crete to find. The palace was, as he said, 'The find of a lifetime – or of many lifetimes . . .' but he did not forget his first enthusiasm although he suffered from the frustration of the intractability of Cretan scripts. By the end of his excavations he had discovered three sorts of writing, the earliest of which he called 'pictographic', because the signs were based on pictures, as in Egyptian hieroglyphs, and the later two Linear A and Linear B, because in these the signs were simply made up of lines. Evans could classify his scripts, and could make progress with such things as the system of numbering used in them, but was fated never to understand them. While the pictographic and Linear A scripts remain intractable, Linear B has since been deciphered.

At the end of the first season's excavation, Evans was able to make some preliminary remarks about the position of the palace in the more general scheme of things as it was then understood. Traces of Neolithic remains had been found, over which was a stage of the building that he characterised as belonging to the Kamares period – recognising its brightly painted pottery as the same ware that had been found in 1893 in the Kamares cave. This period was thought to go back to about 2000 BC. The 'late' or 'Mycenaean' palace which followed was seen to have much in common with mainland Mycenaean sites, with which it was thought to be roughly contemporary, surviving until the fourteenth or thirteenth century. However, this assumption of identity

OPPOSITE An aerial view of the west wing of the palace at Knossos in 1901. The Throne Room complex is covered with a temporary roof.

OPPOSITE Work on the restoration of the Grand Staircase, probably in 1905. The central figures are Arthur Evans, Duncan Mackenzie and, wearing a straw hat, the architect Christian Doll.

with the mainland sites was soon to be revised. Evans naturally used the term 'Mycenaean' to apply to his palace: this was, after all (and in spite of his earlier 'Minoan' suggestion), the accepted terminology of the time. The similarities of the Cretan culture with that of the mainland were immediately apparent. The differences which Evans was later to recognise were more subtle. In any case, the definition of what constituted typically Minoan culture depended on further excavation and the amassing of a really large body of finds.

The one incontrovertible fact was that the Palace of Minos was a huge project, requiring a substantial commitment of both time and money. Wealthy as Evans and his family were, the strain on their resources looked set to be considerable. His father, delighted with Arthur's success, had on the news of his first discoveries instantly sent a present of £500 – such munificence, coupled with Arthur's own resources, would keep things going for the present. An appeal on behalf of the Cretan Exploration Fund, through the British School, had little effect – the Evans wealth was too well known to make them natural targets for charitable donations. Arthur, in any case, was anxious to retain complete control:

> It is just as well that I should be in a more or less independent position in the matter. The Palace of Knossos was my idea and my work . . . I am quite resolved not to have the thing entirely 'pooled' for many reasons, but largely because I must have sole control of what I am personally undertaking . . . my way may not be the best but it is the only way I can work.

The expense of the dig increased as, during the 1901 season, Evans embarked on his influential – and controversial – restorations: influential, in that they give the visitor a dramatic and three-dimensional experience of Minoan architecture – it is possible to be 'inside' the palace at Knossos in a way that is scarcely paralleled at the other palace sites where, with some exceptions, the remains only rarely achieve shoulder-height – and controversial, in that for scholar and layman alike the question of how accurate and how justified the restorations were remains a matter for debate. In fact, justification is not hard to find: the original impulse was more a matter of necessity. The Throne Room complex, like most excavated remains newly missing their blanket of earth, needed protection from the elements. Evans wanted to avoid 'the introduction of any incongruous elements amid such surroundings', and thus decided on the ambitious project of restoring the upper walls and roof in the Minoan style, supported by copies of the downward-tapering columns of the Grandstand fresco made of stone with a plaster facing. This decision set the precedent for all his restoration work throughout the palace. At first he used expensive materials, importing iron girders to replace wooden beams – some of which still lie in Herakleion harbour after a disastrous attempt to bring them ashore. Even for him the expense of such restorations seemed likely to prove crippling: the later introduction in the 1920s

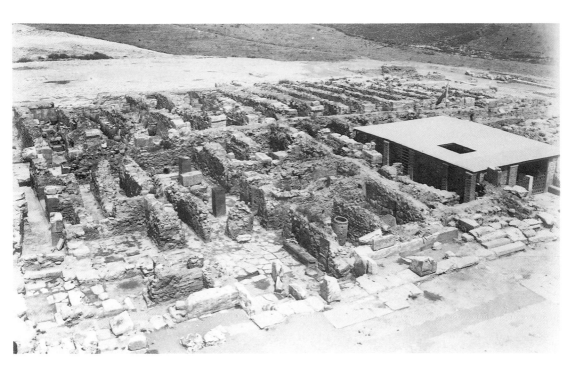

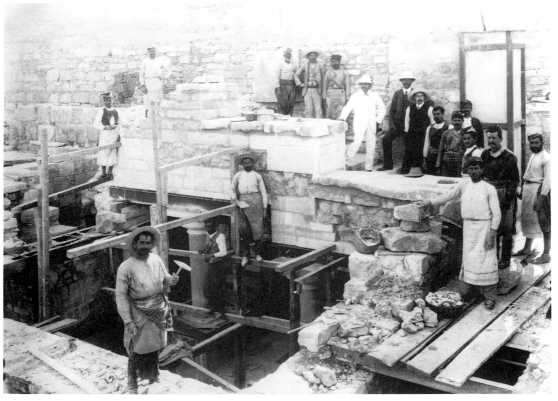

of reinforced concrete, a much cheaper material, was to prove very helpful. Accuracy is another matter. In some cases the restorations have been found wanting, though far more often the assumptions that Evans made have been proved right by later discoveries. Aesthetically the visitor can judge for himself, particularly with the yardstick of the unrestored palaces at Phaistos, Mallia and Kato Zakro for comparison.

By the end of Evans' second season at Knossos in 1901, the ground-plan of the Palace of Minos had been almost completely revealed. Excavations to the east of the Central Court had included the tunnelling operation that brought to light the Grand Staircase – Evans remarked on the fortunate fact that two of his workmen had been in the silver mines at Laurion, and were used to this sort of work – and four flights of stairs, along with evidence for a fifth, had been discovered and, after some difficulties, successfully restored. Most visitors who have walked down these grand Minoan stairs must surely thank Evans for the experience. They lead to the rooms of the Domestic Quarter, on the east side of the palace and built in a cutting on the side of the hill. It is typical of the surprises of Minoan architecture that the character of the rooms they lead to is in many cases small and intimate rather than spacious and grand. The so-called Queen's Megaron is a case in point, small, but with bright frescoes and with an adjoining room which may well have been a bathroom: the terracotta bath-tub now standing there was restored from fragments found scattered in and near the entrance. More grandiose is

Plan of a typical 'Cretan hall' (*top*) and a mainland 'megaron', based on the 'Hall of the Double Axes' at Knossos and the megaron of the palace of Pylos (see also page 101).

the Hall of the Double Axes, which, seeming too imposing for simple domestic use, was identified as a state-room for the king. A tripartite room (comprising vestibule, main hall and light-well) with a verandah on two sides, this Minoan Hall, as Evans called it, was clearly rather different from the mainland megaron, which was characterised by its central hearth. Evans suggested that the Cretan hall was a more southerly type, where heat was not so important and no fixed hearth was needed. This meant that the source of light for the room did not have to be central (since no egress was needed there for smoke), but could instead be placed at one end, resulting in the typically Minoan arrangement of light-well, main area and porch or vestibule. Whether Evans' reasoning was right or not, the contrasts between the Minoan and the Mycenaean palaces were beginning to become more obvious.

Frescoes continued to be amongst the most delightful finds. The profile head and upper body of a young woman in elaborate costume, with darkly made-up eye and rouged lips, was called La Parisienne. She belonged to a composition known as the Camp-stool fresco: compositions with friezes of figures, either processing or, as here, shown in some repeated depiction of apparently ritual actions, were particularly appropriate for the long walls of Minoan corridors. By the South Portico were found remains of a relief fresco showing a male figure with a necklace of lily-shaped ornaments and an elaborate head-dress also decorated with lilies. Evans called him the Priest-King. Such compositions, where plaster was used to build up an image in low relief, seem to have been as near as the Minoans got to monumentality in art, since on the whole their culture did not favour large-scale sculpture – or if it did, the materials used were perishable. The charging bull from the North Portico used the same technique.

Bulls were already established as one of the most notable motifs in Minoan art; indeed, representations of bull-sports had long been known to Evans from various seal-stones. The discovery of a fresco apparently showing two female bull-leapers as well as one male figure in the act of somersaulting over the back of a bull was particularly fascinating. It suggested to Evans that the legends concerning the tribute of youths and maidens exacted from Athens by King Minos as a sacrifice to the Minotaur might have originated from the memory of real bull-sports, perhaps carried out by captives trained and put into the 'arena' like gladiators in ancient Rome.

Links with other areas of the Mediterranean world allowed the Cretan finds to be fixed, with more or less accuracy, in their chronological position. Evans saw Minoan civilisation as part of a nexus that included the Near East and Egypt: indeed he felt that in the Early Bronze Age Egyptian immigrants formed part of the Cretan population, and set some of the patterns for the development of Minoan culture. This view is no longer tenable and the general tendency of research after Evans' lifetime was to emphasise Crete's independence, attributing fewer and fewer elements to direct influence from Egypt

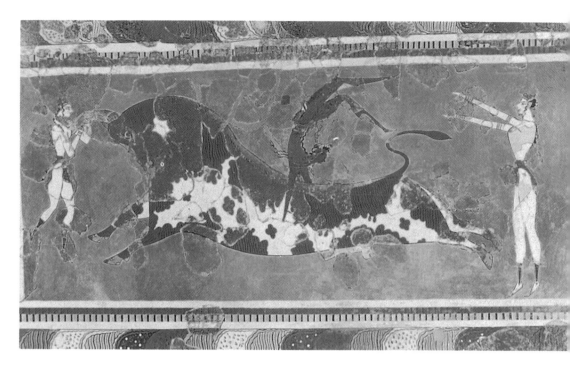

Fresco panel from the palace at Knossos, one of a series showing scenes of bull-sports. Probably Late Minoan II, about 1450–1400 BC. (Archaeological Museum, Herakleion)

and the Near East. Nonetheless, Minoan objects in dated contexts abroad, or datable from foreign imports into Crete, became the fixed points anchoring Minoan relative chronology to absolute dates. Thus, for example, an Egyptian alabaster lid with the cartouche of the Hyksos king Khyan, who ruled in the later part of the seventeenth century BC, was discovered with pottery of the style designated Middle Minoan IIIa, and thus helped to date the first phase of the New Palace at Knossos (though at the time, before revisions in Egyptian chronology, a date of about 1800 BC was suggested for Khyan). Looking to the northwest, similarities between the pottery of the later palace and that of the Greek mainland indicated a chronological link, leading Evans to the sweeping conclusion that the mainland pottery must all have been made in Crete.

Evans began the 1902 season believing that this year would see the end of his work at Knossos, but he was wrong. The 'find of a lifetime' was not to be so easily revealed – the palace site held surprises that caused him real consternation with regard to practicalities, though archaeologically its complexity continued to challenge. The great cutting on the eastern side proved to contain room after room, most of which required the shoring-up and preservation of the upper levels before the lower could be revealed, work which was both slow and expensive. Moreover, the trial pits that Evans had used to determine where to dump the spoil from the site had been unluckily positioned, just missing walls and remains. Much of the excavated earth therefore had to be moved for a second time to allow exploration

beneath it. Nonetheless, although seriously concerned about the cost of his enterprise, Evans could scarcely grumble at the new discoveries that were daily being made.

It would take too long to enumerate all the individual finds from the season, but the so-called Town Mosaic was particularly interesting and unusual. This series of small faience plaques representing houses showed that even dwellings on a more modest scale than the palaces of Crete were multi-storeyed and of some architectural elaboration. Other fragments with human figures, animals and landscape suggested to Evans that the whole composition may have been a narrative scene of some complexity, perhaps including a besieged city, and reminding him of the scenes of peace and war on Homer's Shield of Achilles.

On a more general scale, the publication in 1903 by Mackenzie of a major article on the pottery of Knossos in the *Journal of Hellenic Studies* was a landmark. Here we see the emergence of the tripartite scheme for Minoan ceramics that is still in use today. The Early, Middle and Late groups of pottery were each subdivided into three stages, labelled I, II and III, and the pottery styles – Early Minoan I (EMI), Middle Minoan III (MMIII) and so on – were equated with periods of time. This was reasonable enough for Knossos, where the scheme was invented, but caused problems when it was extended to cover the whole of Crete.

In this article, too, Evans' and Mackenzie's views on the final days of Knossos were clearly set out for the first time. They noted the fine 'Palace Style' pottery of the Late Minoan II period, and associated this with some of the finest frescoes and most accomplished stone vases, as well as with 'the written records of the Palace' – the Linear B tablets. Later scholars would widely come to see LMII as a time when Knossos was under the control of the mainland Mycenaean Greeks. The period began in about 1450 BC, when many other Minoan sites were destroyed and abandoned, perhaps, it would be argued, as the result of a successful Mycenaean invasion. Evans and Mackenzie had no such notion. They saw this period as the final flowering of Knossian life before the destruction of the palace, which they dated to about 1400 BC. After this they felt the palace saw a time of partial reoccupation, characterised by a 'decadent' style of pottery, with 'conventional rendering of foliage and flowers' and the frequent appearance of the *Bugelkanne* (stirrup-jar) – in other words, what we would now describe as typical Mycenaean pottery.

Mackenzie, recognising the wide distribution of such pottery over the Mediterranean basin, discussed the conclusion reached by Furtwängler and Loeschcke in their pioneering study of 1886, where they had specifically called this pottery 'Mycenaean' and claimed that the centre of manufacture was at Mycenae, whence it had spread over a wide area. Now, said Mackenzie, and in spite of the fact that Knossos was in eclipse, the centre of production of this pottery should be recog-

nised as Crete. He traced its antecedents far back in the Minoan tradition, claiming that the origins of later Athenian vase-painting should be seen as going back to Cretan techniques:

> At Athens, after a prolonged period of rivalry between East and West, the old Cretan medium of lustrous black glaze is found to have become Hellenic and Classic in the course of the sixth and fifth centuries BC. And with the old medium it is hardly surprising that old methods of technique should also have survived. Thus we probably have long-surviving tradition rather than accident or reinvention in the fact that in the latter half of the sixth century BC, the style with light design on a dark ground is found once more in competition with that having dark design on a light ground.

This extraordinarily Cretocentric view, claiming a probable Minoan character, and certainly a Minoan origin, for just about everything that had happened in Greek lands from the Bronze Age to the Classical period, was held by both Evans and Mackenzie. Increasingly a hallmark of the various publications that came out of the Knossos excavations, it became a major source of controversy.

Three further full-scale excavation seasons took place before the initial work at Knossos was complete. The year 1903 saw more or less the full extent of the palace site excavated, with the emergence of the Theatral Area of the northwest corner and of the beginning of the wonderfully paved and extremely well-preserved Royal Road. The palace still had unplumbed depths, though, as became apparent with the discovery of the treasures of the Temple Repositories. Beneath the floor of a room directly south of the Throne Room were two rectangular, stone-lined storage places of the sort that Evans called cists. These are a frequent feature in the magazines (long, narrow store rooms) of Knossos, but in this case excavation revealed two larger and more substantial cists underneath the ones first discovered. Here were rich remains that might have been part of the furnishings of a shrine. A remarkable group of faience objects included jewellery, relief plaques that must have been used as furniture inlays, vessels and, perhaps most notably, three figurines of 'snake goddesses'. Two were well preserved and are well known: they wear the flounced skirts and open bodices of Minoan 'court dress'. Each has an elaborate head-dress, one adorned with snakes, the other surmounted by an animal like a leopard, and each has snakes, either entwined around the arms or held aloft. Their fierce expressions and impressive gestures make it likely that they are deities rather than worshippers, though this cannot be certainly established. Their presence reinforced Evans' view that many parts of the palace had a sacred nature, and that Minoan religion had at its centre a female deity.

The recognition of the Linear A script was an important development of 1903. The fact that Evans could instantly compare it to examples found by the American archaeologist Harriet Boyd at Gour-

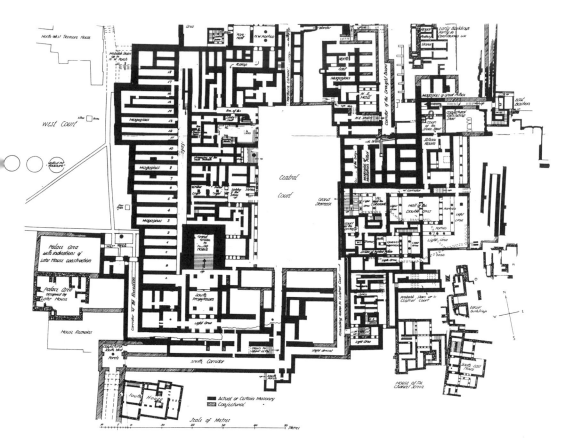

Schematic plan of the Palace of Minos, showing the labyrinthine complexity of the rooms and storage areas. (After Pendlebury, *A Handbook to the Palace of Minos at Knossos*, 1933)

nia, the Italian team at Ayia Triadha, and the British School excavators at Palaikastro and in the Dictaean cave, gives some impression of the lively archaeological scene that had already sprung up all over Crete by this time. Evans had been the trail-blazer, but the new conditions in the island had opened the way to many followers, and the early years of the century must have been a most exciting time. With regard to the relations between Linear A and Linear B, Evans concluded that they were roughly contemporary, and that it was only at Knossos that Linear B superseded the more widespread Linear A. He deduced from this that there must have been a 'dynastic revolution' at Knossos, but stated firmly that the similarities between the two scripts, as well as the apparent continuity in other forms of material culture, meant that there had been no change of race. This has been described as a hypothesis that hardened into a dogma, and would be fiercely opposed when evidence for a period of Mycenaean control at Knossos began to emerge.

The excavation of the Royal Villa, some two hundred yards to the northeast of the palace, underlined the fact that the Palace of Minos, although encompassing many functions within its extensive rooms and courts, was at all periods surrounded by buildings of various types,

some perhaps the residences of important families. In other words, the palace did not stand in splendid isolation, but was at the heart of an important town.

The search for the tombs that were the last resting-place of the inhabitants of Knossos palace and town proved no easy matter. Certainly the cemetery of Zapher Papoura, lying about half a mile to the north of the palace and excavated in 1904, contained more than a hundred burials, but most of these were later than Evans' 'final' (*c.* 1400 BC) destruction at Knossos, and therefore contemporary with his 'decadent' reoccupation period. More obviously of a status to match that of the palace was the tomb found even further to the north, some two and a half miles from the palace itself. This was a built structure, thoroughly plundered, but with sufficient fine vases and fragments of rich finds to show that it had originally been an important sepulchre. Evans called it the Royal Tomb and dated its construction to the Middle Minoan period, though it had been used throughout the Late Minoan age, and reused even later. Rich as it was, though, it was still only a single example. Other cemetery areas did not come to light until later years.

Excavation was pursued along the Royal Road – the magnificent paved way that extended from the Theatral Area of the northwest palace corner. On the north side of the road was found what Evans thought might have been part of the royal armoury and stables: an area in which were important groups of Linear B tablets listing chariot-parts and arrows. Close by were found two groups of real arrows, which had obviously been stored in wooden chests, the chests tied up with string and secured with impressed sealings – lumps of clay into which engraved seals had been pressed.

The Royal Road proved to lead to a very important building that Evans dubbed the Little Palace. Excavated in 1905, this was the largest of the buildings in Knossos town, with imposing main rooms. Some important finds were made there, including the famous stone rhyton, or ritual vessel, in the shape of a bull's head, with gilded horns and crystal eyes. The Little Palace also contained evidence which Evans thought was important for his reoccupation period at Knossos. Its rooms had been subdivided by partitions, in a way that Evans felt was typical of 'squatters' living a degraded life amongst the remnants of former glory. A sunken area of the type that he called a Lustral Basin had also been closed off, and impressions of its fluted wooden columns were preserved in an unusual way in the clay-like material used to block up the spaces between them. Evans, who thought this area was reused as a shrine, called it the Fetish Shrine, placing stones of rough shape (the fetishes) on the balustrade to be photographed. It now seems, however, that the shrine material found here had all fallen from an upper floor. Recent research has also shown that the Little Palace probably suffered a major destruction in the period known as LMIIIa1, in about 1375 BC. This is also the revised

date that many scholars would now give for the final destruction of the palace – a slight down-dating of Evans' suggestion of 1400 BC. The Little Palace would therefore have been destroyed at the same time as the palace itself, and the modifications within it can no longer be seen as a sign of 'squatter' occupation. They belong instead to LMII, the period now generally thought to have seen Knossos under Mycenaean control.

Evans interpreted the 'decadent' last days of the town buildings at Knossos and in the palace itself as the result of internal strife, and of a successful revolution. He specifically denied the possibility of 'a successful foreign invasion', seeming already to be building his defences against any such suggestion. This defensive attitude may have been prompted by the publication, in 1904, of the Phylakopi excavations, in which Mackenzie suggested the possibility that mainlanders might have caused the final destructions both of Phylakopi and of Knossos.

Six years of intensive excavation had revealed at Knossos one of the pre-eminent sites of the Aegean Bronze Age. Joan Evans summed it up more poetically when she says of her half-brother:

> Time and Chance had made him the discoverer of a new
> civilisation, and he had to make it intelligible to other men.
> Fortunately it was exactly to his taste: set in beautiful
> Mediterranean country, aristocratic and humane in feeling;
> creating an art brilliant in colour and unusual in form, that drew
> inspiration from the flowers and birds and creatures that he
> loved. It provided him with enigmas to solve and oracles to
> interpret, and opened a new world for eye and mind to dwell in:
> a world which served to isolate him from a present in which he
> had found no real place.

It would be cynical, and certainly exaggerated, to say that the Minoan world was so exactly to Evans' taste because it was largely the product of his imagination, but there can be no doubt that he projected onto his finds images that he wanted to see. Others found his vision compelling. The idea that the Minoan Cretans were characterised by love of peace and of flowers became widespread – it is, after all, a pleasant thought and most excavators, even today, want to find something to admire in the people they are uncovering, however much they may strive for detachment and a 'scientific' approach. While later researchers redressed the balance to some extent, recognising that the Minoans should be viewed more realistically in terms of what was known of other (invariably more or less warlike) early societies in the eastern Mediterranean, the myth perpetrated by Evans exerted considerable power. Thus when in the late 1970s evidence was found that pointed to human sacrifice in Minoan Crete, the outcry amongst scholars was patently – at least in part – an emotional reaction, motivated by the need not only to debate and evaluate the facts but also to protect the Minoans against accusations of inhuman behaviour.

Evans' house, the Villa Ariadne (*right*), and the view beyond. The garden, nascent when the photograph was taken, is now mature and the house is surrounded with lush foliage.

Evans' commitment to Knossos, and to the attempt to make Minoan civilisation 'intelligible to other men', was implicit in his decision, as early as 1895, as to where he would site his future Knossian home. Picnicking with John Myers on a grassy slope on the west side of the Knossos valley, overlooking the place where the palace still lay concealed, he remarked that when he came to Knossos to dig this would be where he would build his house. He did so, though in fact the Villa Ariadne was not finished until 1906, when it provided a welcome retreat from the malarial area of the old dig-house in the valley bottom. Four-square and substantial, the house was built to Evans' plan and shared the same side of the valley as substantial Minoan neighbours. Like them, the Villa Ariadne was positioned to enjoy afternoon shade; perhaps also like them, it was surrounded by a lush and well-tended garden. It became – and remains – a focus for archaeological activity at Knossos, and though its history is infinitely shorter than that of its Minoan neighbours, it holds memories of almost everyone who has been concerned with archaeological research into Minoan Crete, not only British and Greek residents but visitors from all the other foreign schools.

On 31 May 1908 John Evans died in his eighty-fifth year. For him, Arthur's achievements at Knossos had been a source of deep satisfaction. His continual interest and enthusiasm must have been greatly missed. John's legacy in learned matters was, though, matched in a material way that he could not have foreseen when he began his career in his uncle's paper factories. Later in 1908 the last of the grandsons of old John Dickinson (Arthur's great-uncle) died. Arthur was heir to their large estate and thus inherited both sides of the family fortune. He thus became a richer man than his father had ever

been, and the finances of Knossos never again caused him concern. At the end of the year he decided to resign from his Ashmolean post, where he had achieved much, leaving a flourishing institution to his successor. Knossos thenceforth claimed the lion's share of his time.

In the years that followed, the publication of his discoveries was a major concern, while excavations in and around the palace continued to add small pieces to the great Knossian jigsaw. Academic honours and positions also accrued. In 1911 he was made President of the Society for the Promotion of Hellenic Studies, which he rightly recognised as 'a tribute to one not primarily a Hellenist'. He greatly enjoyed using the opportunity of his inaugural address in 1912 to shock, making to an audience of Hellenists many of the points dear to his heart. Privately he wrote that 'pour épater Messieurs les Hellenistes I told them that Homer, properly speaking, was a translator . . . he worked up an older Minoan Epic . . . I expect rather a shindy!' His presidential address was presumably the cause of some raised eyebrows; it certainly would be today, in its insistence on the 'Minoan' nature of later Greece. While accepting that the Minoans were of a different race from the Greeks, Evans argued that they essentially stamped their influence upon the later arrivals, and that Minoan culture was the foundation stone of later Greek culture. Thus he argued for what he called 'pre-Homeric illustrations of Homer' in Minoan and 'Mycenaean' art – not that he allowed the latter much independent existence, since he saw the mainland as basically Minoan.

In 1914 Evans was made President of the Society of Antiquaries, becoming ex officio a trustee of the British Museum. The First World War, though, cast its grim shadow over the world of learning, as over all else. Distressed that former colleagues were now officially enemies, Evans made impassioned pleas against their eviction from various learned societies. In these difficult times, it was in work that he found solace and his great, many-volumed publication *The Palace of Minos at Knossos* took up much of his attention. 'Into that bright world,' wrote Joan Evans, 'he could escape without evasion or cowardice; and there he could learn that whatever of beauty and culture Time might seem to destroy, Chance might once more revivify in the realm of spirit.'

The monumental *Palace of Minos* was not just a site publication – indeed it quite often frustratingly fails to be that – but was written to a much broader agenda, for it was really a thorough account of all that was known of Minoan Crete at that time. It incorporates information from all the sites that had been excavated, by then a considerable number. Since it was published in four volumes between 1921 and 1936, Evans added up-to-date information as he went along. This was no easy task, as the pace of new discoveries on Crete picked up again after the war. Palaces, tombs, towns, villas and sanctuaries were known, and references to these, as well as comparisons drawn from outside the island, were all included in a book that was encyclopaedic in scope.

DISCOVERIES
ELSEWHERE IN GREECE

I give . . . the chronological table . . . based mainly on the changes in pottery, which, in the absence of written records that we can decipher, is the safest criterion of date. But it must always be remembered that the periods are not separate watertight compartments; they often slide imperceptibly one into the next. It is not reported that Minos declared, 'I'm tired of Middle Minoan III, let Late Minoan I begin.'

J.D.S. PENDLEBURY, *A Handbook to the Palace of Minos at Knossos*, 1933

After the interest aroused in the late nineteenth century by Schliemann's discoveries at Troy and Mycenae, the early years of the twentieth century saw explorations in Crete taking centre stage. Knossos was unrivalled in size and importance, but significant finds were also being made elsewhere, and by the time the first volume of *The Palace of Minos* appeared an island-wide picture of Minoan culture was emerging.

In the south of central Crete the palace at Phaistos provided interesting comparisons with Knossos. It proved to have been built along much the same lines, although it was considerably smaller. On the edge of a ridge looking over the fertile Mesara plain, with Mount Ida rising up to the north, the situation could hardly have been more dramatic, and the palace itself was impressively elegant. Halbherr gave the job of directing the excavations to Luigi Pernier, under whom the palace was basically uncovered between 1900 and 1909, though the first volume of the publication did not appear until 1935. Finds made in the palace were many and various, including much 'Kamares' pottery. Phaistos, like Knossos, had seen two major periods of the palace's existence, but here the Second (or New) Palace had been built with its west façade positioned some metres further to the east. This slight change in position has been most helpful to archaeologists, since part of the western side of the First (Old) Palace was preserved without the complication of later rebuilding on top of it. Interesting finds were made here in excavations in the 1960s, but already it was clear to Pernier that Phaistos was of interest not only for the extensive and elaborate Second Palace but also for what was then called the 'Kamares' phase. The name seemed particularly appropriate at

Phaistos: the entrance to the Kamares Cave itself can be seen from the site, and presumably this was a sacred cave, to which the inhabitants of the palace went with offerings and prayers. Such links between palaces or settlements and natural locations used for worship were increasingly to emerge as Cretan exploration progressed.

Like the British School at Knossos, the Italian school of archaeology established a permanent headquarters at Phaistos, and work in the area has been more or less continuous up to the present day. The large villa of Ayia Triadha, occupying the other end of the Phaistos ridge, was the second major Minoan site explored by the Italians, who discovered it while investigating various tombs in the vicinity. Halbherr himself directed the excavations there, which took place mainly between 1903 and 1905, with further work from 1910 to 1914. The excavation was carried on in rather a piecemeal way, perhaps because to some extent it was considered a poor relation to that of Phaistos. There was at first no publication, though work from the 1970s onwards has aimed to fill the gap. It remains a matter for conjecture quite how this large building, of considerable architectural refinement, related to the palace of Phaistos itself. Wonderful finds were made there, including remains of frescoes and a well-known series of black steatite vases with carved relief decoration. Famous, too, is the limestone sarcophagus found in 1903 in a nearby tomb. This, the Ayia Triadha Sarcophagus, is covered with a thin layer of plaster skilfully painted with scenes connected with funerary rituals, an important source of information for Minoan beliefs.

In 1915 Joseph Hazzidakis began a series of campaigns in the area of Mallia, on the north coast of Crete some thirty-five kilometres east of Herakleion, where he recognised and revealed part of a third Minoan palace. He sought the collaboration of the French School, who eventually took over the excavations, conducting a series of campaigns between 1921 and 1932 that brought to light both the palace and parts of the Minoan town. Here, too, the French presence continues to the present day. Built mainly of local red sandstone and mud brick, the palace of Mallia has a more provincial air than Knossos and Phaistos and lacks some of their refinements. Rich finds were made there, though, including two remarkable swords, one with a pommel of rock-crystal, the other with a decorative gold roundel with the figure of an acrobat in relief. Gold was also found in the building complex called Chrysolakkos (gold pit), which lies between the palace of Mallia and the sea and which may have had a funerary use. Tradition held that treasures had been plundered from there, hence the name, but the looters had missed the gold pendant with two bees around a honeycomb which is perhaps the most famous piece of Minoan jewellery.

Such finds of Minoan jewellery in excavated contexts helped with the identification of a remarkable group of jewellery acquired by the British Museum in 1892, known as the Aigina Treasure. Said to have

Gold pendant from the Aigina
Treasure with the so-called
'Master of the Animals' – a
figure, perhaps a nature god,
holding a goose in each hand.
In a typical Cretan kilt and
with an elaborate head-dress,
he stands amongst lotus flowers
and is flanked by unidentified
curving elements with bud- or
shoot-like ends.
About 1750–1500 BC.
(BM Cat. Jewellery 762)

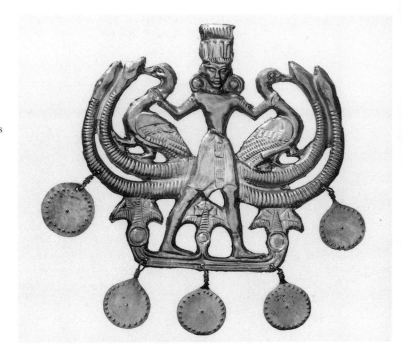

come from a tomb on the island of Aigina, the treasure was first
published by Arthur Evans in the year following its acquisition. At
this stage Evans was Keeper of the Ashmolean and had not yet begun
his Cretan explorations. He recognised the treasure as 'Mycenaean',
but dated it as late as 800 BC, for he felt that Mycenaean traits might
have survived on Aigina for a long time and he recognised eastern
influences in the jewellery which he thought should bring it close to
the so-called Orientalising period in Greece, which began in about
the seventh century BC.

Other scholars were subsequently to think the treasure either late
Mycenaean or later. It was not until the 1950s that Reynold Higgins,
then an Assistant Keeper in the British Museum, put forward the
suggestion that the non-Mycenaean elements in the treasure were not
post- but pre-Mycenaean – that is, Minoan. He proposed that the
treasure had come from Crete, suggesting that it might in fact have
been taken from the Chrysolakkos complex at Mallia, and dated it to
between about 1700 and 1500 BC.

The identification of the Aigina Treasure as Minoan has long been
accepted, though Higgins himself, as he pursued the convoluted quasi-
detective story of the Treasure's history, came to doubt his Chryso-
lakkos theory, and to feel that the jewellery had more probably been
made in a Minoan colony on Aigina. Minoan jewellery from known con-
texts is rare – valuables being the last thing that their owners would
knowingly discard, and tombs being so frequently robbed – but a recent
addition to the excavated parallels for the Aigina Treasure comes from

Tell el-Dab'a in Egypt, where a gold pendant of similar type to the one in the treasure was found, along with other Minoan imports, in a context dated to about 1780–1740 BC.

Hazzidakis also excavated before the First World War at Tylissos, west of Herakleion, where he found a group of three large and obviously important villas. While these illustrated Minoan life away from the palaces, but still on a relatively grand scale, the discovery of the town of Gournia gave the first opportunity for shedding light on the lives of more ordinary people in a small working town.

Gournia was revealed in 1901–3 by the American scholar Harriet Boyd, who had met Arthur Evans in Athens as he passed through on his way to begin his excavations at Knossos. She had been encouraged both by him and by David Hogarth to pursue her idea of excavating in Crete. When she visited Knossos in Evans' first weeks there, she saw the last earth being removed from the gypsum throne in the Throne Room, before going on to see Federico Halbherr at Gortyn. Then, armed with advice and encouragement, she went to the rugged eastern end of the island looking for promising sites to dig. Based at Kavousi, she surveyed a number of sites around the northern end of the Isthmus of Ierapetra before local information led her to Gournia, a Minoan settlement on a low hill overlooking the sea. Here with great energy and enthusiasm she uncovered almost the whole of the ancient town, from its 'governor's house' on the highest point to the rows of small dwellings lining the network of narrow streets. This was a contrast indeed to the imposing Minoan palaces and the relatively humble finds, from potter's wheels to fish hooks, gave a vivid impression of the daily life and concerns of the inhabitants. Harriet Boyd was a contrast herself to the other excavators then working in Crete, being the only woman amongst them, but she greatly enjoyed life in the field, meeting difficulties with a resilience that earned her the respect of both colleagues and workmen. She was a pioneer in a discipline that has always been refreshingly free of prejudice against women, and her contribution was valued for its own sake.

Harriet Boyd began the long-term association that American researchers continued to have with this eastern part of Crete. She had on her team a young fellow American, Richard Seager, who at first acted as the expedition's photographer and also supervised some of the Gournia excavations. He moved on to uncover part of the important Early Minoan site at Vassiliki, where he brought to light substantial architectural remains of a large building, as well as quantities of the characteristic mottled pottery that came to be known as Vassiliki Ware. Seager was only twenty-three when he finished work at Vassiliki, but he had already become thoroughly immersed in Cretan researches. He went on to explore the Minoan settlement on the offshore island of Pseira, where finds included fragments of relief frescoes showing Minoan ladies in court dress – remarkably sophisticated for a place quite removed from the palatial centres. His work on Mochlos,

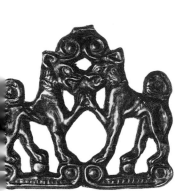

Gold pendant with two confronted dogs from Avaris. This piece is like the Aigina Treasure pendant (*opposite*) in style and technique, and is probably of Minoan workmanship. 18th century BC. (Cairo Museum)

another offshore islet, revealed important Early Minoan built tombs, with rich finds including stone vases, seals and gold jewellery, while near to his house at Pachyammos a storm revealed Minoan burials in pithoi, or large storage jars, buried in the deep sand that gives Pachyammos its name.

Seager was taken ill while sailing from Egypt to Crete in 1925, and died shortly after arriving in Candia, aged only forty-three. Arthur Evans was at Knossos at the time, and sadly sent the news to *The Times* in London, with a warm tribute to Seager's contribution to knowledge of Minoan Crete. He was buried on the island, and a wreath from the Greek Government was laid on his grave with a speech expressing gratitude for his archaeological work. 'Crete . . .', said the local governor, 'is thy second native land and holds with true affection and pride thy bones.'

The types of Early and Middle Minoan burials discovered by Seager on the north coast of Crete stood in contrast to those in the south of the island, where between 1904 and 1918 the Greek scholar Stephanos Xanthoudides excavated a number of the circular tombs of the Mesara plain. Such 'tholos' tombs were particularly common in this region and the finds made within them included several indications of early contacts with the eastern Mediterranean and Egypt. Xanthoudides' large-scale publication *The Vaulted Tombs of Mesará* remains a most useful source of information, though its title famously begs the question of whether these tombs actually were vaulted: arguments about the evidence for stone vaults have continued, and roofs of more flimsy materials seem more likely particularly for the larger tombs. The relationship between the Cretan tholoi and the later examples on the Greek mainland also caused some controversy, for the chronological gap between the two groups was sufficient to create difficulties for any claim of a direct link, though on the face of it some connection is likely.

As well as settlements and tombs, Minoan sanctuary sites also came to light. Evans led the way in pointing out that the sacred and the secular were together within the walls of the Minoan palaces, and that Minoan shrines were found within buildings: he had come across nothing that seemed equivalent to the later freestanding temples. This pattern was repeated at Gournia, where a small shrine was recognised in one of the buildings of the town. Nonetheless, the sacred caves that had been discovered both on Mount Ida and in the mountains surrounding the Lasithi plateau (where D.G. Hogarth had excavated in the Dictaean Cave) made it clear that the Minoans worshipped also in natural locations. Further proof of this came from the so-called peak sanctuaries, a type of hilltop site where, although there might be a sacred enclosure and even simple buildings, worship essentially took place in the open air. Small votives, either in bronze or terracotta, were found among the rocky outcrops on such sites. Representing worshippers, animals or crops, they had clearly in some cases been

thrown into sacred fires. Peak sanctuaries were excavated by J.L. Myres at Petsofa, near the town site of Palaikastro at the extreme eastern end of Crete, in 1903, and by Evans himself near Knossos, when in 1909 he uncovered the peak sanctuary on Mount Iouktas, the hill that dominates the Knossos valley from the south.

While little evidence had been found for Minoan habitation of the western part of Crete, the centre and east of the island were, by 1921, positively peppered with dots on the map that showed Bronze Age sites. At all of these the excavators adopted the chronological scheme evolved by Arthur Evans, so that the notion of the tripartite division of Minoan history into an early, a middle and a late phase became thoroughly accepted. These three main periods, designed to correspond in a general way with the Old, Middle and New Kingdoms of Egypt, were themselves subdivided into three, labelled I, II and III, to allow greater precision in dating. This scheme, based on the pottery and stratigraphy of Knossos, gained widespread support not only because it worked but also on what might be termed philosophical grounds. The idea that civilisations naturally had three stages – a beginning, a period of full flowering, and a decline towards the inevitable end – seemed so obvious that it was almost propounded as a natural law. Thus Gustav Glotz, the French author of a general work on Aegean civilisation published in 1923, wrote, 'Evans, it is clear, combines the data of the stratification with the universal laws of evolution and the requirements of the human mind when he assumes with such regularity a period of growth leading to a period of apogee, followed by a period of decadence and transition.'

The 'requirements of the human mind' may have encouraged a tripartite scheme because of the model of a human lifetime, with its periods of growth, maturity and decay. Such patterns had long been recognised both in human history and in art. We have already seen that in the Classical world mankind's development was thought by Aristotle and others to fall into three phases. The Renaissance artist Giorgio Vasari wrote of ancient art in just these terms. In the Preface to his *Lives of the Painters, Sculptors and Architects* (1550) he says:

> For having seen in what way art, from a small beginning,
> climbed to the greatest height, and how from a state so noble she
> fell into utter ruin, and that, in consequence, the nature of this
> art is similar to that of the others, which, like human bodies,
> have their birth, their growth, their growing old and their death;
> they will now be able to recognise more easily the progress of her
> second birth and of that very perfection whereto she has risen
> again in our times . . .

In the neo-classical revival of the eighteenth century, Winckelmann's influential ordering of Greek art into Archaic, Classical and post-Classical periods followed the same pattern.

The tripartite scheme is not without potential difficulties. Charles Newton, for example, fell foul of the preconceived idea that

Mycenaean art had to be part of the beginning of the cycle of Greek art – the 'growth' period – and therefore failed to recognise its sophistication. The idea of inevitable decay can also bring problems. Arthur Evans himself characterised Crete in his Late Minoan III period – the fourteenth and thirteenth centuries BC – as being in decline and by extension applied this view to the Greek mainland, though we now recognise this as a period when Mycenaean power and influence were at their height, widespread throughout the eastern Mediterranean.

However that may be, Evans' chronological system is still used. Inevitably, though, since it is schematic, the reality that it represents was far more complex. Possible exceptions to Evans' 'rules' were early recognised, and reservations about certain aspects became entrenched within the system. For example, excavators of non-palatial sites pointed out that pottery styles developed differently outside the palaces. Thus Seager, in 1917, could say:

> Personally I think . . . his [Evans'] LMII period at Knossos in
> point of time is probably what I call LMI and I think the
> Italians agree with me . . . There is no use entering into all the
> pros and cons but to my mind the LMII pottery is merely a local
> product called for on a great palace site like Knossos and never
> was made on the smaller sites where what I call LMI pottery ran
> on through both periods. Evans and I always have awful
> arguments about this.

This was an early, indeed almost prescient, recognition of the sort of problem inherent in the Evans system that is still debated today. It highlights, too, another illogicality, namely the equation of pottery styles with periods of time and the use of the same terminology for both. Thus, for Evans, MMIa was both a style of pottery and a period when that pottery was used. But if, as later emerged, the style of pottery that he called EMIII was actually still used in the eastern part of Crete when MMIa was in use at Knossos, it immediately becomes apparent that one cannot speak of 'the MMIa period' and expect it to equate with an actual period of time, for the same period of time is patently 'the EMIII period' elsewhere in Crete. Nonetheless, the Evans system continues to be used (with whatever mental adjustments are needed to accept its inconsistencies) for the simple reason that it is very hard to replace it with anything better. A useful attempt was made by Nicholas Platon, who suggested the use of the architectural history of the palaces as a basis, and the adoption of 'pre-palatial', 'protopalatial' (relating to the First or Old Palaces), 'neopalatial' (relating to the Second or New Palaces) and 'postpalatial' as the main divisions. This system, too, is widely used, but generally in conjunction with that of Evans, which has to be invoked when greater precision is required.

Meanwhile, on the Greek mainland excavations and discoveries were being made which, while in the shadow of the dramatic finds in Crete, were laying important foundations for the period between the

two world wars, when the mainland would again come to centre stage and controversy about the relationship between the two areas would rage.

Mycenae, Tiryns and Orchomenos, Schliemann's sites, were of course already known, and a far fuller picture of Mycenae as a great and important centre had emerged under Tsountas' patient hand. Work on the pottery of the mainland had been put in train by Furtwängler and Loeschcke, pioneers at the end of the nineteenth century of the kind of detailed study of pottery that was recognised as essential in the twentieth. The time was ripe for excavation on sites with names that did not resound in the lines of Homer or the Greek myths, but which nevertheless would give some good, reliable, stratigraphic information on which the study of the Greek mainland could be based.

The first two decades of the twentieth century saw the beginning of the work of two men whose names will dominate our next chapter, the Englishman Alan Wace and the American Carl Blegen.

Alan Wace went to Athens as a student of the British School in 1902. He became interested in the Neolithic pottery of Thessaly, and it was in this part of Greece that he undertook his earliest excavations. He was Director of the British School from 1914 to 1923, during which time he first met Carl Blegen. Blegen was excavating Korakou, a mound near Corinth, in 1915 and 1916 on behalf of the American Institute of Classical Studies, and Wace collaborated in the study of the site and its pottery. It was published in 1921, the same year as the first volume of *The Palace of Minos*.

The ancient name of Korakou is not known, though it may well be the Ephyra of Homer, which seems to have been the most important Bronze Age site in the Corinth area. Blegen, though, was not at first concerned with names famous in Homer. His early work not only at Korakou, but also at sites such as Gonia, Hagiorgitika and Zygouries, saw him pursuing pottery and stratigraphy and, as he put it, 'the nameless *tis* [someone] of the Homeric poems, who with his fellows formed the bulk of the population and rendered Agamemnon's glory possible'. At Korakou, then, his main concern was with the analysis of the pottery found in layer after layer of its deep stratigraphy. The site was not so dramatic as Tiryns or Mycenae, but the careful analysis of its ceramics would enable the pottery from those great sites to be studied on a proper basis for the first time. As Blegen succinctly remarked, 'Korakou explains Tiryns and Mycenae.'

Wace and Blegen, then, were from the first engaged in work of great significance, establishing new knowledge that was based not on impressive finds but on the careful study of hundreds of potsherds – perhaps the least dramatic category of material. The discovery of stratified sequences of mainland pottery allowed them to collaborate on their influential article of 1918, 'The Pre-Mycenaean pottery of the Greek mainland'.

The significance of this article was twofold. First, it brought the

analysis of pottery into its rightful position as the very basis for prehistoric research. If the ceramic sequences are not studied and dated, there can be no basis for chronology and therefore no real understanding of any other aspects of the ancient cultures under consideration. Wace and Blegen established a dating sequence for the pottery of central and southern Greece that is still the basic framework used today.

The second great importance of their article lay in the establishment of a tripartite scheme for mainland chronology, using the terminology Early, Middle and Late Helladic for its three main periods. This was based on Evans' Minoan system formulated at Knossos. As the title of their article implies, they were not primarily interested in the later period of mainland pottery, which saw the wide diffusion of recognisably Mycenaean types. Instead, they wanted to chart its earlier progress, recognising that mainland pottery at this early stage had an identity quite separate from anything produced in Minoan Crete. They therefore characterised the products of the Mycenaean age as 'the fruit of the cultivated Cretan graft set on the wild stock of the mainland', and went on to say that 'the underlying mainland element influenced the dominant Minoan art so as to make it Mycenaean as opposed to Cretan.' This way of looking at the relationship between the two has now become canonical, though the differences between Minoan and Mycenaean objects remain, in some cases, impossible to pin down.

Although their scheme was borrowed from Crete, it was based on observation of pottery from the sites in the Corinth area and many of its details differed, as one would expect, from its Minoan counterpart. In particular, while the authors recognised that there would usually be internal divisions discernible within the three broad periods, they felt that these should be distinguished on a site by site basis and did not lay down a universal system that was expected to work throughout the mainland.

Evans should perhaps have been flattered at the way in which Wace and Blegen built on his work, but already it was clear that their views and his about the relationship of the mainland and Crete were diametrically opposed. He continued to see the mainland as essentially Minoan, dismissing their suggested terminology with the acerbic comment, 'Late Helladic? The Roman wall itself becomes Late British with equal reason!' The omens were not good, and this difference of opinion would cast a long shadow over the progress of research into the Greek Bronze Age in the 1920s and '30s.

III

MINOANS
VERSUS
MYCENAEANS

ALAN WACE
AND CARL BLEGEN

. . . Blegen has got a Palace apparently of the Homeric
period – really Nestor's – and 185 clay tablets
inscribed in a form of the Minoan script . . .

Letter of J.D.S. PENDLEBURY, 1939

WACE AT MYCENAE

It was largely due to Arthur Evans that the British School turned its
attention to Mycenae after the years of the First World War. Evans
felt that new excavations should be made there 'in view of the great
discoveries in Crete which have thrown entirely new light on the origin
and development of the Mycenaean civilisation'. Alan Wace was keen
to take on the job, for which he was eminently well qualified since as
well as his work with Blegen at Korakou and on mainland chronology
he had also spent some time during the war studying pottery from
Mycenae in the National Museum in Athens. Christos Tsountas was
happy to waive his rights to the site, and so the necessary permits were
arranged. Wace carried out annual seasons of excavation at Mycenae
between 1920 and 1923.

He came to a site already famous for dramatic finds, a site about
which much was already known. Schliemann's discoveries had been
supplemented by the work of the German scholar Georg Karo on
the analysis and understanding of the Shaft Grave treasures, while
Tsountas, digging more widely, had recovered the ground-plan of the
Mycenaean palace. Already, though, twentieth-century archaeological
thought was weighing in the balance the confident endeavours of the
nineteenth century and finding real knowledge in many respects still
sadly lacking. Wace's contribution could scarcely be so dramatic as
Schliemann's, but it was timely and of lasting value. He inherited an
unbalanced situation, where certain areas and aspects of the site had
been thoroughly examined, but where the overall picture remained
patchy. His task was not only to sort through all the accumulated
evidence but also to pursue new excavations with specific, and answer-
able, questions in mind. Discoveries elsewhere allowed him to apply
to Mycenae the still-emerging chronological information based on

mainland pottery from other sites. His work permitted a truly coherent view of the history of Mycenae to be formed for the first time.

The connections of the British School at Athens with Mycenae have continued to this day, with Wace's campaigns in the '20s seeing the introduction of recognisably modern excavation there. In contrast with the autocratic ways of Schliemann and Evans, who had generally

Portrait of Alan Wace in the 1920s.

employed one or two assistants and a large, ill-supervised workforce, Wace's team consisted of a number of School students, many of whom were to go on to distinguished archaeological careers, working with up to fifty-five local workmen. The publication of the excavations was also to be in the 'modern' mode, with particular members of the team taking responsibility for publishing specific types of find.

We may begin our survey of Wace's achievements at Mycenae with the palace, the central and highest point of the site. Re-examination added some details to the ground-plan revealed by Tsountas, including the find of the so-called red bath, a sunken area reached by steps rather like the lustral basins of Crete, covered with red plaster. 'Local rumour', says Wace, 'declares this to be the scene of the murder of Agamemnon.'

While the erosion of the hilltop meant that in the area of the palace stratification scarcely existed, elsewhere the examination of pottery in

association with structures already exposed at last allowed their dating. Thus Wace was able to demonstrate that the huge Cyclopean walls of Mycenae actually dated from the Late Helladic III (LHIII) period, after about 1400 BC: a date which at the time seemed surprisingly late in the citadel's history, since it had been expected that it would have flourished at about the same time as the Second Palaces in Crete, perhaps in the sixteenth or fifteenth century. Contemporary German excavations at Tiryns showed that there, too, the massive walls were of LHIII date.

The dating of the walls of Mycenae had its effect on the understanding of the Shaft Graves and the circle in which they lay. Wace demonstrated that early in Mycenae's history, when the citadel itself occupied quite a small area on the top of the hill, an extensive Middle Helladic cemetery had occupied the southwest slope, in the area where later the Grave Circle, the nearby houses, and the citadel wall were built. Part of this cemetery, he maintained, began to be used for 'royal' (modern self-consciousness would probably substitute 'élite') burials at some time not long before the beginning of the sixteenth century BC. The elaborate form of the Shaft Graves was, according to Wace, a more splendid variant of the Middle Helladic cist grave, which was cut as a simple, roughly rectangular hole. Important burials continued to be made in the Shaft Graves until late in the sixteenth century, each grave being used repeatedly. Then, when the graves were no longer in use, they were still remembered with reverence: hence the altar that Schliemann had found at a low level in the Grave Circle.

This area was left outside the fourteenth-century citadel walls but when, in the thirteenth century, the plan was made to extend the citadel of Mycenae, the old cemetery area was still given special treatment. The 'royal' graves were already in a circular enclosure, but were now provided with the handsome wall of double slabs, while the citadel wall itself was curved round the outside of the Grave Circle. The area needed to be terraced, to compensate for the original sloping surface, thus increasing the depth of earth over the Shaft Graves. Some of the stelai or grave-markers were moved to the level of the new surface and the double wall, so that the position of the graves should not be lost. Schliemann's finds had proved the graves were rich: it is an indication of how important they were thought to be that such elaborate works were carried out to preserve them.

The Lion Gate was another part of this programme of works, which clearly marked a confident high spot in Mycenae's fortunes. Wace follows Evans in his interpretation of the relief, saying that the lions guard a pillar which represents strength and protection, and which is probably an aniconic (that is, non-representational) image of the Great Mother Goddess, protectress of the citadel. Scholars are not now so keen on the notion of a universal 'Great Mother' goddess, though the idea that the pillar may represent the protective power of a deity is still widely accepted. It is interesting to note that in some

respects Wace was wholly in agreement with Evans about the main-
land debt to Crete. This is particularly marked in religious matters,
where he followed Evans' view that the Mycenaean religion was taken
over in its entirety from the Minoans, though in fact the process now
seems to have been a good deal more complicated.

Outside the citadel walls, Wace turned his attention to the cemet-
ery areas of Mycenae, excavating and publishing a group of chamber
tombs, and re-examining the tholos tombs. Nine of these monuments
were known; the Schliemanns had worked on the two best preserved –
the so-called Treasury of Atreus and the Tomb of Clytemnaestra –
and Tsountas had excavated the other seven examples. It had quickly
become apparent that such noticeable structures were rarely left
unplundered. Indeed, excavation had revealed so few finds that their
dates were quite unsure. By Wace's time the recognition of the rela-
tively early date of the Shaft Graves ensured general acceptance that
the tholos tombs were later, both types being recognised as princely
burials which were unlikely to be contemporary. Wace made a
thorough and detailed study of the tholoi, and was able to plot a
typological sequence based on their architectural and structural
elements. Associated pottery was also examined in the attempt to
anchor the sequence firmly. He demonstrated that the rather simpler
forms and techniques of three of the tombs (Epano Phournos, the
Cyclopean tomb and the Tomb of Aigisthus) placed them early in the
sequence, in the middle came the Lion Tomb, Kato Phournos and
the Panagia tomb, while the latest and most accomplished examples
were the Tomb of the Genii, the Tomb of Clytemnaestra and, above
all, the remarkable Treasury of Atreus.

Some questions remained, such as the problem of whether the
'dromos', or entrance passageway, was left open to reveal the door in
the tomb itself, or whether it was filled with earth, requiring a huge
effort to clear it when subsequent burials were to be made – for it was
clear that the tholoi were used for multiple burials. Another, perhaps
connected, problem was the presence in many tombs of later, post-
Bronze Age pottery. This could have been deposited during later use
of the tombs, implying full access to them, or may have been slipped
in through holes in the dome. The establishment of hero cults at some
of the tombs may have accounted for some later uses.

Perhaps most difficult to resolve was the question of the origin of
the tholos tomb type. The Minoan circular tombs of the Mesara Plain
were obvious possible forerunners, but the theory that the tholos type
came from Crete presented difficulties. It was not surprising that the
earlier Cretan tombs should be much simpler than the solidly con-
structed mainland examples – as we have seen, it is not clear how the
Cretan tholoi were roofed, if at all – but more intransigent was the
chronological problem. The Cretan tholoi ceased to be built in about
Middle Minoan II, in absolute terms some time before 1700 BC, while
the mainland ones began only in the Late Bronze Age, the very earliest

dating possibly to *c.* 1600 BC. There is therefore a gap of at least one hundred years between the two series of tombs. Later tholoi on Crete were presumably reintroduced from the mainland. While the problem may not be insuperable (and recent research has returned to the possibility of Cretan influence lying behind the first mainland tholoi), Wace's initial conclusion was that the Mycenaean tombs were unlikely to have been copied from those in Crete.

Wace's work on the tholos tombs seems now to be sound and uncontroversial scholarship, yet Arthur Evans reacted to it very negatively indeed. It became one particular focus amongst the many ways in which he disagreed with Wace and other scholars of the Helladic mainland. He actually published a monograph, *The Shaft Graves and Bee-hive Tombs of Mycenae and their interrelation*, specifically aimed at undermining Wace's research and denying its validity. In particular, he claimed that Wace had got his typological sequence the wrong way round, and that the Treasury of Atreus and the finest tholoi were early – and therefore contemporary with the great age of Minoan Crete – while the other tombs represented a falling away and decadence. Even more dramatically, he suggested that the contents of the Shaft Graves (which, it perhaps goes without saying, he considered to be almost entirely Minoan in character) were actually the original contents of the tholos tombs, brought into the citadel and buried at some time of danger. This, in his view, happily brought together the finest grave-goods and the finest type of grave.

Evans' theory completely ignored the dating evidence from pottery available for the tholos tombs, and his reversal of Wace's typology was not well founded. His mistaken view partly rested upon the fact already touched on, that his chronological system presumed a regular pattern of growth, maturity and decay. He felt that the Treasury of Atreus must necessarily be a product of maturity and could not possibly be of the late date suggested by Wace, since this would put it into his period of decline. The mistake, though, was not simply a result of a tripartite chronological system. It arose from Evans' 'pan-Minoan' theories, which did not allow the Mycenaean culture any independent existence and thus did not allow it to have its own cycle of beginning, middle and end. Just as Newton before him had made Mycenaean artefacts the primitive forerunners of later Greece, now Evans could not see them except in terms of the last decadent gasp of his own Minoan culture. According to him, all that was good or sophisticated on the mainland had to come more or less directly from Crete; it had essentially to 'be' Minoan. Thus the fine building of the Treasury of Atreus had to belong to the period of similarly fine building in Crete, which was *par excellence* the time of the Second Palaces.

The growing body of evidence that Evans was wrong, that Helladic culture grew and flourished in its own right, with a debt to Crete that had to be carefully evaluated, was anathema to him. The situation was seen by Wace and his colleagues as a complex one: they recognised the

enormous debt that the Mycenaean mainland owed to Minoan Crete, and much thought was put into constructing plausible ways of seeing the relationship between the two areas. For Evans, on the other hand, it was a simple matter: his Minoans were dominant and he viewed them as the masters in all respects. There may have been a Greek-speaking 'underclass' – he had, after all, to make some accommodation for the fact that in later times the mainland was Greek – but in his view Minoan Crete exerted both political control and artistic influence until some time after the 'final' destruction of Knossos, when both Crete and the mainland fell into decline. Evans had reluctantly to allow that at some stage in the fourteenth and thirteenth centuries the mainland had become dominant, but he felt that by then Minoan influence was so all-pervasive that essentially Minoan culture, translated into mainland guise, was inherited by the Classical world.

It is unfortunate that the debate was not carried forward in a reasoned and academic way. Evans, while generally encouraging to younger scholars, could not tolerate radical disagreement from them, especially when this took the form of a challenge to the supremacy of his beloved Minoans. He attempted, as the grand old man of Aegean prehistory, to sweep all arguments before him in an overbearing way. This must have been as annoying as it was difficult to deal with for Wace and, as Helen Waterhouse put it, 'This unhappy schism made it difficult for a number of years for Minoan and Mycenaean studies to be pursued as a whole and without partisanship.' In fact, in 1923 the British School at Athens abruptly stopped Wace's work at Mycenae and his tenure as Director was not renewed. Wace was, however, too good a scholar for this to blight his career: he became Laurence Professor of Classical Archaeology in the University of Cambridge and was eventually able to return to Mycenae to excavate in 1939. Moreover, he had the satisfaction of knowing that, as research progressed, he was increasingly proved to have been right, not only in what he had said about the monuments of Mycenae itself but also in terms of the broader picture. The Mycenaeans did have an independent culture and it did flourish particularly in the fourteenth and thirteenth centuries BC. Wace would even, unlike Evans, live long enough to know of the decipherment of Linear B. The proof that the tablets were in Greek, and that this was the language of the administration not only of the mainland palaces but also of the palace at Knossos itself in its latest stage, would be the final factor that dispelled the 'Minoan mirage' engendered by Evans – but this is to get ahead of the story.

BLEGEN IN THE PELOPONNESE

Amidst the clashes of temperament that characterised the debate on Minoan and Mycenaean relations, Carl Blegen seems to have provided an oasis of calm. A quietly spoken American scholar from Min-

neapolis, Minnesota, Blegen was to be distinguished by his restrained but firm insistence on the truth as he saw it. His was a style that indulged in no pyrotechnics – although one of Schliemann's successors on the site of Troy, he could scarcely have been more different from that volatile exhibitionist – and one has the sense of his quietly putting into position building-blocks of knowledge while storms raged around him. Certainly his achievements were to be of great importance, cul-

Portrait of Carl Blegen at Troy in 1937.

minating in his excavation of two major sites. Troy, already known but still problematic, was to yield up more of its secrets to his careful spade, while the finding of 'Nestor's Palace' at Pylos was the crowning achievement of his career.

After his earliest researches at Korakou came other sites in the Peloponnese that threw light on life outside the main Mycenaean centres. Zygouries, between Corinth and Mycenae, had flourished early in the Bronze Age, but Blegen felt that by the Late Bronze Age it was entirely dependent on Mycenae, allowing him to speculate about the rise of the great strongholds and the influence, or indeed control, that they exerted over their immediate neighbourhoods. One of the most interesting features of Zygouries was the 'potter's workshop', which proved to contain a group of vases that had apparently never been used and were of recent manufacture at the time when the workshop was destroyed. Dating from the beginning of the Late Helladic IIIB period, they provided a rare, text-book illustration of a range of contemporary pottery.

Prosymna was the name given by Pausanias to the area of the Temple of Hera at Argos (the Argive Heraion), just south of Mycenae. The name may date back to the Bronze Age and was therefore chosen by Blegen when he published *Prosymna: the Helladic settlement preceding the Argive Heraeum*, to distinguish the prehistoric remains on the site from those of later periods. His discoveries gave an important hint that there could be continuity in the use of sacred places from the

Bronze Age to Classical times, though in fact the overlay of later remains had removed much of the earliest evidence from the site. Blegen concluded that an extensive settlement must have lain there, but was not able to recover much evidence for its nature, or to prove whether it had religious importance.

More interesting were the Middle and Late Helladic tombs surviving in considerable numbers to the north and west of the settlement area. The Late Helladic chamber tombs, fifty in number, contained many interesting finds and provided much information about burial practices. They were used for multiple burials – close to five hundred bodies were found in all – and the dromoi or entrance passages seem to have been filled in after each interment. Remains of earlier burials were swept together to make room for new ones, and were sometimes buried in cists (rectangular box-like holes) dug into the floor. Signs of burning were interpreted by Blegen as fires lit for fumigation of the tombs, for cremation of the bodies was clearly not practised. Only one 'larnax' (clay coffin) was found, though these were common in Crete. The body was usually laid directly onto the floor, or sometimes onto a low stone bench along one side of the tomb.

In 1928, the year which saw his last excavation season at Prosymna and the publication of the second volume of *The Palace of Minos*, Blegen and his colleague, the linguist Professor J.B. Haley, published an important article on 'The Coming of the Greeks'. The aim of this collaboration was to collect place-names in Greek lands that linguists had agreed were most probably pre-Greek (and non-Indo-European) in origin. Such names typically ended in -nthos and -ssos, and included Korinthos, Parnassos, Knossos and so on. They also included certain names of plants, such as hyakinthos and terebinthos, the turpentine tree. The idea was that both names of places and of natural features, as well as of things such as plants, might well survive in use even when the land was taken over by invaders speaking a new tongue. Blegen took this linguistic distribution map and compared it with what was known from archaeology – both excavation and surface survey – of the Bronze Age population of Greece. He discovered that the early names coincided in particular with places known to have been inhabited in Early Helladic times. This seemed to show that in all probability the Early Helladic people who gave the names to the places were not Greek speakers. Blegen and Haley therefore suggested that it was towards the beginning of the Middle Bronze Age that speakers of Greek came into the Greek peninsula. Blegen went on to associate these people with the makers of the grey Minyan pottery that appeared in Greece at about this time. Later research has tended to show that the situation was more complex than this would imply, but the article certainly broke new ground.

It was important, too, for the authors' conclusions about the situation on Crete. There, with no discernible break in language or culture, it could be assumed that the non-Greek-speaking Minoans

flourished from the Early to the Late Bronze Age. Then, with the destruction of Knossos at the end of Late Minoan II, came a change. The enfeebled island was, according to Blegen, controlled in the LMIII period by 'an offshoot from the powerful dynasties established at Mycenae and Tiryns in the Argolid'. By this stage, at least, the islanders must have begun to use Greek. It was soon suggested, indeed, that Greek-speaking dynasts already occupied Knossos during LMII.

Blegen and Haley's conclusions represented a further challenge to Evans' thinking. He assumed that the language of the mainland would have been Minoan at least from about 1600 BC and the Shaft Grave era until some time in the fourteenth or thirteenth century, supposing that the language would have been part of the package of cultural influence and political control. Only in the last centuries of the Bronze Age could he envisage the arrival or emergence of a Greek-speaking mainland population.

BLEGEN AT TROY

While Arthur Evans took issue more publicly with his countryman Wace, there can be no doubt that the quietly persistent Blegen was equally important in bringing about changed attitudes and showing that for all Evans' greatness, there were ways other than his of looking at the overall picture of the Aegean world. Blegen was therefore a force to be reckoned with and a thoroughly seasoned scholar, when at a mature stage in his career he turned his attention from obscure places to the problems of perhaps the most famous site of all. Troy, which had lured Schliemann back and back again, still offered the prospect of problems to be solved. The great advances in archaeological techniques since the end of Dörpfeld's last season in 1894 meant there was a very real opportunity for advancement of knowledge of the site. In particular, the detailed information about Mycenaean pottery available to Blegen meant that Troy's relations with the Aegean world could potentially be better understood. And then, there was the Trojan War . . . could new techniques at last discover the truth behind the myth?

Blegen, with his vast wealth of field experience and his record of publications of the highest standard, seemed as uniquely well qualified to excavate Troy as Wace had been for Mycenae. He was now professor at Cincinnati University, a position he had held since 1927, and the University was able to finance the excavations – thanks largely to Professor Semple, chairman of the Classics Department, who went with Blegen as general director of the excavations when in 1932 they set off for Troy.

The campaign lasted for seven seasons, between 1932 and 1938, and the results were published in the 1950s. Inevitably, what emerged from Troy was a picture far more complex than any that had gone

before. Schliemann had recognised nine cities, the characterisation of which had been refined by Dörpfeld. Blegen, while retaining this basic structure, recognised a great many more phases and subphases within each of the main layers. His eventual Trojan scheme had nine main levels, but forty-nine phases represented in the tell.

Troy I to Troy V were the successive cities of the Early Bronze Age, which saw the settlement flourishing. Fortified, and on a low hill (which was, of course, to become higher as occupation debris built up on it), Troy seems always to have been the dominant settlement in the northwest corner of Anatolia. During the long and prosperous Early Bronze Age it shared in a north Aegean culture, having links with important island sites such as Thermi on Lesbos and Poliochni on Lemnos. Seaward connections were always important for the site and at some time its proximity to, and perhaps control over, the entrance to the Dardanelles must have begun to contribute to the city's long-term success.

Blegen's excavations revealed also the importance of agriculture to Trojan life, and the site clearly controlled the surrounding fertile area. Sheep bones were plentiful, with sheep probably providing both meat and wool: the large number of spindle-whorls found led to the suggestion that the wool industry was important. Deer bones in Troy III also suggested successful hunting.

'Treasures' and exotic imports may indicate not only trading contacts with the outside world but also aggressive raiding and looting on the part of the Trojan chieftains. The treasures found by Schliemann had already indicated considerable wealth. They were caught in the great fire that brought Troy II to an end and never recovered by their original owners. They therefore remained to bear witness to the richness of the site, which seems, apart from such disasters, to have enjoyed unbroken development throughout the thousand years or so of the Early Bronze Age. Towards the beginning of the Middle Bronze Age, however, the situation seems to have changed.

Blegen noticed several significant elements that marked the beginning of the long period of the site's history known as Troy VI. Most noticeable was the pottery in a smooth grey fabric with angular shapes that, as we have seen, Schliemann described as 'Lydian', later failing to recognise its similarity to the ware that he found at Orchomenos. By Blegen's time this pottery had become known as Minyan, and was recognised as apparently typical of newcomers to Greece early in the Middle Helladic period. He therefore came to the interesting conclusion that these people and those who had brought a new culture to Troy were related.

Other changes apparent in Troy VI were a more spacious town plan, and new fortifications. An innovation with intriguing Homeric overtones was the use of the domestic horse: the Homeric epithet, or stock description, of the Trojans is 'tamers of horses'.

According to Blegen, Troy VI came to an end in the first half of

the thirteenth century BC (the modern excavators suggest 1250 BC) after an existence of about 450 years. By this time quantities of Mycenaean pottery were being imported to the site: whatever the relations of its inhabitants were with the people of mainland Greece, they certainly had strong trading ties in that direction. The destruction of the strongly fortified citadel was not attributed by Blegen to human hand. It was, he felt, clearly due to earthquake damage. Large-scale destruction certainly took place, but equally quickly the inhabitants began to rebuild.

Troy VII, which had been noted by Dörpfeld as showing no marked change in pottery, was nonetheless a city of smaller, more crowded and less careful construction than Troy VI. Blegen explained this in terms of the haste to rebuild, but also the need to crowd as many people into the citadel as possible. He felt, too, that the sinking of storage jars into the floors of houses indicated a 'siege mentality', as if the inhabitants knew that trouble was threatening. The end came perhaps within as little as a generation of the great rebuilding: Blegen dated the destruction of his Troy VIIa to about 1250 BC, or perhaps a decade or two earlier (though this again has been down-dated by the modern excavators who give a date of about 1180 BC). He also attributed the end of Troy VIIa to human agency, and said it was 'accompanied by violence and by fire'. He became firmly convinced that at last archaeology had found evidence for the Trojan War.

Remains of human skeletons were found in the ruins of Troy VIIa, contributing to the impression that the city had suffered a sudden and violent end. Extensive traces of burning also seemed to fit well with the story of the sack of Troy. All in all, Blegen felt able to assert quite confidently, 'It is Settlement VIIa, then, that must be recognised as the actual Troy, the ill-fated stronghold, the siege and capture of which caught the fancy and imagination of contemporary troubadours and bards who transmitted orally to their successors their songs about the heroes that fought in the war.'

Such confidence now seems breathtakingly optimistic; even then, sceptical voices were soon raised. Critics pointed out that the 'siege mentality' had been exaggerated: such things as sunken storage jars were found elsewhere, and were probably simply designed to keep the contents cool and make them easier of access. The human remains, few and fragmentary, were susceptible to other explanation. The single 'Achaean' arrowhead that Blegen had discovered was too small a thing to carry the great weight of the reconstruction of the Trojan War.

Later commentators have wondered whether Troy VI, with its relatively spacious layout and huge fortifications, might not have been the real city behind the Homeric tale. Certainly it fits better than its impoverished successor the Homeric epithets applied to Troy: a 'broad city', with 'fine towers' and 'lofty gates'. Other scholars, with the scepticism of our modern age, have said that the question simply

cannot be answered by archaeology. We cannot, when dealing with a pre-literate society, hope to 'prove' by excavation that a specific event took place. This seems incontrovertible. We can, though, hope to find the most plausible background for the story, and however sceptical our age it is undoubtedly true that many people are still 'believers', thinking the story likely to preserve some elements of real events, attached to real and known places, however much the narrative has changed in transmission. This appears to be the view of Troy's current excavator, to whose work we shall return later. For Blegen, as for Schliemann, an important mainland site now beckoned. He and his team finished writing up the Trojan excavations into a large-scale publication that appeared between 1950 and 1958, but after seven seasons he considered the actual fieldwork to be finished. He therefore, like Schliemann before him, decided to follow one of Homer's heroes back to home ground on the mainland. The wise old king Nestor, and his palace at 'sandy Pylos', became his object.

THE 'PALACE OF NESTOR' AT PYLOS

It was in the spring of 1939 that Blegen laid out his first trench at Ano Englianos, and began to reveal Nestor's Palace to the world. Like Evans at Knossos, he had almost instantaneous and remarkable success. Unlike Knossos, though, the site of Pylos had been lost, and a great deal of thought, not to say inspiration, had gone into the decision about where exactly to dig.

Pylos was a place-name associated in antiquity with at least three places in the western Peloponnese. Strabo had argued that of these the northernmost could be discounted, but the middle, 'Triphylian' Pylos should be preferred over the southern, 'Messenian' site as the most probable location for Nestor's capital. His view was not universally accepted, and the southern location, specifically the site of Koryphasion, just inland from the Bay of Navarino, was from antiquity onwards widely thought to have been Nestor's home. However, opinion swung back to 'Triphylian' Pylos when the tholos tombs at Kakovatos were excavated by Dörpfeld, who claimed the remains on the hilltop opposite them, although badly eroded, as Nestor's home. The nearby sandy beach completed the picture, making the identification plausible, if not compelling. So the matter lay until Blegen took up the search.

His decision to revert to the 'southern' Pylos was engendered by a number of factors. Several tholos tombs were by then known in the area, making it equally likely that a royal residence had been in this vicinity. The wide, sheltered Bay of Navarino seemed particularly appropriate for a kingdom that had sent ninety ships – the second largest contingent – to join the Trojan campaign. Additionally, the area seemed generally well endowed with the natural water, fertile land and building materials which would support a Mycenaean

palace. Koryphasion, the hilltop site, seemed not to be the only possibility. Other hills were potentially equally convenient. After some days of searching, and displaying a nose for antiquities that was quite as impressive as that of Schliemann when he found the Shaft Graves, Blegen chose his hilltop and laid out his first trench.

The site that Blegen chose to explore was on a low hill called Ano Englianos some six miles northeast of the Bay of Navarino. With commanding views of the countryside around, the position was practical and defensible, and had fresh water and building materials nearby, though it lacked the stony acropolis and towering walls of sites such as Tiryns or Mycenae. Before excavation, the more modest indications of early habitation included visible lumps of ancient masonry, as well as many Mycenaean sherds that appeared in the cutting of the modern road running inland from the coast.

While the hilltop looked promising, with many features that one would expect in the site of a Mycenaean palace, there were other possibilities in the vicinity – Blegen and his team did not expect the dramatic and instantaneous success that rewarded their first trial trench. The date was 4 April 1939. 'By mid-morning', Blegen wrote, 'even the rosiest expectations had been surpassed.' He goes on to detail the finding of substantial stone walls, fragments of plaster with painted decoration, a cement-like lime floor and, most remarkably of all, five clay tablets bearing incised signs of the Linear B script, the first of their kind ever discovered in mainland Greece. 'It was at once obvious', Blegen said, 'that a palatial building occupied the hill.'

The excavation of Pylos was like that of Knossos in that the site was covered by only a relatively thin layer of earth, and by chance the first area revealed proved to be of immense interest and significance. Work proceeded at a more measured pace, in keeping with the improved archaeological techniques of the age, but it rapidly became apparent that here was a Mycenaean palace, comparable in size and layout with other known mainland examples. The broader picture, though, was as nothing compared to the excitement of the small archive room filled with Linear B tablets brought to light during the first days of excavation. Indeed, with the shadow of war seeming ever more threatening, it appeared likely that immediate excavation of the whole palace would not be possible, so that the first season concentrated particularly on preserving this archive.

Like those of Knossos, the Linear B tablets of Pylos were made of local clay, sun-dried rather than fired. Such tablets can have been used only for short-term storage of information, which was perhaps transferred to animal-skin or even papyrus if a more permanent record were required, though no evidence for the use of such materials has survived. In all cases the tablets are preserved only where they have accidentally been baked in fires that destroyed the buildings in which they were stored. Those at Pylos were in an unstable and friable condition when first excavated. They had to be extricated with great

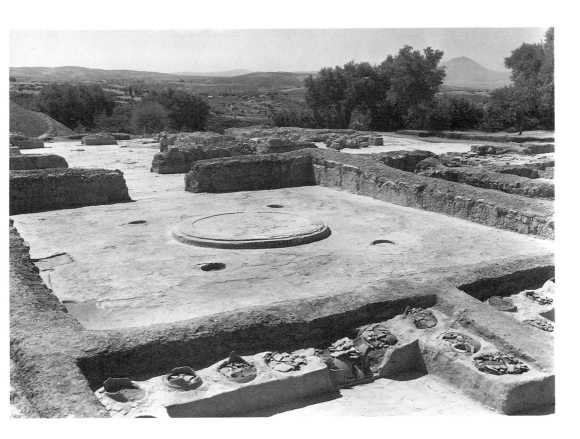

The 'megaron' of the 'Palace of Nestor' at Pylos and part of the storage area, with remains of sunken 'pithoi' (storage jars), in 1956.

care, and dried to a state of complete hardness before they could be handled. Then the lime accretion that mostly covered the writing could be scraped away and the process of recording and interpretation could begin.

The discovery of tablets so like those of Knossos instantly posed significant questions. Linear B was still undeciphered, and the tablets from Knossos not fully published. It was widely, and perfectly reasonably, assumed that the language represented by the script was the native Cretan tongue. The tablets at Pylos, then, could be interpreted as an indication that the Minoan language and bureaucratic system were in use there – the ultimate vindication of Evans' view of Cretan domination of the mainland. There was, though, a chronological problem. The pottery found with the Pylos tablets showed them to date to about 1200 BC and, as we have seen, it was by now accepted by the majority of scholars that people of Hellenic stock, probably Greek-speaking and the ancestors of the later Greeks, had been established in Greece since the beginning of the Middle Bronze Age, *c.* 2000 BC. Even followers of Evans would find it difficult to explain the presence of the tablets at Pylos in 1200 BC, when they believed Knossos, with its tablets, to have been destroyed in about 1400 BC and to have been occupied by decadent 'squatters' for the next two centuries.

Evans himself, by now an old man, had suggested that after about 1400 BC the Minoan 'ruling class' might have migrated from Knossos to Mycenae, and perhaps to other mainland centres. He seems to have thought that the Minoan language and system may then have survived locally at a site like Pylos for two centuries, but this theory strained probability and carried little weight. While interpretation of the Pylos tablets would not be put on a firm footing until 1952, when Linear B was deciphered, it should be said here that their careful excavation and processing meant that they would then come to provide a remarkably full and comprehensible archive.

The first season at Pylos was less than two months long – the growing indications that the world would soon be at war meant that only preliminary work could be undertaken on the site as a whole. Even so, its size and layout began to emerge and Blegen had no hesitation in claiming that this was the site of a Mycenaean palace. The presence of the archive supported this assertion, as did finds made outside the palace itself. A nearby tholos tomb was located and excavated during this first season, while the site of another was identified, bringing the number known in the vicinity to five. Tombs of this important type in such numbers were in themselves a likely indication of the presence of a palace nearby. Blegen certainly felt that he could give a name to his site. Tradition dictated that here in Messenia this could be no other than the palace of Nestor – the 'sandy Pylos' of the Homeric poems, the object of Blegen's quest. This identification was published, but it was not until Blegen's renewed campaign between 1952 and 1964 that a fuller picture of this remarkable site was made possible. We may anticipate a little here, and finish the story of the discoveries at Pylos by looking ahead to the results of these excavations.

Blegen uncovered the remains of an impressive Mycenaean palace complex. It had been destroyed by fire, and the walls throughout were preserved only to a low height. No human remains came to light, nor were there many rich portable finds, indicating perhaps that the inhabitants were able to escape with their most treasured possessions. The palace did, however, contain plentiful pottery and other less valuable items, as well as interesting fixed installations in work and storage areas, all of which contributed to the picture of life within its walls.

The hilltop site was inhabited from the Middle Helladic period, but it was after a destruction dated to about 1300 BC that those buildings whose remains survive today were constructed. First came the structure occupying the west of the site, which has two large pillared halls. It may by itself have originally constituted the palace. Then, possibly a generation later, the main palace was built. At its heart lies a typical megaron or main hall, approached by a pillared porch and vestibule. The large circular central hearth of the megaron was made of plaster and painted with spiral and flame-shaped decoration. It was flanked by the four columns that supported the clerestory roof –

a raised section open at the sides to allow the smoke to get out. Remains of frescoes show that the walls were richly decorated. Amongst these the painting of a bard playing a lyre may echo the real entertainment that would have taken place in this hall. The floor was also plastered and covered with painted decoration arranged in squares. The patterns are mostly abstract, but one particular square seems to have been specially decorated with a stylised octopus because it occupied the space directly in front of the throne.

Entrance to the palace was gained through a gateway with deep, single-columned porches both in front and behind, leading into the relatively small central courtyard. To the left of the entrance and court was the archive room – perhaps positioned to allow easy access for official visitors from outside the palace bringing information to the scribes – and a possible waiting room with a plaster bench that may have been for visitors waiting to be taken into the megaron and the presence of the ruler.

To the right of the entrance lies a suite of apparently private apartments. The main room is referred to as the 'Queen's megaron'. It certainly seems domestic in scale, though may be equally appropriate for a king. Adjoining, but actually reached from the courtyard, is a bathroom with a most elegant terracotta bath, waisted in shape and set in a plastered surround.

Other living apartments may have been on the first floor, since at ground level the rest of the palace seems largely to have been dedicated to store rooms of various types. Nearly three thousand kylikes, or stemmed drinking cups, were found in one of the pottery stores: presumably the output of a pottery workshop that would fulfil more than just the palace's needs. Similarly, the quantity of olive oil kept in the rows of pithoi, or giant storage jars, in the palace store rooms was clearly for more than just immediate palatial use. Pylos, like the other Mycenaean palaces, must have been the centre for collection and distribution of agricultural and other produce from the surrounding area, as we can see from its Linear B records. In addition it has been suggested, on the basis of evidence from the Linear B tablets, that a speciality of Pylos might have been the production of scented oils.

The destruction of the palace, which according to Blegen took place in about 1200 BC, was one of a series that affected most Mycenaean centres and saw the beginning of the end of the Mycenaean world. The Palace of Nestor showed no signs of any major reoccupation. Some scholars have seen evidence in its Linear B tablets of preparations for a possible invasion: one tablet apparently refers to groups of men set to watch and presumably to defend the coast, while another lists what may be unusually rich offerings for the gods, of a sort that might be promised under threat of attack. However this may be, the palace was burned and subsequently lay undisturbed, until archaeology revealed its substantial and fascinating remains.

THE INTERRUPTION
OF WAR

*The optimists among us sometimes fancy themselves striding from one
crest in the Greek mountains to another – until from some appalling
height they see the nature of the terrain; only people like
Pendlebury put the dream into practice.*

DILYS POWELL, *The Villa Ariadne*, 1973

In 1939 the world was poised on the brink of war and the progress
of archaeological research was to suffer complete dislocation. It is
appropriate to sum up the state of knowledge when this break
occurred.

The inter-war years had been a time when mainland studies had
caught up with those on Crete. In retrospect we can see that the
attempt to make a synthesis that would fit the known facts from both
the Cretan and the mainland side was the chief preoccupation of the
period. The debate was dominated by the influence of Sir Arthur
Evans, who never wavered in his pan-Minoan view, still stated in the
clearest possible terms when he came to publish the final volume of
The Palace of Minos, which appeared in 1935 and contained a summa-
tion of his forty years of exploration in Crete.

Researchers on mainland sites, much under the spell of Evans'
views at first, were slow to formulate the picture of a mainland devel-
opment that was indebted to Crete, but separate from it. By 1939,
though, most scholars allowed the mainland more independence than
Evans' view permitted – yet the 'Cretan mirage' was still widely
influential.

In Crete a time of consolidation had seen both new discoveries and
much work on and around known sites, broadening and deepening
knowledge of the Minoan world. The Villa Ariadne continued to be
the focus of British work on the island, first as Evans' private home,
where he ruled as benevolent despot, but later as the property of the
British School at Athens. Evans' generous gift of 1926 gave to the
British School all his Cretan property, including the site of the Palace
of Minos, the Villa Ariadne, and some adjacent land mainly under
vines. Income from this and endowments made by Evans went not
only towards the upkeep of the estate but also to pay the salary of the
Knossos Curator, a new post first filled by Duncan Mackenzie.

Mackenzie, who had for so long been Evans' right-hand man at Knossos, occupied the post for only four years before he was dismissed, due to signs of mental instability. He died in a mental institution not long afterwards. It is said that his ghost walks the basement corridors of the Villa Ariadne. Evans thought the dismissal 'broke his heart' – a traditional reason for a haunting.

He was succeeded as Knossos Curator by John Pendlebury, a dark-haired, tall and energetic young scholar whose intelligence was matched by his athletic ability, and whose feats of walking over the rough Cretan terrain became legendary. Pendlebury's early interests had embraced both Aegean and Egyptian archaeology. His first major publication had been *Aegyptiaca* (1930), a catalogue of Egyptian objects found in Crete. Moreover, between 1929 and 1935 he combined his summer role as Knossos Curator with excavations in Egypt during the winter season, digging at Armant and at Tell el-Amarna.

Evans continued to visit Knossos, conducting his last excavation there, that of the Temple Tomb, in 1931. Although he and Pendlebury had some heated arguments (Evans perhaps finding the role of benevolent despot hard to give up), on the whole they got on well; when Pendlebury married a fellow British School student, Hilda White, and they had a baby son, Evans congratulated the two of them warmly, saying 'A Knossos nursery will be a new feature!'

In 1935 R.W. 'Squire' Hutchinson took over the job of Knossos Curator, leaving Pendlebury and his wife Hilda free to travel and excavate in Crete. They worked particularly in the mountains fringing the Lasithi plateau to the north, where they excavated in the Trapeza cave and on the high, remote site of Karphi, which proved to have been inhabited at the very end of the Minoan period, a time of uncertainty when inaccessible sites were often chosen, presumably for the safety that they offered.

Pendlebury had, at Arthur Evans' behest, written the short but invaluable *Handbook to the Palace of Minos at Knossos* (1933), which is probably still the best book to carry around the site. Now he was collecting material for his most ambitious project, a book about Minoan archaeology called *An Introduction to the Archaeology of Crete*. The intention was to provide an island-wide survey bringing together all the available information in a reasonably small compass. The project, which again had Arthur Evans' blessing, was much needed, since the great length of Evans' own encyclopaedic *Palace of Minos* meant that it was not widely affordable, and certainly not widely portable.

Pendlebury's extensive knowledge of Crete had mostly been gained on foot during prodigious walks. It was possibly these, above all, that made him a well-known figure on the island even before his death in its defence fixed his position in the islanders' affections, and indeed in their mythology, for ever. He was famous for the speed with which he covered the mountainous terrain and tales were told decades later in Tzermiadhon of the speed with which 'Bleberry' would lope up the

steep path to Karphi when he was excavating there. His book reflected this minute knowledge, as well as presenting an up-to-date survey of what was known about Cretan archaeology in 1939.

The work was arranged chronologically, on Evans' system, and allowed the broad sweep of the island's history as revealed by archaeological research to be seen and understood. For each period a distribution map of sites was given. It is striking to see how large a number of sites was then known, ranging from the palaces and their surrounding towns through the country houses and farms to the sacred caves and remote hilltop sanctuaries. The pattern of settlement was quite dense, particularly over the central and eastern part of the island. Within this broader picture Pendlebury adopted a thematic approach, discussing for each period various types of material culture, such as sculpture, pottery and the like, as well as social elements such as religion and burial customs.

With regard to those matters connected with the mainland that might cause controversy, Pendlebury managed to seem remarkably fair and open minded, disagreeing with Evans on some issues, but at the same time much in agreement with his mentor in broad terms. Thus he quite breezily stated that the Helladic terminology for the Greek mainland must be accepted: the culture there was not simply Minoan, and so the Minoan system could not be used. He was also quite happy to see such things as the tholos tombs as a mainland contribution, and to support Wace's dating of them. However, he went on to say that the mainland – indeed, the Aegean as a whole – became so 'Minoanised' that in his view it could only have been dominated politically, as well as culturally, by Minoan Crete.

Pendlebury cited some arguments with which he did not himself agree. A most interesting example of this came in his discussion of the Late Minoan II period at Knossos. The Palace Style pottery of this period, as well as such aspects as an increase in militarism, had long made LMII stand out as an odd phenomenon, peculiar to Knossos. Pendlebury noted that the pottery had distinct mainland affinities, but still assumed that the influence went from Crete to the mainland, not vice versa. When Knossos was destroyed at the end of LMII, he thought that this, like the rather earlier LMIb destructions at all the other major sites, was a result of invasion, probably by disgruntled mainlanders trying to throw off the Cretan yoke. He did, though, quote an alternative explanation, attributing it to Wace but saying it was not yet published. This suggested the almost unthinkable – that Knossos was in mainland hands in LMII and that it was for this reason that the pottery and other aspects of material culture seemed different from what had gone before. Pendlebury did not agree with this, and it is strange that what was to become the orthodox view should thus creep into the literature through the back door.

While *An Introduction to the Archaeology of Crete* took a view that in many respects accorded with that of Evans, Pendlebury, as one might

expect from so much younger a scholar, was far more open to other opinions. He was, for example, on cordial terms with Alan Wace, whom he thanked for reading the manuscript. His book was published in the same year as Wace and Blegen's important article 'Pottery as Evidence for Trade and Colonisation in the Aegean Bronze Age'. This significant piece of work took issue with the notion of Minoan control of the mainland, though it did not yet argue the opposite view for Knossos in LMII. Rather the authors contented themselves with

John Pendlebury in London in the 1930s with a replica of the head of Nefertiti found at Amarna.

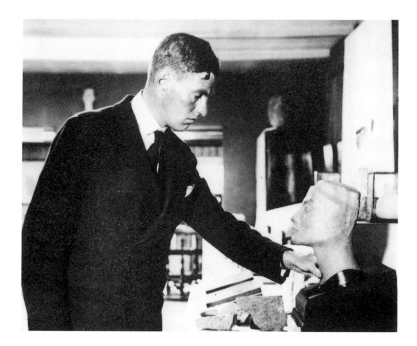

pointing out not only that the mainland in the Late Bronze Age displayed many cultural features which differed from those in Crete but also that Aegean pottery imported into other lands during this period, and particularly into Egypt, was predominantly Mycenaean, not Minoan, in origin. This was even the case during LMI and II when, although Knossos was powerful and influential, Minoan pottery was scarce in Egypt, whereas mainland types were appreciably more plentiful. This presaged the great flood of Mycenaean pottery in Egypt in the later period when Mycenaean influence was at its height.

The article argues for more work on the origins of pottery fabrics and for more rigorous use of precise terminology. The theory of a Cretan conquest or colonisation of the mainland, it concludes, should 'no longer be allowed to cloud the historical implications of the archaeological evidence of the Late Bronze Age in the Aegean'.

By the beginning of the Second World War, then, Aegean archaeology, though still a relatively young branch of the discipline, was firmly on the map. Many key sites were known, though none had

given up all its secrets. Many important issues remained to be resolved, but the amount of information available from sites and objects had grown remarkably swiftly since the dawn of the twentieth century and the foundations for modern knowledge, modern thought and, indeed, modern controversies were recognisably laid.

The war itself brought tragedy to Crete and to the lives of those who had worked there. John Pendlebury's knowledge of the terrain made him a natural choice for service on the island and he was happy to fight in defence of his much-loved second home. He was killed in the first hours of the Battle of Crete in May 1941, aged only thirty-six. Arthur Evans, nearly ninety, reacted with great sadness. 'Here am I, still alive,' he is reported to have said, 'and that young man with all his promise is gone.'

This was not the only bitter news that Evans heard at the end of his long life. At the time of his death the Villa Ariadne was the headquarters of the occupying German forces in Crete, while the perils of war threatened the ancient remains that he had striven to present once more to the world. He did not live to know that the Palace of Minos escaped unscathed. The effects of the forces of destruction could be seen nearer to home: he visited London to see the damage done by incendiary bombs to the British Museum, of which he had been a Trustee. Yet in spite of such violent times his own death in Oxfordshire was peaceful. He had achieved his ninetieth birthday and had just finished an article for the local archaeological journal on the route of a Roman road that crossed his land: the very last contribution to archaeological knowledge of this consummate and visionary scholar.

The war years, together with the aftermath of civil war in Greece, meant that the flow of information from fieldwork was interrupted for a considerable time. Exceptionally, some scholars who found themselves on Greek soil were able to conduct minor pieces of investigation, but on the whole their attention, like that of the rest of the world, was elsewhere. Works of synthesis and analysis achieved in libraries and studies were not so immediately affected and some progress could be made, though few of those quiet worlds were untouched by the vicissitudes of war. One notable and great work that did emerge at this time was that of the Swedish scholar Arne Furumark, who in 1941 published his *Mycenaean pottery: analysis and classification*. Here for the first time the whole body of Mycenaean pottery was studied, its shapes and motifs analysed and its stylistic development charted. It quickly became a standard work, which is still used as the basis for study of Mycenaean vases.

The jigsaw of the Greek Bronze Age was, despite all this, still missing one hugely significant piece, which was not put into place until the decade after the Second World War. The decipherment of Linear B and its effects will be the main theme of the next chapter.

THE DECIPHERMENT
OF LINEAR B

During the last few weeks, I have come to the conclusion that the
Knossos and Pylos tablets must, after all, be written in Greek . . .

M. VENTRIS, BBC Third Programme, June 1952

The debates about relations between Minoan Crete and Mycenaean
Greece, and indeed between the Bronze Age and the Classical period,
were completely changed in the post-war years by the decipherment
of Linear B, and its identification as an early form of Greek.

In retrospect, it seems strange that the possibility of Greek being
the language of the Linear B tablets was not more immediately appar-
ent. As early as 1893 Tsountas had suggested that the Bronze Age
inhabitants of Mycenae spoke Greek. Blegen and Haley had then
established a correspondence between traces of a pre-Greek language
and the sites inhabited in the Early Helladic period, and had therefore
suggested that the next cultural break after this – at the transition
from Early to Middle Helladic – was probably the horizon that saw
the arrival of Greek-speakers in what we now know as Greek lands.
This was accepted by many scholars, including Wace, who had argued
against Evans increasingly firmly in support of the independence of
Mycenaean culture. Evans allowed that a Mycenaean 'underclass'
may have spoken Greek, but thought the dominant stratum of main-
land society was Minoan, speaking the Minoan language.

Consideration of the language of the tablets was, however, very
much conditioned by the fact that until the discovery of the Pylos
tablets in 1939, Linear B had been found only in Crete. Moreover, it
had on the island a clear predecessor in Linear A, so that both could
reasonably be assumed to have been used to write the Minoan lan-
guage. Even when the Pylos tablets were uncovered, it was still pos-
sible to believe that they were written in Minoan. They could be
interpreted as supporting Evans' view of Cretan domination of the
mainland, though since they were dated to about 1200 BC they had
in that case to be characterised as a survival, one of the last remnants
of Minoan influence in a time of general decline. The slowly growing
recognition of the fact that at Knossos between about 1450 and
1400 BC an increasing number of Mycenaean characteristics became
noticeable was potentially helpful for an appreciation of the possible

historical position of Linear B. However, the suggestion that there might have been mainland domination of Knossos in this period was far from accepted at the time of the decipherment. Linear B's identification as Greek therefore took everyone by surprise.

In 1936 the British School at Athens held an exhibition in Burlington House in London to celebrate its fiftieth anniversary. Sir Arthur Evans arranged a special section to illustrate his discoveries in Crete, and on 16 October gave a lecture entitled 'The Minoan World'. In the audience was a fourteen-year-old boy from Stowe School called Michael Ventris.

Fascinated by Evans' account of the clay tablets from Knossos that no one could read, some of which were included in the exhibition, Ventris decided that he would try to decipher them. He never forgot this early resolve. Though he trained and practised as an architect he spent much spare time in his adult life pursuing the decipherment. He was a talented linguist and cryptographer, and the story had a fairy-tale ending in Ventris' eventual success. In June 1952 he made his famous BBC radio broadcast in which he said, 'During the last few weeks, I have come to the conclusion that the Knossos and Pylos tablets must, after all, be written in Greek – a difficult and archaic Greek, seeing that it is five hundred years older than Homer, and written in a rather abbreviated form, but Greek nevertheless.'

He had been tentative at first, because he himself had not expected this outcome: indeed at the precocious age of eighteen he had published an article in the *American Journal of Archaeology* suggesting that the 'Minoan' language of the tablets would turn out to be related to Etruscan. It was only when he had recognised the possibility of a Greek identification on what one might call cryptographic grounds that he rationalised the possibility in a way essentially still accepted today, pointing out that Linear A might have been used to write the Minoan language, and Linear B adapted from it to write Greek. Linear B was, after all, the script of the mainland palace at Pylos, but was found at Knossos only at a late stage of the palace's history, when Evans had noticed other signs of foreign influence. The idea of foreign – Mycenaean – domination of Knossos in the Late Minoan II period, tentatively formulated by Wace and mentioned but dismissed by Pendlebury, was thus powerfully supported.

Tragedy was to strike with the untimely death of Michael Ventris in a car accident at the age of thirty-four. By then he had a collaborator, John Chadwick, a Cambridge philologist who had written and congratulated him on his decipherment as soon as it had been made public. Their epoch-making *Documents in Mycenaean Greek* was published in 1956, just weeks after Ventris' death.

The decipherment built on earlier work achieved partly by Arthur Evans himself and partly by the American scholar Alice Kober. It was a source of great frustration to Evans that, having found in Crete the evidence for early writing that he had predicted before he even

visited the island, the scripts proved so intractable. He planned a large-scale publication of all the writing he had found at Knossos, the first volume of which, *Scripta Minoa I*, appeared in 1909. This dealt fully with the remains of Cretan pictographic or 'hieroglyphic' script – the term which Evans used, though we now know the signs bear no relation whatever to Egyptian hieroglyphs. His views on Linear A and Linear B were to be found (to the extent that they appeared at all) in *The Palace of Minos*, but he never published the majority of the Knossos tablets, presumably always hoping for a breakthrough in his attempts at decipherment. The immense job of putting together *Scripta Minoa II* fell to Sir John Myres after Evans' death.

In spite of this, Evans himself did make some progress that would later be seen as useful, not only in the classification of the scripts and the workings of the systems of numbering that they incorporated, but also in his recognition that the signs in Linear A and B were likely to represent syllables and, moreover, that Linear B seemed to represent an inflected language (that is, a language where the nouns have different endings in different cases). He was helped towards these conclusions by the work of the philologist A.E. Cowley, who based them partly on comparisons with the later syllabary of Cyprus, a writing system that was related to Linear B. Evans observed that if the values for the Cypriot syllabary were borrowed and applied on one of his Knossos tablets the word 'po-lo' would appear next to an ideogram of a horse, instantly bringing to mind the Greek word 'polos', meaning 'foal'. Evans pointed this out only to dismiss it as coincidence: he was never to know how prophetic his remark had been.

In articles published between 1943 and 1950 Alice Kober argued that the language of the Linear B tablets was probably different from that of Linear A, and made further progress towards the establishment of plausible case-endings for certain sign groups on the tablets. Her conclusions proved to have been entirely correct, though she worked in the abstract and never allocated phonetic values to the Linear B signs. The amount of progress she could make was, though, limited by the fact that so few tablets were published. This situation was to be immeasurably improved with the appearance in 1951 of the preliminary publication, by Emmett Bennett, of the Pylos tablets.

Considering the upheavals caused by the war, this was a commendably speedy preparation of a complex piece of work. It increased enormously the amount of material available to be worked on. Evans had published only about one hundred of the approximately three thousand Knossos tablets: some 1,200 came from Pylos. Moreover, the Pylos tablets were generally larger, and had been found and were published in cogent groups, with tablets dealing with the same subject 'filed' together. For these reasons, too, they were to prove a fruitful source of information. Indeed, it was not long after the Pylos publication that Michael Ventris made his major breakthrough.

Ventris had, from the beginning, circulated to a small group of

interested scholars a series of 'Work-Notes' charting the progress of his research and soliciting responses at each stage. The first of these was dated 28 January 1951; it was the twentieth, dated 1 June 1952, which was tentatively entitled 'Are the Knossos and Pylos Tablets Written in Greek?'. Much careful and complex thought is represented by these 'Work-Notes', to which no summary can do justice. Authorities agree, however, that two major discoveries precipitated Ventris' eventual success. The first was the realisation that, while the Cypriot syllabary was helpful (although the precise relationship between the two is not clear, it is now recognised as a descendant of Linear B) the Cypriot spelling rules did not apply to the last consonant of Linear B words, which was not written. This explained why a list of names that seemed all to belong to men, and might therefore be expected to have a masculine nominative ending, actually all ended differently. This was a useful step forward.

The other hypothesis that proved invaluable was the idea that place-names might appear in the Linear B tablets. The names of places near to Knossos were known from Classical times, and might in some instances at least be expected to have remained unchanged. One that Ventris thought might occur was Amnisos, the harbour town of Knossos, and he located a group of signs that was a good candidate. He felt he could recognise the 'a' from its great initial frequency, the 'ni' from Cypriot parallels, and so on. He provisionally placed not only Amnisos, but also Knossos itself and Tylissos, another local place-name, in the grid that was his main working tool. Then, on a rather different basis the word for coriander was added. This spice was named on both the Knossos and Pylos tablets, spelled slightly differently but followed by the same ideogram. The values thus assigned within the grid allowed the recognition that the words for boy and girl, which had hypothetically been recognised because of their ideograms, could be read as 'ko-wo' and 'ko-we' – the 'kouros' and 'koure' of Homeric Greek. Moreover, the signs recognised as meaning 'total', because of their position next to the totals on the lists, were read as 'to-so' and 'to-sa', the perfectly recognisable Greek neuter singular and neuter plural of the word meaning 'so much'.

The first formal publication of the decipherment came in 1953, when Ventris and Chadwick published in the *Journal of Hellenic Studies* their article 'Evidence for Greek Dialect in the Mycenaean Archives'. By this stage the decipherment was substantially complete, its results thenceforth usable by other scholars working on other tablets. Some linguistic problems did still remain – in particular, the loose spelling rules of Linear B meant that many alternative readings could be given for certain sign groups. Moreover, the very early stage of the Greek language had unfamiliar features. Some tablets remain incomprehensible to this day. Scepticism about the correctness of the decipherment was, however, largely allayed by the discovery of new tablets from the reopened excavations at Pylos, where Blegen began work again in

1952. Here tablets came to light that worked well according to the rules Ventris and Chadwick proposed, though they had not been discovered at the time the rules were formulated.

The exciting work of interpretation could begin, and the process has been continuous from that time. Although the tablets are simply lists and inventories of goods and personnel controlled by the palaces, careful study can extract from them much information about the Mycenaean world. They throw light, to a greater or lesser degree, on such diverse matters as political geography and the organisation of the Mycenaean kingdoms, social structures, palatial economy, religion and so on. Naturally the information is limited by the sorts of records the tablets represent; it is sad that no literary or other, longer texts

Two Linear B tablets from Knossos, the smaller listing sheep, the larger recording offerings of oil to a goddess. About 1375 BC. (BM GR 1910.4–23.1 and 2)

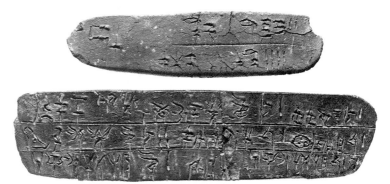

are preserved. It is arguable that none such ever existed: the Mycenaean world may have known only limited literacy with writing being used only for this somewhat prosaic record-keeping. This is the view of John Chadwick, though others have argued that the forms of the Linear B signs seem designed for some more flowing medium than a stick on wet clay and surmise that pens and other writing surfaces must have existed. The existence of signs painted on vases may support this view, but the evidence is otherwise almost entirely lacking. Nonetheless, the decipherment of Linear B unlocked a whole new field of information about the Greek Bronze Age. For this reason it must be ranked with the great excavations of Greek Bronze Age sites as a major and important discovery. Two results were of particular relevance to our story. The first was the controversy that arose concerning the date and significance of the Knossos archive, and the second was the effect of the decipherment on the debate about continuity between the Bronze Age and the Classical period in Greece. We shall return to the question of continuity in the final chapter, but must first turn our attention to Knossos and the Linear B tablets found there.

THE DATE OF THE KNOSSOS ARCHIVE

The discovery of the Pylos tablets and their apparent similarity to those of Knossos led Carl Blegen to question whether the two archives

could really be separated by some two hundred years. The date given by Evans for the destruction of Knossos was about 1400 BC, while Pylos was destroyed in about 1200 BC. Could the scribal tradition really have been so conservative that almost nothing had changed in the way Linear B was written over two hundred years? Blegen thought not. In 1958 he suggested that the context of the Linear B tablets from Knossos should be re-examined.

The argument was not in fact strictly limited to these two sites. Linear B tablets came to light on the Greek mainland not only at Pylos but also at Mycenae, at Tiryns and at Thebes, where new excavations in the 1960s added tablets to the series of stirrup-jars with painted Linear B inscriptions already known from early excavations. These, we might say in passing, had been assumed by Evans to be evidence for Minoan domination. They are of interest now because clay analysis makes it seem likely that they were manufactured in the Chania area of Crete; thus they form part of the evidence for the growth in importance of Western Crete in the Late Minoan III period.

Mycenae, Tiryns and Thebes produced only small numbers of tablets and the Knossos and Pylos archives remained by far the most informative groups. The Theban finds, however, were of interest because of their date. Brought to light in 1963 by Nicholas Platon and Evi Touloupa in a building that was apparently an annexe of the Mycenaean palace of Thebes, Platon dated the destruction that sealed them to about 1300 BC. Since the Theban Linear B was very like that from Pylos, this could indicate that the writing system did indeed belong to a very conservative tradition which had scarcely changed over the course of a hundred years. This might, then, support the notion that the Knossos tablets could easily be even two centuries older than the mainland examples without the script seeming very different.

Despite this, Blegen's suggestion of 1958 was influential. He speculated that the Knossos tablets might date from the destruction of a palace rebuilt and occupied by a Mycenaean ruler in LMIII – perhaps the historical figure or figures behind the character of Idomeneus, whom Homer says led a contingent from Crete to the Trojan War. This was a radical reinterpretation of Evans' period of miserable squatter 'reoccupation' in LMIII.

The philologist Professor L.R. Palmer took up the problem, pointing out that from a linguistic point of view few significant changes are apparent in the language of the mainland tablets as compared with those from Crete, and therefore the internal evidence does not point to a considerable time lapse between them. Others, though, John Chadwick amongst them, continued (and continue) to believe that the observable changes are perfectly consistent with a difference in date. If philological opinions continued to differ, what of archaeological considerations? The tablets, being amongst the latest finds from Knossos, came to light in the very earliest, exciting – but inevitably

rather confusing – days of excavation there. This was part of the problem, particularly since Evans had of necessity reinterpreted his early finds in the light of subsequently emerging information, as all excavators will. Since excavation inevitably means destruction of context, the only hope of recovering any accurate information about the context of the tablets lay in the re-examination of the records of the early days of digging at Knossos.

The excavation records had been preserved in the Ashmolean Museum and the notebooks of Arthur Evans and daybooks of Duncan Mackenzie became central to the argument. Palmer was not an archaeologist, so John Boardman, then Reader in and later Professor of Classical Archaeology in the University of Oxford, also re-examined the evidence. Their efforts were to bring them to diametrically opposed views: Boardman supported Evans' position and associated the tablets with a final destruction at Knossos in about 1400 BC while Palmer continued to believe Evans was wrong and associated the tablets with a Mycenaean palace of the 'reoccupation' period, destroyed in the twelfth century BC. The resulting book, *On the Knossos tablets: two studies,* published in 1963, was not a collaborative effort as planned, but two completely separate works under the same cover. The dispute was carried on with some feeling, even reaching a wider and non-specialist audience through the letters page of *The Times*. Such a drawn-out argument becomes more comprehensible when we realise that, some three decades later, a consensus has still not been reached.

The problem began with the LMII period at Knossos. The view that Mycenaeans were not only present in considerable numbers at this time, but were also at least to some extent politically dominant in Crete, had become orthodox, and is still held by the majority of scholars. Some, though, and most notably James Hooker, sounded a cautious note, pointing out that potentially the same pitfalls accompanied this theory of political domination as had accompanied Arthur Evans' idea of Minoan political domination of the mainland. Hooker counselled restraint, interpreting the Mycenaean traits at Knossos in LMII as indicative of close trading contacts, certainly, and a good deal of cultural influence, but stopping short of the notion of political control. He interestingly suggested, too, that the Linear B tablets represented the lingua franca of trade and contact between the Minoan and Mycenaean worlds, so that some of the remaining problems in interpreting Linear B vocabulary as Greek might be a result of its essentially hybrid, mixed Minoan and Greek, nature.

Hooker's view did not gain wide acceptance, and so for most scholars it remained likely that Mycenaeans were in control at Knossos in LMII, and were no doubt using Linear B tablets as administrative records throughout this period. It was felt that only the records belonging to a single year were baked, and thus preserved, by the fires associated with the destruction of the palace. Evans had

placed this destruction at the end of LMII, with an absolute date of *c.* 1400 BC. Refinements in the analysis of pottery styles led Mervyn Popham, a leading authority on Minoan ceramics, to adjust the date downwards, saying the very latest pottery associated with the tablets in the destruction horizon belonged to the beginning of LMIII, in real terms perhaps close to 1375 BC. This date, and this association, were widely accepted.

There were, though, still those who doubted, and the problem of the date of the tablets was inevitably tied up with the status of the last days of Knossos. When, exactly, did the palace cease to be a 'palace'? When did it cease to act as the administrative centre of its region? For some, the fourteenth and thirteenth centuries – the LMIII period – were essentially post-palatial. Nonetheless, there seemed good reasons to reassess Evans' picture of LMIII Knossos, which depicted the palace in miserable decline, with 'squatters' colonising its rooms and corridors and scraping a living amidst its fading glories. Later research had suggested that the island of Crete, although relatively speaking a backwater in an increasingly Mycenaean world, had in fact seen peaceful and prosperous conditions in this post-palatial age, particularly in its first part, the LMIIIa period. It therefore seemed feasible that the palace of Knossos could still have functioned as an administrative centre during LMIII and perhaps right up to the end of the period in *c.* 1200 BC.

The answer may lie in a compromise position, such as that suggested by those scholars who would put the final destruction of the Palace of Minos at a date towards the end of the fourteenth century BC. This would fit reasonably well with the general picture as we understand it, and is naturally appealing to those who temperamentally seek a consensus, but hard evidence may now never be forthcoming. Still, we cannot be too sure. A recent piece of research concludes that a tablet from Knossos is recognisably written by the same scribal hand as one from Chania, firmly dated to the middle of the LMIIIb period (*c.* 1250 BC). It may be argued that such certainty is impossible on the basis of small scraps of handwriting nearly four thousand years old, but such work nevertheless holds out the tantalising prospect of new and concrete pieces of evidence being discovered.

We leave the subject with just one final thought: it has until recently been assumed that, although tablets were found at different places within the Palace of Minos, the archive is essentially unitary, with all the tablets dating from a single season and caught in a single destruction, of whatever date. It now seems possible that the situation, as so often, was more complex: it is suggested that one group of tablets, in particular, was caught in a destruction earlier than that affecting the rest. Clearly this changes the basis of the argument. The implications have still to be assessed, but we have certainly not heard the last word on the Knossos Linear B tablets.

IV

CERTAINTIES
AND
UNCERTAINTIES

LATER EXCAVATIONS

*We are far less certain of everything than our predecessors
often seemed to be, and continually ask new questions
without having sufficient data to answer them.*

OLIVER DICKINSON, *The Aegean Bronze Age*, 1994

By the 1950s the initial phase of discovery of the Greek Bronze Age
was more or less complete. The succession of the three main cultures,
Cycladic, Minoan and Mycenaean, was in place, with the main char-
acteristics of each defined. Many refinements were yet to be made,
dramatic new discoveries would still come to light and the emphasis
of research would continue to change with the times – nevertheless,
the foundations for our modern understanding had been laid.

Excavations have continued apace, at both old and new sites. Space
will not allow any but the most fleeting reference to the majority of
the new investigations, but we must attempt here to bring up to date
the stories of those major sites that have continued to be pivotal to
our understanding – Troy, Mycenae, Knossos and the palaces of
Crete – as well as sketching in the Cycladic picture a little more fully,
particularly with the excavations on Keos and Thera.

TROY AND THE TROAD

Troy is the subject of a new campaign of excavations that are entirely
modern in outlook and technique. The site where the story began can
therefore stand both as a model for the contemporary approach and
as a marker for the way archaeology has progressed since it was the
subject of Schliemann's pioneering excavations.

The excavation of Troy was resumed in 1988 under the direction
of Professor Manfred Korfmann from the University of Tübingen, in
partnership with archaeologists from the University of Cincinnati.
The large team includes geophysicists, palaeobotanists, philologists,
numismatists and other specialists, who come not only from Germany,
the US and Turkey – the nation hosting the project – but from all
over the world. This truly international effort is backed up with much
modern technology, from computers to remote sensing devices for
surveying what lies beneath the earth without the need to dig. The
excavation is the largest currently running in the Mediterranean.

The motivation for the project is not Homer, but neither is Homer
irrelevant: the pendulum has swung to a middle position in this

respect. The interest of the site resides in the fact that it was clearly of great importance in antiquity, standing as a vital link between East and West and potentially giving information relevant to both over a long period of time. The question of how the remains connect with the Homeric tales is just one of a series of questions that the excavators hope to illuminate.

Korfmann began work in the Troad not at Troy itself but at the Bay of Beşik, lying to the southwest, where geophysicists have worked to reconstruct the ancient coastline. It seems that the harbour of Troy was here, rather than at the mouth of the Dardanelles, as had previously been thought. A nearby cemetery contained burials which were contemporary with Troy VI, the city of about 1700–1250 BC. These were neither typically Trojan nor typically Mycenaean, but may have represented a mixed population of workers and traders living there seasonally: no related settlement remains have been found. Some of the burials were cremations, which fitted in with Blegen's discovery of a late Troy VI cremation cemetery. It had long been assumed that Homer's heroes were cremated because that was the rite familiar in the eighth century BC, the time when the poems reached their final form. Cremation was never the prevailing type of burial in the Late Bronze Age Aegean, so it is intriguing to find it in the vicinity of Troy.

The citadel of Troy itself, then, was approached by a team very much aware both of its broad context as a link between East and West and its local context within the Troad. Their excavations within the city and in its immediate vicinity were to bear fascinating fruit. Perhaps the single most significant find has been that of an outer fortification surrounding a 'lower town' around Troy VI, confirming that the city at this period had been larger than the relatively small area within the huge citadel walls. Schliemann would have been fascinated to know this. He had tried to prove that his Priam's Troy, Troy II, had been a fortified citadel at the heart of a larger settlement, but had been unable to do so.

There can be little doubt that Schliemann would have been delighted with the emergence of Troy VI and the growing feeling that this, if any, is the city most likely to lie behind the story of the Trojan War. The excavations since his time, up to and including the modern campaign, could all – with his eye of faith – be seen as making more likely the equation between Troy VI and Homer's 'broad city' with 'fine towers' and 'lofty gates'. Korfmann points out that as late as the eighth century BC, however far into decline Troy had slipped, its huge walls would still have been standing, in places to a height of seven or eight metres, and would have been a most impressive sight.

Much in the contemporary approach would have driven Schliemann to distraction. The slow progress of excavation and the extreme restraint about interpreting any of the archaeological results as 'proofs' of Homer would be anathema to him. He would, though, be impressed with the speed at which the results are published, which

The use of remote sensing equipment in the current excavations at Troy.

matches his own high standards. One also feels that he might have relished some of the modern technology, particularly if it allowed him, as it does the modern team, to star in his own excavation reports on video.

MYCENAE AND THE PELOPONNESE

The extraordinarily rich finds from the Mycenae Shaft Graves had from their first discovery been subject to bizarre interpretations, with suggestions including the possibility that they were Scythian, Byzantine, Celtic or even fakes. Even when knowledge of Mycenae and the Mycenaean world had advanced, they still seemed to burst upon the scene with no precedent on the site for the wealth they represented, leading to the suggestion that the princes of a nomadic dynasty had brought their amassed booty to this last resting place. The discovery of a second Grave Circle at Mycenae in 1952 was therefore of great help in furnishing a background against which the remarkable finds from Schliemann's excavations could be evaluated. Now it could be seen that both the rich contents and indeed the type of grave developed naturally from predecessors in the newly discovered circle, called Grave Circle B by its excavators, George Mylonas and John Papadimitriou. Schliemann's circle was subsequently known as Grave Circle A – somewhat confusingly, since 'B' is the earlier of the two.

Grave Circle B, excavated in three seasons between 1952 and 1954, lay outside the walls of the citadel close to the Tomb of Clytemnaestra – indeed, it was restoration work on this tomb that led to its discovery. The burials within it began in the seventeenth century BC and overlapped considerably in time with those of Schliemann's circle, Circle A, that began early in the sixteenth century. Mylonas suggested that in both cases the circle was constructed before the graves were dug within it. Twenty-eight graves were found in Circle B, of which fourteen could be classed as true Shaft Graves. Others were simple cist graves of the typical Middle Helladic type, thus confirming Wace's theory that Shaft Graves were just a more elaborate development of these. The wealth of the graves also varied: some had only sparse contents while others were rich, with weapons, pottery and ornaments of fine gold. A single electrum face-mask foreshadowed the more extensive use of masks in Circle A. Other exciting finds included an amethyst seal engraved with the bearded head of a man and a rock-crystal dish in the form of a duck.

The 1950s and '60s also saw excavations revealing more of the realm of the living at Mycenae. Houses within and outside the citadel were uncovered by Wace, Taylour and Mylonas. Three important neighbouring buildings outside the walls were named the House of Sphinxes, the House of the Oil Merchant, and the House of Shields, reflecting finds made within them, but it is not clear whether they were residential and domestic, or contained only workshops and stor-

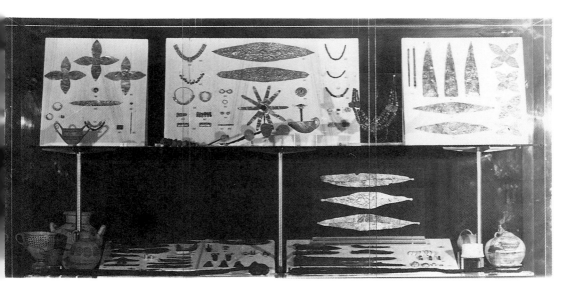

Finds from Grave Circle B at Mycenae.

age areas. Inside the citadel further houses were found, but on the steep, terraced slopes of the Mycenae acropolis only the basements of buildings survive, again often leaving their function obscure. Exceptions include the Granary, just inside the Lion Gate, where a function as a grain store seems clearly indicated. A complex of buildings has also more recently been recognised as a cult centre, at the heart of which lies a shrine or temple with numerous large clay figurines, representing deities or worshippers. The frescoes found in nearby rooms further underline the religious nature of this part of the site.

Swedish explorations in the Argolid included work at the fortified citadel of Asine, lying southeast of Mycenae on the coast, and at that of Midea, which was roughly halfway between Mycenae and Tiryns. Tombs in the vicinity of Midea (the site is known as Dendra, the name of the modern village) contained rich finds. A tholos tomb, two tumuli and a number of chamber tombs were excavated: in one of the latter was a remarkable suit of bronze body-armour. The Swedes also worked at Berbati, a settlement near Mycenae which was probably one of the main centres of production of Mycenaean Pictorial Style pottery.

Elsewhere in the Peloponnese, work in the Pylos area revealed sites and tombs with significant finds, suggesting that this too had been an important area of the Mycenaean world. In Laconia, the Vapheio tholos with its rich contents had suggested the existence of Mycenaean settlement in the locality, though none had actually been found. Excavations near the Menelaion, a later shrine to Menelaus and Helen on a hilltop southeast of Sparta, led to the discovery of a large and clearly important Mycenaean building.

Evidence of Mycenaean settlement elsewhere in Greece and the islands continued, and continues, to grow. We might single out in

particular the case of Athens, where remains of Mycenaean fortifications on the Acropolis showed that this city, so famous in Classical times, had also been important in the Bronze Age. Nonetheless, the supremacy of Mycenae as the most important centre in the Mycenaean world has not been challenged: to this extent, at least, the tradition recorded in Homer seems to hold good.

THE CYCLADES: KEOS AND THERA

The Cyclades also produced significant new finds, notably on the island of Keos, just off the coast of Attica, and even more dramatically on the island of Thera, the southernmost of the Cyclades.

Keos (or Kea, as it is more informally called in modern Greek) was excavated from 1960 onwards. It was the last great project of John Caskey, who was Blegen's student and successor at Cincinatti. After working at Troy, he had gone on to excavate the House of the Tiles at Lerna, an important Early Bronze Age building on the Greek mainland. The excavations on Keos, which are still being published, were to reveal a substantial settlement with a long and well-stratified

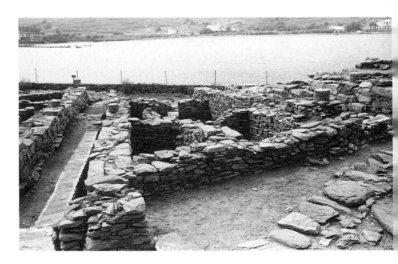

The temple at Ayia Irini, Keos, in 1973, from the north-west. The first free-standing Bronze Age temple discovered in Greece, it contained a remarkable series of large-scale terracotta figures, probably dating from early in the Late Bronze Age.

history. It is invaluable as a source of information about the nature of Cycladic settlements and the extent to which they retained their 'island' character in spite of intensive cultural influences from Minoan Crete and Mycenaean Greece.

Local and imported pottery, fragments of frescoes, Linear A tablets – the site has produced many interesting finds. Perhaps most dramatic was the discovery of a temple – the first large, freestanding building to be confidently interpreted as such in the Bronze Age Aegean – and its contents, which included a number of large, in some cases almost life-size, terracotta female figures.

This find was remarkable in two ways. Firstly, temples had not

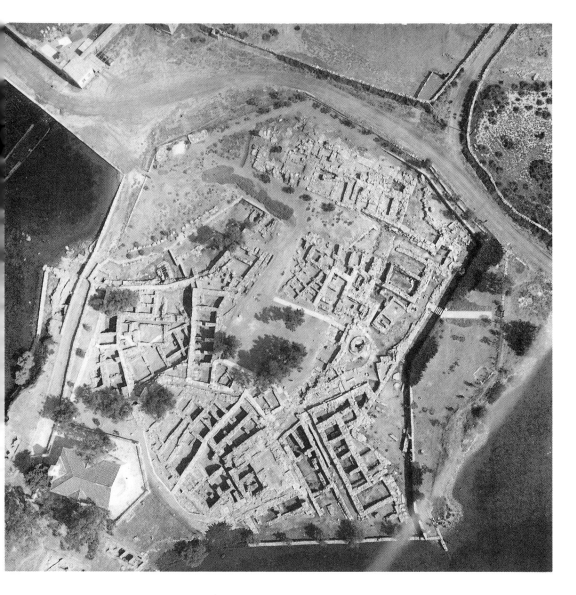

Aerial view of the site of Ayia
Irini, Keos, in 1977.

previously been identified in Bronze Age Greece. Sites recognised as
sacred in Minoan Crete had included caves, 'peak sanctuaries' on
mountain tops, and shrines incorporated into buildings – palaces or
houses. Sites of Mycenaean religious activity were even more elusive.
The Keos temple paved the way for the recognition of similar struc-
tures at places such as Phylakopi and Mycenae.

Secondly, the terracottas showed that there was some production
of large-scale figures in the Bronze Age Aegean. It had previously
seemed that, with the exception of such special cases as the relief over
the Lion Gate at Mycenae, the Mycenaeans had adopted from the
Minoans an essentially small-scale sculptural tradition. Many figur-

ines were known which represented deities or worshippers, in a variety of materials, but these were all relatively small. The Keos figures, which again must represent either the goddess or her worshippers, showed that, in terracotta at least, large-scale pieces were made. Scattered finds had previously suggested the existence of large-scale sculpture, perhaps made of wood. It remains true, however, that evidence for large-scale sculpture in the Aegean is still sparse compared, for example, with that from contemporary Egypt.

As early as 1939, the Greek archaeologist Spyridon Marinatos published an article in the journal *Antiquity* in which he expounded a new theory. He had been pondering the destruction of the Minoan civilisation of Crete, which had apparently been a sudden event, bringing devastation to a number of flourishing sites at a date then generally put at *c.* 1500 BC (now defined as the end of Late Minoan Ib *c.* 1450 BC). The idea that this might have been caused by a natural catastrophe was attractive, and Marinatos thought of the volcanic island of Thera, separated from Crete by only sixty-nine miles of open sea. Thera was known to have suffered a large-scale eruption that changed the configuration of the island, blowing the centre from its roughly circular shape and producing, or at least greatly enlarging, the deep 'caldera' into which ships now sail, while at the same time cloaking the remaining land with a thick mantle of volcanic ash. This ash had buried ancient remains on the island, and early chance discoveries, some connected with the removal of ash for the building of the Suez Canal, had revealed rooms with painted plaster, pottery and other finds, and even an inlaid dagger of the type known from the Shaft Graves of Mycenae. The French archaeologist M. Lenormant had in the nineteenth century found pottery beneath the ash deposits which was recognisably similar to Mycenaean pottery from Ialysos and Mycenae. All these early investigations were small-scale and scrappy, however, and their precise locations were generally unknown.

Marinatos' theory was a bold one, and the cautious editors of *Antiquity* published it with the warning note that in their opinion it needed 'additional support from excavation'. This he determined to seek, but the war prevented instant action and it was not until the 1960s that he was able to begin work on Thera. He carefully evaluated local information about the most likely spot to dig. The very thick layer of volcanic ash over much of the island precluded excavation, which could take place only in an area where natural erosion had reduced this layer to manageable proportions. Such was the case on the southern side of the island, near the village of Akrotiri, where low and flattish land sloped gently to the sea. Here local report told of finds being made; subsidence of the ash indicated buildings underneath and local livestock were found by Marinatos to be drinking

The façade of the West House, facing on to 'Triangle Square', within the Bronze Age town at Akrotiri on the island of Thera.

water from prehistoric stone bowls. He decided that this would be a good area to investigate.

Excavations began in 1967, under the auspices of the Greek Archaeological Society, and continue to this day. It rapidly became apparent that the Akrotiri site would be of prime importance for our knowledge of the Greek Bronze Age. Houses and streets – a whole section of a Bronze Age town – began to emerge from the enveloping layer of ash and pumice. The buildings were marvellously well preserved, their contents more or less as their inhabitants had left them. No people had been trapped by the destruction – at least not in the part of the town so far excavated – so it seems they had had some warning of disaster and were able to escape. Many of their possessions were left behind; even the shape of their wooden furniture was in some cases preserved as impressions in the ash that swept into their rooms. Perhaps most exciting of all for the modern world, their wall-paintings once again came to light – in need of careful restoration, but substantially complete, and still glowing in something like their original colours.

It is probably true to say that first impressions of this Bronze Age town concentrated on its obvious debts to Minoan Crete. Both art and architecture showed distinct Cretan influence. Indeed, the evidence from Akrotiri often put things long known from Crete into a

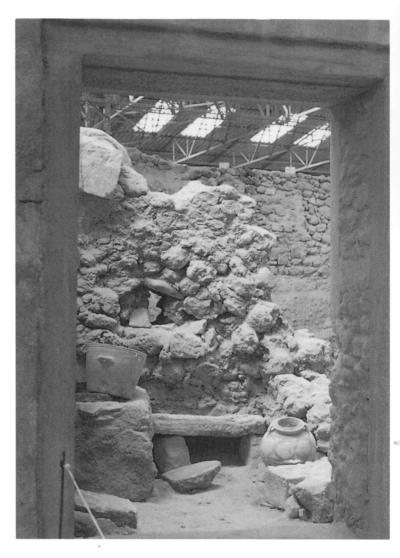

The mill installation in Room Delta 15 at Akrotiri, with a bench, a heavy grinding stone and a container which probably held flour.

new perspective. Thus while Minoan buildings on Crete were rarely preserved above a few feet in height, and complete façades and buildings were known only from representations, on Thera the buildings themselves were preserved to two and three storeys, confirming the impression gained from Minoan illustrations in a wonderful way and truly adding three-dimensionality to the picture. The idea that one could walk through a Minoan town square and be surrounded by Minoan buildings would previously have seemed like a Hollywood-inspired dream: now it became a reality. And, as if this were not enough, the frescoes added new representational evidence. In one example, the Fresco of the Fleet, there were not only houses but two complete painted towns, as well as a flotilla of brightly decorated ships sailing between them.

The obvious connections with Minoan Crete were unsurprising, in view of the proximity of that island and its developed civilisation. Still, as research progressed it became apparent that Akrotiri was essentially a Cycladic town, with roots extending back into the island culture – a culture which had a long history and which shaped many aspects of Theran life, even when Minoan influence was at its strongest. Certainly this was apparent from the pottery of the site, most of which is locally made, often decorated in the attractive, bright and breezy island style. The frescoes, too, exhibit many characteristics typical of the Cyclades, though belonging in more general terms to the same artistic current as those of Minoan Crete.

The purely Cycladic elements that persist throughout the life of Akrotiri seem powerfully to argue that the town should not be seen as a Cretan colony, or as under Cretan political control. No particular advantage to Crete can be perceived in such a relationship. It seems more likely that the town depended for its livelihood partly on agriculture, partly on trade. The excavators suggest it must have had a good harbour, well situated on the sheltered southern shore of the island, and this, perhaps even more than the local availability of fertile land, determined the position of the site. From here contacts with the outside world could be maintained. The island, a natural first landfall for ships sailing northwards from Crete, lies in a good position to act as a middleman between Crete and the Greek mainland. Indeed, it has been suggested that the islanders may have had special skill as sailors and could have been in demand to carry Minoan and Mycenaean goods abroad.

The bold hypothesis that the destruction of Minoan Crete was due to Thera's eruption did not stand up to close scrutiny. In particular, it became clear that chronologically the eruption could not have caused the destructions that affected most of the Minoan sites at the end of LMIb. Instead it coincided with the much less thoroughly devastating destruction horizon on Crete during LMIa. The absolute dating of the eruption has recently been a matter of some controversy, scientific methods apparently indicating a date towards the end of the seventeenth century BC, almost a hundred years earlier than the date of *c.* 1530 BC now quoted for the Cretan destruction. The final verdict on this new evidence has yet to be delivered: many carefully worked out synchronisms with Egypt would fall apart if the new date were accepted and, though many of these have always been arguable on an individual basis, it is at present hard to see quite how the cumulative evidence could have been so misleading.

CRETE: KATO ZAKRO

Excavations have proliferated in Crete. All the palace sites have continued to be investigated, with interesting results. We have mentioned the discovery of a wing of the First Palace of Phaistos; at Mallia, too,

exciting new protopalatial buildings have come to light in the town. Stratigraphical excavations were undertaken at Knossos in the area of the Royal Road in the 1960s to try to clear up some of the remaining problems there, while excavations in advance of a planned extension to the Stratigraphical Museum revealed part of the Minoan town. Apparent evidence for human sacrifice and possible cannibalism here tied in with finds at Anemospilia, near Archanes, where a human sacrifice seems to have been going on in a tripartite shrine at the moment when an earthquake caused the building's collapse. Such revelations of the darker side of Minoan existence were extremely upsetting to some scholars, although it should perhaps not have come as too much of a shock that such a dark side existed.

The Greek archaeologist Nicholas Platon began surveying the eastern end of the island of Crete in 1952. He was convinced that it should have formed an important part of the Minoan world and, more specifically, that the sheltered harbours of the east coast must have been significant for Cretan trade, particularly with the Near East and Egypt. In principle, it seemed likely that a Minoan palace should have existed in the area and there were already indications, from early excavations and chance finds, that east Crete was rich in Minoan remains.

In fact, Minoan habitation was already known on the bay of Kato Zakro itself. D.G. Hogarth of the British School had conducted a campaign there in 1901, after he had helped Evans begin the excavations at Knossos. He had revealed parts of some twelve substantial Minoan houses, as well as traces of several burials in the ravine leading to the bay of Zakro. He had not, however, discovered the palace, though it later became clear that his excavations had touched its outermost edge.

The British School also dug at Palaikastro, north of Zakro, between 1902 and 1906, and revealed remains of a prosperous town, situated between good fertile land and a sheltered bay. Extensive remains of streets and houses were discovered and further excavations in recent years have continued to make interesting finds there.

Platon's survey extended widely over the Siteia region, adding many new sites as well as further information about those already known. He discovered a series of important Minoan mansions – essentially farming establishments, like the villas of the Roman world. He located a number of tombs and two sites of the type known as peak sanctuaries. There seemed to be a complete local hierarchy of sites with only the palace missing. This was the position when Platon reached the Kato Zakro area.

The survey had not primarily been concerned with finding sites to excavate extensively, as this is always an expensive and time-consuming business. Sites threatened by development had been dug, and relatively small-scale excavations carried out elsewhere. It was on this rather restrained basis that in 1961 Platon laid out trial

trenches at Kato Zakro. These quickly revealed part of what seemed quite probably to be palatial store rooms, as well as further important buildings of the Minoan town. It was obvious that large-scale excavation was desirable. With remarkably happy timing, it was at this moment that generous private sponsorship was offered for an excavation project in Crete. A full-scale excavation could therefore immediately be planned by the Greek Archaeological Service and in 1962 the digging of Kato Zakro began.

The palace that was discovered was the fourth to be excavated in Minoan Crete, and the smallest, though comparable in scale with Phaistos and Mallia, both of which are only slightly larger. Zakro quickly proved to be their equal in importance because of the finds made within it: it was never reoccupied after a major destruction by fire in about 1450 BC, and was therefore essentially undisturbed and unplundered.

Kato Zakro has a small area of fertile land, but it soon became apparent that Platon was right in his surmise about the importance of the location for maritime trade. The bay of Zakro, a sheltered anchorage on the extreme eastern end of the island of Crete, was not only the nearest point to the eastern lands with which the Minoans were early in contact, but would have provided an invaluable haven for ships rounding the end of the island in stormy weather. Proof of overseas contacts and the importance of maritime exchanges came to light in the first days of the excavation proper, when four unworked elephant tusks, from Africa or Syria, and a group of oxhide-shaped copper ingots were found. Cyprus was an important source of copper but, surprisingly, on analysis these ingots turned out not to be Cypriot: their source is unknown.

Such rich discoveries emphasised the fact that the inhabitants do not seem to have come back to the palace after the fire in order to remove valuable items, though the relative scarcity of jewellery and objects in precious metals implies that they had found time as they escaped to take such things with them. The destruction of Kato Zakro belonged to that great wave of disasters that overtook most of the Minoan sites in Crete in about 1450 BC. The reasons for this are still not clear – whether natural disaster, foreign invasion, internal strife or a combination of factors – but whatever prevented the return of the inhabitants left a wonderfully rich site for archaeology, full of information and excavated by techniques which were a great deal more up to date than those used in uncovering the other Minoan palaces early in the century.

In common with the larger palaces, Zakro is constructed around a rectangular central courtyard. The orientation is northeast to southwest, like that of the Central Court at Mallia; those at Knossos and Phaistos are more accurately aligned on a north to south axis. The layout of the surrounding rooms and areas also has much in common with Mallia, particularly on the west side of the Central

Court, where three entrances led to a large, pillared Hall of Ceremonies, lit by a paved light-well, with a floor elaborately decorated with rectangles marked off with red painted plaster. In the light-well were found a chlorite rhyton (libation vesel) in the form of a bull's head, like the well-known example from Knossos, and another on which an elaborate hilltop sanctuary is carved in low relief. Store rooms of this west wing contained very fine pottery of the so-called Floral and Marine styles; spacious apartments probably existed on the upper floor. The southwest corner of the palace contained an archive of Linear A tablets and a room identified as a Treasury, where built-in chests of mud-brick with plaster floors contained remarkable finds. These included fine pottery, faience vases in the shape of seashells and, most notably, an array of stone vases, of various shapes and exquisitely made. The stones used include marble, porphyry, alabaster, obsidian and basalt. Perhaps finest of all is the justly famous miniature rhyton in rock-crystal, ovoid in shape and pointed at the end, with a handle made of rock-crystal beads on a bronze wire, and a collar decorated with pieces of gilded ivory.

To the north of the Central Court lay a banqueting hall above a kitchen, while, as at the other palaces, the rooms identified as Royal Apartments lay to the east of the Central Court. Unfortunately, due to cultivation of the land the east wing at Zakro is not well preserved. Only foundations survive of what appear to have been two spacious and elegant halls. Adjoining these is a room containing a large cistern fed by a spring in the adjacent Spring Chamber. It is not known whether this cistern was simply for water storage, for decoration, or even perhaps for bathing. What is clear is that the provision and storage of water was of major concern to the builders of Zakro: in addition to these installations there was a well in the southeast corner of the palace. The water-table was probably quite high: today, in fact, due to the lowering of the eastern end of Crete since the Bronze Age, the site of Zakro is waterlogged for much of the year – a factor that contributed to the excellent preservation of some of the finds.

A counterbalance to the results of survey and excavation in eastern Crete has been provided in recent decades by work in the west of the island. Here a certain amount of catching up was necessary, since from Evans' time onwards archaeological activity had concentrated on the centre and the east, and there had been a tendency to assume that little was known of the Minoans in the west because there was little to know. The suggestion that the modern town of Chania may have been the site of a fifth Minoan palace has received powerful confirmation from excavations in what seem to be palatial, or at least very important, buildings there. Informative finds have been made, though the density of later building in Chania limits the possibilities for excavation. Nonetheless Chania and its region were clearly important in Minoan times, perhaps particularly so in Late Minoan III, after the fall of Knossos, when the balance of power in the island as

a whole may have shifted westwards. The continuing use of Linear B there may indicate this. A range of sites, including important country houses, has also come to light in western Crete.

TWO EXCITING NEW FINDS: ULU BURUN AND AVARIS

It is interesting to speculate as to whether further major sites will be uncovered or finds made which shed new light on the Greek Bronze Age. Experience shows that this is very likely. Intensive excavation has always been expensive and time-consuming, so most of the known sites are only incompletely explored, while survey indicates the presence of others which remain untouched. Only in rare circumstances is it possible that saturation coverage has been reached: it is, for example, a melancholy possibility that all, or almost all, Early Cycladic cemetery sites have been discovered, and in many cases despoiled, so that we may never have further Cycladic figurines from excavated contexts to explain the many uncertainties still surrounding their use and meaning. In general, however, the prospects for future finds must be good, and we might end our survey by mentioning two relatively recent discoveries which were not part of the mainstream of excavation in Greece, but which were still of obvious and immediate significance for Greek Bronze Age studies.

The first of these was the find of a Late Bronze Age shipwreck made in 1984 by George Bass and his team of underwater archaeologists at a place called Ulu Burun, east of Kaş, off the southern coast of Turkey. Here, well-preserved and at a depth which just allowed the divers to work there (though only for periods of twenty minutes at a time), was a cargo ship which held a wealth of raw materials, as well as some fine finished goods – a veritable treasury of information about Late Bronze Age trade. The nationality of the ship has not yet been determined, since it held produce from the Mycenaean world and further afield in Europe, from Cyprus and the Syro-Palestinian area, and from Egypt. The ship was probably making a circuit around the eastern Mediterranean – it seems to have been heading westwards, towards Greece, when it sank – carrying large supplies of copper, ingots of tin and glass, unworked ivory and quantities of resin, perhaps for perfumed oils. Egyptian scarabs and western Asiatic seal-stones may have been the personal property of the crew. The Mycenaean pottery on board dates the wreck to about the late fourteenth century BC.

The great wealth represented by the cargo has led to the suggestion that this was a ship working directly at the behest of a powerful king or ruler of one of the Late Bronze Age states of the eastern Mediterranean. Alternatively, an independent merchant might have carried such goods, perhaps collected together and destined for one of the entrepôt sites which supplied whole hinterlands with raw mat-

erials and foreign goods. Our limited knowledge of the organisation of ancient trade and ancient economies allows various possibilities. Nonetheless, the Ulu Burun shipwreck confirms previous hypotheses about the circular routes and mixed cargoes of Bronze Age merchant ships, and provides the perfect 'closed context' for a most interesting range of material, which is still being analysed and assessed.

The second recent discovery that has thrown light from an oblique source onto the Bronze Age in Greece was made at the site of Tell el-Dab'a in the Nile Delta. This, the ancient Avaris, was the capital of the Hyksos kings of Egypt, and has been the subject of excavations by Professor Manfred Bietak and his Austrian team. The finds of Kamares pottery and the gold pendant of Minoan type that showed links with Crete in the eighteenth century BC have already been mentioned (see pages 114 and 143). Even more remarkable was the discovery on the site of a series of wall-paintings, dating from the sixteenth century BC, so Minoan-looking in style and execution that they would have seemed perfectly at home on the walls of Knossos.

The themes of the paintings seem quintessentially Minoan. Thus there are not only scenes of bull-jumping, but even a bull's head seen *en face* in front of a labyrinth pattern – almost more Minoan than

Fresco in Minoan style and technique, showing a bull-jumper falling head-downwards to the right and, on the left, part of the head of a bull. From Tell el-Dab'a, the ancient Avaris, capital of the Hyksos kings of Egypt in the Nile delta. 16th century BC. (Cairo Museum)

anything yet found in Crete. The costumes and long, curly black locks of the participants seem wholly Minoan in style. On another composition, animals leap through the landscape in the typical Aegean 'flying gallop', with both front and back legs extended. The technique, too, seems entirely similar to that used in Crete. The paintings are, though, rather earlier than the majority of those known from Crete and earlier than those from Thera on the traditional dating. This may be because the Minoan tradition of figured painting had

been in existence for some time before those examples that survive in Crete. Many experts believe that a Minoan hand can be seen in the Avaris frescoes, either because there was a fashion for things Minoan or even, it has been suggested, because of inter-dynastic marriages between the Hyksos kings and the rulers of Minoan Crete. However this may be – and the context of the paintings is rather unhelpful, since they seem to have been thrown out of the room or rooms that they once decorated – it is clear that very close contacts existed between Egypt and Crete at this time. Contemporary scholars are having to adjust their ideas to encompass this new evidence, but Arthur Evans would not have been surprised.

ATTITUDES AND TECHNIQUES

The application of scientific techniques has been mentioned in our survey of discoveries since the 1950s. There can be no doubt that science has revolutionised our understanding of certain problems. Thus the development and continuing refinement of radiocarbon dating has enabled chronological conclusions that were not previously possible, which have been particularly valuable for the early stages of the Bronze Age, where no other information is available. For the later period, when archaeological synchronisms can be made with civilisations with written records, such as ancient Egypt, the scientific and archaeological data must be combined, with the latter frequently giving more chance of precision. In matters such as the date of the Thera eruption the evidence from different sources must be evaluated, and it is not a simple matter to arrive at a definite answer. Yet greater certainty may be hoped for as both science and archaeology progress.

The analysis of pottery and metal artefacts to show provenance has been a powerful tool in the reconstruction of ancient trade, and has helped to elucidate many questions of relationships within Bronze Age Greece and in the wider world. Of its many applications, we may just mention the programme of analysis that has shown Mycenaean pottery from Cyprus and the eastern Mediterranean to have been manufactured on the Greek mainland – often in the area of Mycenae itself – and exported. This surprised those commentators who had seen in it specifically 'eastern' characteristics, but it seems likely that particular types of vase were made for export, presumably because the potters knew that items such as large vessels decorated with pro-cessions of chariots were popular in Cyprus. Analysis of metals, too, though not uncontroversial, has been of major importance, since the need for metals can be seen as one of the major factors behind trade and exchange in the ancient world. The complexities of ancient trade become ever more apparent, but there is no doubt that science is of immense importance in establishing the basic facts which archaeo-logists must then try to explain.

Advances in scientific techniques are inextricably linked to chan-

ging attitudes to the pursuit of the Greek Bronze Age, partly because new techniques open up the possibility of asking new questions, partly because new questions are asked and the techniques then sought to answer them. From whichever side the impetus comes, scientists and archaeologists are united in the search for as broad a range of information as possible about the ancient world. Modern fieldwork aims to recover as full a picture as it can of the ancient sites and their inhabitants, no longer concentrating only on palaces and fine works of art, but attempting to set these things against the wider picture of both their natural and their social environment. For this reason, fieldwork increasingly involves specialists from other scientific disciplines. Geologists, for example, work to reconstruct the nature of the ancient land surface, the configuration of the coastlines and so on, while botanists identify remains of seeds and pollens to illuminate ancient agriculture and diet. At the same time surface surveys, in which archaeologists walk over the landscape in an organised pattern to pick up surface sherds and other indications of the presence of ancient sites, have increasingly been used to clarify the history of settlement of an area, and the changing patterns of man's habitation and use of the land over a period of time.

The beginnings of both these approaches can be seen in the work of Schliemann, and in that sense have been part of Greek prehistoric archaeology for as long as the discipline has existed. Schliemann sent samples of various finds for analysis by specialist scientists, as well as consulting other scholars extensively on a whole range of matters. He also sought excavation permits to cover the whole of the Troad, traversed the ground in detail (as had many travellers before him), and generally showed a keen awareness of the importance of seeing his site within the broader perspective.

Similarly, recognition of the fact that 'ordinary' sites should be examined to balance the picture provided by palaces goes back at least as far as Harriet Boyd and her work at Gournia, and the theme was taken up by Blegen during his excavations in the Peloponnese. Palaces continue to fascinate, however, and it is noticeable that whenever new Minoan buildings of some architectural refinement are discovered in Crete the word 'palatial' is whispered on the grapevine, as if everyone's secret wish is to find a palace. Still, while the emphasis on the recovery of all sorts of contextual information may have grown, and the attempt may now be more self-conscious, the modern attitude has grown naturally out of the work of the pioneers.

A more radical difference between current thinking and that of the 1950s lies in the interpretation of archaeological remains and the sort of explanations that now seem most acceptable or probable. Since the material remains of the Greek Bronze Age have always been like a picture book without a text, archaeologists have traditionally not only revealed the pictures but also attempted to reconstruct a text to go with them – in effect to write the 'history' of prehistoric Greece.

At first the tendency was to try to reconstruct the same type of history as was obtainable elsewhere in the ancient world from written records. This naturally laid great emphasis on single events and individual actions, often of kings or princes, but was not much concerned with the processes by which certain places or societies became the way they were. Recognition of the fact that the archaeological record alone could not deal in specifics was slow to come, and arguably had not arrived even by the time of Blegen, with his belief that he had 'found' the Trojan War. Now there is general acceptance that no such individual event can emerge from the kind of evidence provided by archaeology. Even if we knew exactly what we meant by the Trojan War – and we know enough about the Homeric poems for a fundamentalist approach to be impossible – it is clear that the archaeological evidence cannot be applied to the question 'Did the Trojan War take place?': the two simply do not meet on the same plane. One need only consider what sort of evidence would have to be found at Troy to answer the question unequivocally. Without writing, 'proof' is well nigh unimaginable.

The Trojan War may be an extreme example of the attempt to find 'events' in the archaeological record, but a tendency to invoke invasions and mass movements of peoples to explain cultural change was a related phenomenon. Again, attitudes can be seen to have changed quite radically over the last forty years. The search for the dynamics of change within the structures and social systems of the Greek Bronze Age cultures themselves, rather than from outside agencies, has been one of the major contributions of the movement that grew in the 1960s and '70s and that came to be called 'New Archaeology'.

'New Archaeology' arose in North America in response to problems in the interpretation of sites belonging to pre-literate communities in the New World. The movement was therefore always particularly concerned with prehistory. Broadly, the aim of its pioneers was to make archaeology more truly scientific in its methods, and certainly more self-conscious about its methodology. They proposed that hypotheses logically deduced from a set of archaeological data should then be tested against new data: if their predictions proved accurate, then the hypotheses were 'proved' and could be accepted. This ideal was not always easy to put into practice, since the vagaries of the material record did not always allow the recovery of the necessary new data. Argument at first raged about the effectiveness of the 'new' approach, particularly since its exponents were often outspoken about the shortcomings of traditional archaeology. As we have seen, it could with some truth be argued that many elements in 'New Archaeology' were not so 'new', but were simply defined overtly (and, some thought, over-wordily) for the first time. Nonetheless, there can be no doubt that 'New Archaeology' introduced useful new emphases to Aegean prehistory, contributing to the formation of the modern view.

We may take as an example the question of the Dorian Invasion, which Greek tradition had placed at the very end of the twelfth century BC and which had, from Tsountas' time onwards, been seen as the reason for the collapse of the Bronze Age world. Tsountas himself had painted a violent picture of the Dorians coming down from the north destroying Mycenaean centres with fire and the sword. In fact, though, the archaeological evidence for an irruption of new people at this juncture proved to be entirely lacking: the more sites were excavated, the more it seemed that the picture in the twelfth and eleventh centuries BC was of the same people in Greece, even though in very reduced circumstances. The world of the Mycenaean palaces had collapsed, but this collapse had not apparently been accompanied by an incursion of new people. Moreover, John Chadwick felt that Dorian features were already present in the language of the Linear B tablets, making it at least arguable that these 'invaders', who certainly were present and important in later Greece, had been there all the time.

The Dorian Invasion began to seem an unlikely explanation for a complex situation; it should perhaps be regarded as an aetiological myth – a story that had arisen in later times to explain the origin of the situation inherited by the Greeks. A different sort of analysis was provided by scholars in the 'New Archaeology' tradition, who looked for internal factors, rather than outside agents, to explain the series of circumstances and events that led to the disappearance of the Bronze Age world. They came up with the model called 'systems collapse'.

This model assumed that the 'system' that was Mycenaean society was made up of a whole series of aspects – its subsystems – which stood in changing relation to each other, but in a state of equilibrium. When for a variety of reasons the equilibrium between various subsystems was disturbed, a complex pattern of disruption emerged which eventually caused the downfall of the whole 'system', and the end of the Mycenaean world.

This sort of analysis, applied to Aegean prehistory particularly by Colin Renfrew, has gained currency because of its recognition of the essential complexity of human affairs. Single great events, whether man-made, such as war, or natural, such as pestilence, famine or earthquake, can obviously have a momentous – though straightforward – effect on the course of history. The sheer scale of change wrought in Greece at the end of the Bronze Age, however, seems too great for any single factor on this list to have been responsible. A combination of factors seems much more likely. Moreover, the flexibility of an explanation such as 'systems collapse' fits better with the complicated but piecemeal and unsatisfactory evidence that we have. It stands a good chance of being as right as we can get at present.

'New Archaeology' began sufficiently long ago now for it to be clear that its initial strident stance against the 'Great Tradition' of Classical archaeology has to a large extent been replaced by a middle

way, where the best elements of both approaches are combined to take learning forward. Thus the importance of field survey, particularly favoured in the 'new' approach, has amply been proved by such pioneering efforts as the Minnesota-Messenia expedition, a multi-disciplinary survey of the area of Nestor's Palace, followed by work in areas including Boeotia, the Peloponnese, Crete, Melos and Keos. Survey has not replaced excavation, however, and it is generally recognised that the ideal situation, where finance permits, combines both techniques, so that a broadly based picture of a certain area, gained from survey, is accompanied by detailed knowledge of certain sites within it, provided by excavation.

By the same token, it is now recognised that the attempt to understand processes and to reconstruct the fullest picture of ancient societies is not incompatible with detailed studies of certain types of architecture or artefact, which are themselves a potentially illuminating part of the broader picture.

CURRENT TRENDS

*Most of the meta-narratives of prehistory turn out to be shallow tales,
thinly disguised wish-fulfilment on the part of the times and
nationalities which invented them . . . The temptation is thus to
abandon grand narrative altogether, and be satisfied with . . . telling
petites histoires . . . Yet there is also something to be said for
preserving a wider vision – if only because it is uncomfortable to sit for
any length of time on a pile of deconstructed rubble.*

A. SHERRATT, Review of A. Schnapp's *La Conquête du Passé*,
Times Literary Supplement, 21 October 1994

One important result of the decipherment of Linear B was the realis-
ation that the Mycenaean world could not simply be dismissed by
Classicists as 'pre-Hellenic', for it truly was the earliest age of Greece.
The nature and extent of continuity between the Bronze Age and the
Archaic and Classical periods continued to be a matter for debate,
but the proof that the Mycenaeans were Greek-speaking meant that
they had to be seen as the ancestors of the Classical world, whatever
transformations had taken place in the intervening centuries. This
delighted Wace, and would have pleased Evans, since they had been
united in feeling that Bronze Age achievement underpinned the later
glories of Greece and it was for both of them a matter of crusading
zeal to prove that this was so. They fought the battle over many years
for there was a strong inclination among Classicists of the old school
to deal with the problems of prehistoric art and culture by denying
its 'Greekness', and thus dismissing it more or less summarily.

This attitude had developed in the late nineteenth and early twenti-
eth centuries. In the immediate aftermath of Schliemann's excava-
tions, Charles Newton had discussed Mycenaean artefacts as if there
were no question that they were Greek, and had tried to fit them into
the first stage of the development of Greek art. It was partly the
difficulties inherent in this approach, and partly the growing evidence
for the richness and complexity of Bronze Age culture that led scholars
in the following decades increasingly to emphasise the gulf between
Bronze Age and later products. We have already seen Evans
responding vociferously to Percy Gardner, his predecessor as Presid-
ent of the Hellenic Society, who in 1911 said 'the chasm dividing
prehistoric from historic Greece is growing wider and deeper; and

those who were at first disposed to leap over it now recognise that such feats are impossible'. The idea of a gulf also very much sets the tone of Adolf Michaelis' *A Century of Archaeological Discoveries* (1908), which gives the impression that Bronze Age products not only fail to be Greek, but also quite often fail to be art, and are therefore only of peripheral interest to those engaged in the noble pursuit of fifth-century Greece. Thus although Bronze Age excavations were very prominent in the century of discoveries that Michaelis sets out to describe, they receive relatively brief coverage.

At the outset Michaelis defines archaeology as what he calls 'the archaeology of art'. He is not interested in objects that 'express no artistic character', and takes the view that prehistory is occupied with anthropology, ethnology and the history of civilisation, subjects which he says – bizarrely enough to modern ears – 'are as foreign to our studies as the questions of currency, trade and history would be to numismatics'. Moreover, the archaeology of art is not concerned with the ancient people's burial customs, their 'mode of living, their dress or their furniture'. This definition of archaeology is less open-minded and less helpful than the earlier view of Charles Newton, who argued strongly for the preservation together in museums of both acknowledged masterpieces of ancient art and the smaller, more humble, objects of everyday use, feeling that the former could only be understood in the context of the latter – a view substantially the same as ours today.

It is plain to see why Michaelis' narrowly proscriptive attitude would have annoyed Evans, not least in the implicit assumption that students of the art of fifth-century Greece could automatically claim the moral high ground. Yet Michaelis did allow that there was some merit in the art of the Greek Bronze Age, particularly that of Minoan Crete. He also, unlike Newton, was able to view Minoan and Mycenaean artefacts as fully developed within the terms of their own cultures. He certainly saw a gap, though, after the Bronze Age, and felt that a completely new artistic process began several centuries after the Dorian Invasion, with the beginnings of 'the true Hellenic art'. Bronze Age products had therefore, Michaelis concludes, to be placed 'before the beginning of Greek history'.

In a way, this awareness of the separateness of the Bronze Age was a necessary step towards seeing the Cycladic, Minoan and Mycenaean cultures in their own terms. Nevertheless, even as late as the 1950s Wace felt strongly that a 'Classical backlash' had prevented full appreciation of the Bronze Age and its influence on later Greece, and had tended to marginalise Bronze Age studies. He found in the decipherment of Linear B a powerful new argument to support his case for continuity. When he wrote the Introduction to Ventris and Chadwick's *Documents in Mycenaean Greek* (1956), he took the opportunity to strike a polemical note, saying, 'From the beginning of Schliemann's discoveries at Mycenae, the conservatism of classical archaeo-

logists has obstructed progress in the study of Greek civilisation as a whole . . . this spirit . . . has impeded progress in our studies of pre-Classical Greece . . . Greek art is one and indivisible, and has a continuous history from the first arrival of the Greeks.'

As William McDonald has pointed out, Wace's extreme view is typical of a pattern in Aegean studies. 'New evidence produces an extreme position which, in turn, gives rise to an opposed, similarly extreme position. Eventually a middle stance prevails.' This has proved true of the question of continuity. The notion of an unbridgeable chasm is no longer tenable: it is now clear, for example, that the progress of pottery production in Greece can be traced from Mycenaean to sub-Mycenaean, Protogeometric and Geometric styles. Continuity of other sorts is incontrovertible, that of language particularly so. On the other hand, Wace's picture of an unbroken continuum seems overstated. His claim that writing cannot have been lost has not been substantiated and certainly its reintroduction to Greek lands using the Phoenician alphabet represents a complete change. The fact that deities familiar from the Classical pantheon appear on the Linear B tablets, while at first seeming to indicate continuity, needs careful assessment, for both the attributes of, and attitudes to, these gods may have changed radically. Other aspects of the Archaic and Classical world seem to arise afresh. The development of the polis, or small city-state, for example, contrasts with the larger Mycenaean kingdoms. The architecture and art of the Mycenaean palaces, with their bright frescoes and golden cups, certainly disappeared.

New information about and understanding of the Dark Age is growing apace; indeed the term seems increasingly inappropriate both in view of the amount we know about this period and in the way in which it is characterised. Certain areas of Greece are being shown to have been less poverty-stricken and less isolated than had previously been thought, and to have recovered more quickly from disruption at the end of the Bronze Age. Even so, there was disruption, for whatever reason or reasons, and the late Bronze Age and early Iron Age of the twelfth and eleventh centuries saw a restless period with movement of peoples and considerable change. The question of continuity must therefore be evaluated carefully; as predicted by McDonald's model, neither the chasm nor the unbroken continuity arguments can prevail. The answer must lie somewhere in the middle ground.

Where, then, do we now stand in relation to the Greek Bronze Age? What is our inheritance from our predecessors in the field, from the great names of the early pioneers to the practically anonymous workers on field surveys or in pottery sheds? It is tempting to paint a rather lugubrious picture: a Hesiod-like view of decline from an age of fresh, childlike optimism, when men really could move mountains, and find a heroic world beneath them, to a state of post-modern paranoia, self-analytical and nihilist, too much aware of the limitations of what is archaeologically possible. The original impetus towards

exploration was individual- and events-based – from the outset the Greek Bronze Age, although offering no readable texts, carried the weight of expectation that the door to the mythological world peopled by characters such as Minos and Agamemnon would be opened. The first great discoveries bolstered such expectations: the citadel of Mycenae was seen to be 'rich in gold' as Homer said; the large and elaborate palace at Knossos could surely belong to none other than Minos as tradition demanded, and by the 1930s Troy itself was shown to be 'well-walled', with 'fine towers' and 'lofty gates'. It seems a sad decline to our modern recognition that the material remains of a preliterate society, incompletely recovered, can properly be expected only to answer limited and impersonal questions.

From the beginning it was of course apparent to judicious commentators that what was emerging from the earth had no straightforward correlation with the stuff of myth or tradition. As early as 1878, Charles Newton had written of the difficulty of finding 'by what test we may discriminate between that which is merely plausible fiction and that residuum of true history which can be detected under a mythic guise in this and other Greek legends . . .'. This was in his review of Schliemann's work at Mycenae, which he ends with the optimistic hope that further archaeological excavation will elucidate such matters. He would perhaps have been disappointed to know how entirely appropriate his formulation of the problem still seems today.

This is not to say that more than a hundred years of endeavour has been in vain. Knowledge has most certainly advanced, and the sheer amount of raw data available in the form of finds, from the largest palace to the smallest potsherd, is immeasurably increased. We have seen something of the difficulties involved in the successive stages of 'placing' these objects in the broader picture of the development of Greek, indeed eastern Mediterranean, culture. The evolving view of the relations between myth and the material remains was similarly fraught with difficulties. Early optimism was not entirely misplaced – no one could reasonably deny the connection between the world of the Greek Bronze Age and the tradition of the 'heroic' age of Greece, even if it would be oversimplifying matters to say it 'is' that world. The high point of optimism that encouraged the excavators of Troy to identify the archaeological remains of the Trojan War in the Hisarlik mound has not subsequently been maintained, however, and indeed seems faintly aberrant even in the context of its time. It is true that after Schliemann it had become widely accepted that there probably was a real event or events behind the Homeric story of the Trojan War, but the difficulties of pinning down events from Greek myth in the excavated remains were always apparent, and had been recognised even by Schliemann himself during the advanced stages of his career. A feasible background for the stories could be hoped for, but the specifics of people and events were always going to prove elusive – inevitably, if they were not historical in the way in

which we understand the word. Places and objects were potentially more fruitful, at least giving a firm foundation from which the enquiry could start.

The whole complex subject was reviewed by Hilda Lorimer in her masterly *Homer and the Monuments* in 1950. She examined all aspects of the connections between the material world revealed by archaeology and the world depicted in Homer, from the large-scale questions of social and political institutions to the detailed analysis of objects described by Homer and found in the material remains. Her survey included the entire period from the Bronze Age to the time at which the *Iliad* and the *Odyssey* reached their final form, and indeed her analysis of the latest elements in the poems was very influential in confirming that they were composed in the later part of the eighth century BC – the date to which they are still assigned today. She demonstrated convincingly – and perhaps disappointingly to those who were hoping that the discovery of the Greek Bronze Age would solve at least the historical part of the 'Homeric Question' – that the Mycenaean world and the world of Homer were not one and the same thing. Indeed, she argued that the poems did not present a coherent and unitary picture of a world that one could hope to identify in the archaeological record: rather they contained elements from various periods of the composition and transmission of the traditional material of which they were composed.

Lorimer's work just predated the decipherment of Linear B, which would dramatically add a new element to the debate, but in general her conclusions provided a firm foundation for continuing research. The subsequent trend was one of increasing caution, and a sort of minimalist backlash can be discerned in the 1960s and '70s, when increased awareness of what constituted rigorous archaeological proof led sceptics not just to reject the evidence for the Trojan War but again to wonder whether the mound of Hisarlik really could be identified as Troy. Such scepticism is quite rightly still with us. We must be aware of the limitations of our evidence, and the case cannot be said to be 'proven', though the circumstantial evidence is surely overwhelming. Perhaps our modern age sees elements of a new romanticism: in spite of the general recognition that the Mycenaean world is not that of Homer it is remarkable how many exhibitions of Greek Bronze Age material have titles such as 'The World of Homer's Heroes'. They explain in their labels and catalogues the complexities of the identification of this world, but such a title is felt to breathe life into the artefacts on show. However cautiously we claim the connection, the impressive citadels and elaborate objects of the Mycenaean world are animated by their Homeric associations – proof, if it were needed, of the greatness of the Homeric poems, perhaps proof too that archaeological truth is not the only kind of truth.

Other sorts of mythology and mythologising have had to be reconsidered in recent decades, some ancient, some of more recent date.

Thus the ancient tradition of the Dorian Invasion was seen to have no counterpart in archaeological reality, while the idea of the 'Coming of the Greeks' can almost be seen as a modern myth. It would not be fair to be dismissive of the expression or of the question as it was formulated. We have, after all, seen that significant research resulted from the enquiry into the identity of the Greeks and the date and nature of their arrival in their land. Nonetheless, the accumulated evidence bearing on the question has shown that a complex range of circumstances is encompassed by the expression, which in reality becomes almost meaningless. There were no people that could be defined as 'The Greeks' before their existence in Greek lands; more-over, they perhaps did not so much 'come' as arise from a mixture of people arriving and people already there. It is a picture of inexplicable, because unrecoverable, complexity.

Such reflections may lead to nihilistic despair about how much we can ever really know. It is perhaps scant comfort to reflect that the very recognition of complexity is an advance. The trend of recent research has so often been to reconsider hypotheses such as that which saw Greeks, horses and Grey Minyan pottery sweeping in from the north, and to conclude that the reality must have been more complicated. The historian and archaeologist Franz Maier has appositely drawn attention to the term 'factoids', a term used to refer to hypotheses so often repeated in the literature that they acquire a spurious quasi-factual status. Re-examination is always worthwhile, and in so far as one can generalise, such 'factoids', while often seeming still to contain an element of truth – after all, they came about in response to archaeological evidence – almost invariably now seem to be over-simplified. If one can draw any positive lesson from this, it can be summed up in a principle borrowed from scholars who work to restore ancient texts into which mistakes have been introduced over years of copying and recopying. The rule (*'lectio difficilior potior'*) says that the more difficult version is to be preferred, since the tendency of the ancient copyists, if they encountered problems, was to simplify, using the form of words most familiar to them. In reading the archaeological record too, we should bear this in mind. The inclination to simplify is useful – we could hardly organise or make any sense out of the vast amount of data without it. Yet it has perhaps always been clear that a very complex and only partially understood ancient reality lies behind our rationalisations and the stories we tell.

In the end, however difficult they may be to interpret, we must be grateful that archaeology has brought back to light the buildings and the objects created by the early peoples in Greek lands. If the proper study of mankind is man, we need make no apology for contemplating these early products of man's hands. It would be a failure of human curiosity, indeed of human ingenuity, if we did not try to recreate a picture of the societies that made and used them.

BIBLIOGRAPHY

This bibliography, while not exhaustive, includes works mentioned or referred to in the text (except where such references are self-contained) as well as a selection of further reading. Abbreviations used: *AJA* (American Journal of Archaeology), *BSA* (Annual of the British School at Athens) and *JHS* (Journal of Hellenic Studies).

ANCIENT AUTHORS

The Loeb Classical Library remains a useful resource for consultation of Greek and Latin texts with a parallel English translation, and the works of Hesiod, Homer, Herodotus, Thucydides, Diodorus Siculus, Lucretius, Aristotle, Strabo, Pausanias and Pliny can all be found in this series. The translations are in some cases rather old-fashioned, and the Penguin Classics, which also include most of the ancient authors mentioned, are generally more accessible.

SITE PUBLICATIONS

BASS, G.F. AND OTHERS. 'A Bronze Age Shipwreck at Ulu Burun: 1986 campaign', *AJA* 93 (1989), 1–29

BLEGEN, C. *Korakou: A prehistoric settlement near Corinth*, New York, 1921
 Zygouries: A prehistoric settlement in the valley of Cleonae, Cambridge, MA, 1928
 Prosymna: The Helladic Settlement preceding the Argive Heraeum, 2 vols, Cambridge, MA, 1937
 Troy and the Trojans, London, 1963

BLEGEN, C., J.L. CASKEY, M. RAWSON AND J. SPERLING. *Troy I General Introduction: The first and second settlements*, Princeton, 1950
 Troy II: The Third, Fourth and Fifth Settlements, Princeton, 1951
 Troy III: The Sixth Settlement, Princeton, 1953
 Troy IV: Settlements VIIa, VIIb and VIII, Princeton, 1958

BOSANQUET, R. AND OTHERS. 'Excavations at Palaikastro I–V', *BSA* 8 (1901–2), 9 (1902–3), 10 (1903–4), 11 (1904–5), 12 (1905–6)

Excavations at Phylakopi in Melos, London, 1904

BOYD HAWES, H. AND OTHERS. *Gournia, Vassiliki and other Prehistoric sites on the Isthmus of Hierapetra, Crete*, Philadelphia, 1908

CASKEY, M. AND OTHERS. KEOS II *The Temple at Ayia Irini: Part I The Statues*, Princeton, 1986

CHAPOUTHIER, F. AND OTHERS. 'Mallia', *Etudes Crétoises* 1, 4, 6, 12, Paris, 1928, 1936, 1942, 1962

DÖRPFELD, W. *Troja und Ilion*, 2 vols, Athens, 1902

EVANS, A. *The Palace of Minos*, vols I–IV, London, 1921–36

LEVI, D. *Festòs e la civiltà minoica*, I, Rome, 1976, II(1), Rome, 1981

LEVI, D. AND F. CARINCI. *Festòs e la civiltà minoica*, II(2), Rome, 1988

MACGILLIVRAY, J.A. AND OTHERS. 'Excavations at Palaikastro 1986–88', *BSA* 82 (1987), 83 (1988), 84 (1989)

MARINATOS, S. *Excavations at Thera*, vols I–VII, Athens, 1967–73

MURRAY, A. AND OTHERS. *Excavations in Cyprus*, London, 1896

MYLONAS, G. *Grave Circle B at Mycenae*, Greek edn, Athens, 1973

PELON, O. 'Le palais de Mallia V', *Etudes Crétoises* 25, Paris, 1980

PERNIER, L. AND L. BANTI. *Il palazzo minoico di Festòs*, 2 vols, Rome, 1935, 1951

PLATON, N. *Zakros: The Discovery of a Lost Palace of Ancient Crete*, New York, 1971

SAKELLARAKIS, J. AND E. *Archanes*, Athens, 1991

SCHLIEMANN, H. *Troy and its Remains*, London, 1875
 Mycenae, London, 1878
 Ilios: The City and Country of the Trojans, London, 1880
 'Exploration of the Boeotian Orchomenos', *JHS* 2 (1881), 122–63

Troja: Results of the Latest Researches, London, 1884
Tiryns: The Prehistoric Palace of the Kings of Tiryns,
London, 1886

SEAGER, R. *Explorations in the island of Mochlos*, Boston
and New York, 1912

VAN EFFENTERRE, H. *Le palais de Mallia et la cité
minoenne*, Rome, 1980

WACE, A. 'Mycenae: Report of the excavations of
the British School at Athens 1921–3', *BSA* 25 (1923)
 Mycenae: An archaeological history and guide,
 Princeton, 1949

XANTHOUDIDES, S. *The Vaulted Tombs of Mesara*,
London, 1924

OTHER WORKS

ALLEN, S.H. 'In Schliemann's Shadow: Frank
Calvert, the unheralded discoverer of Troy',
Archaeology May/June 1995, 50–7

ALLSEBROOK, M. *Born to Rebel: The life of Harriet Boyd
Hawes*, Oxford, 1992

Bennett, E.L. *The Pylos Tablets: A preliminary
transcription*, Princeton, 1951

BIETAK, M. 'Die Wandmalereien aus Tell el-Dab'a
'Ezbet Helmi', erste Eindrücke', *Ägypten und Levante* 4
(1993), 44–58
 'Les fresques minoennes dans le delta orientale du
 Nile', *Le Monde de la Bible: Archeologie et Histoire* 88
 (1984), 42–4

BIETAK, M. AND OTHERS. *Pharaonen und Fremde:
Dynastien im Dunkel*, Vienna, 1994

BLEGEN, C. AND J. HALEY. 'The Coming of the
Greeks', *AJA* 32 (1928), 141–54

BLEGEN, C. AND A. WACE. 'Pottery as evidence for
trade and colonisation in the Aegean Bronze Age',
Klio 32 (1939), 131–47

BOARDMAN, J. AND L. PALMER. *On the Knossos Tablets*,
Oxford, 1963

BROWN, A. *Arthur Evans and the Palace of Minos*,
Oxford, 1983
 'I propose to begin at Gnossos', *BSA* 81 (1986),
 37–43
 *Before Knossos: Arthur Evans' Travels in the Balkans
 and Crete*, Oxford, 1993

Burn, L. *Greek Myths*, London, 1990

CALDER, W. AND D. TRAILL (EDS). *Myth, Scandal and
History: The Heinrich Schliemann controversy and a first
edition of the Mycenae diary*, Detroit, 1986

CESNOLA, L. PALMA DI. *Cyprus: Its ancient Cities,
Tombs and Temples*, London, 1877

CHADWICK, J. *The Decipherment of Linear B*, 2nd edn,
Cambridge, 1967
 The Mycenaean World, Cambridge, 1976

COOK, J.M. *The Troad: An archaeological and
topographical study*, Oxford, 1973

COURBIN, P. *What is Archaeology? An Essay on the nature
of archaeological research*, English edn, Chicago, 1988

DANIEL, G. *150 Years of Archaeology*, 2nd edn,
London, 1975

DAVIES, W.V. AND L. SCHOFIELD (EDS). *Egypt, the
Aegean and the Levant*, London, 1995

DEUEL, L. *Memoirs of Heinrich Schliemann*, London, 1978

DICKINSON, O. *The Aegean Bronze Age*, Cambridge,
1994

DI VITA, A. *Ancient Crete: A Hundred Years of Italian
Archaeology*, Rome, 1984

DODWELL, E. *A Classical and Topographical Tour
through Greece during the years 1801, 1805 and 1806*, vols
1–2, London, 1819
 *Views and Descriptions of Cyclopian or Pelasgic Remains
 in Greece and Italy*, London, 1834

DOUMAS, C. (ED.). *Thera and the Aegean World*, I, II,
London, 1978, 1980
 Thera: Pompeii of the Ancient Aegean, London, 1983
 The Wall-paintings of Thera, Athens, 1992

EASTON, D. 'Priam's Treasure', *Anatolian Studies* 34
(1984), 141–69
 'Schliemann's mendacity: a false trail?', *Antiquity*
 58 (1984), 197–204
 'Troy before Schliemann', *Studia Troica* 1 (1991),
 111–29

EVANS, A.J. *Cretan Pictographs and Prae-Phoenician
Script*, London and New York, 1895
 Scripta Minoa I, Oxford, 1909
 'The Minoan and Mycenaean Element in Hellenic
 Life', *JHS* 32 (1912), 277–97
 *The Shaft Graves and Beehive Tombs of Mycenae and
 their Interrelation*, London, 1929
 Scripta Minoa II (ed. J.L. Myres), Oxford, 1952

EVANS, J. *Time and Chance: The story of Arthur Evans
and his forebears*, London, 1943

FINLEY, M. *The World of Odysseus*, 2nd edn,
Harmondsworth, 1979

FITTON, J.L. *Heinrich Schliemann and the British
Museum*, London, 1991

'Charles Newton and the Discovery of the Greek Bronze Age' in *Klados: Essays in honour of J.N. Coldstream*, London, 1995

FORSDYKE, J. *Greece before Homer: Ancient Chronology and Mythology*, London, 1956

FOXALL, L. AND J.K. DAVIES. *The Trojan War: Its Historicity and Context*, Bristol, 1984

GALE, N. (ED.). *Bronze Age Trade in the Mediterranean*, Goteborg, 1991

GARDNER, P. Presidential address, *JHS* 31 (1911), lii–lxi

GLADSTONE, W.E. *Studies on Homer*, London, 1858

GORING, E. *A Mischievous Pastime*, Edinburgh, 1988

GRAHAM, J.W. *Palaces of Minoan Crete*, 2nd edn, London, 1980

GROTE, G. *A History of Greece*, 12 vols, London, 1846–56

HAGG, R. AND N. MARINATOS. *The Minoan Thalassocracy: Myth and reality*, Stockholm, 1984
The Function of the Minoan Palaces, Stockholm, 1987

HIGGINS, R. *The Aegina Treasure: An Archaeological Mystery*, London, 1979

HOGARTH, D.G. *Devia Cypria: Notes of an Archaeological Journey in Cyprus in 1888*, London, 1889
Accidents of an Antiquary's Life, London, 1910

HOOD, S. *The Arts in Prehistoric Greece*, Harmondsworth, 1978
'An early British interest in Knossos', *BSA* 82 (1987), 85–94

HORWITZ, S. *The Find of a Lifetime*, New York, 1981

KEMP, B. AND R. MERRILLEES. *Minoan pottery in second millennium Egypt*, Mainz, 1980

LORIMER, H. *Homer and the Monuments*, London, 1950

LOWENTHAL, D. *The Past is a Foreign Country*, Cambridge, 1985

LUDWIG, E. *Schliemann: The story of a gold-seeker*, London and Boston, 1931

McDONALD, W. AND C. THOMAS. *Progress into the Past: The Rediscovery of Mycenaean Civilisation*, 2nd edn, Bloomington, 1990

MACKENZIE, D. The Pottery of Knossos', *JHS* 23 (1903), 157–205

MARINATOS, S. 'The Volcanic Destruction of Minoan Crete', *Antiquity* XIII, 425–39

MEYER, E. *Heinrich Schliemann Briefwechsel*, 2 vols, Berlin, 1953

MICHAELIS, A. *A Century of Archaeological Discoveries*, London, 1908

MYERS, J., E. MYERS AND G. CADOGAN. *The Aerial Atlas of Ancient Crete*, London, 1992

MYRES, J.L. *Homer and his Critics*, London, 1958
Handbook of the Cesnola Collection, New York, 1914

NEWTON, C. 'Dr Schliemann's Discoveries at Mycenae', *Edinburgh Review* 1878, reprinted in *Essays on Art and Archaeology*, London, 1880

PARRY, A. (ED.). *The Making of Homeric Verse: The collected papers of Milman Parry*, Oxford, 1971

PENDLEBURY, J. *Aegyptiaca*, Cambridge, 1930
The Archaeology of Crete: An Introduction, London, 1939
A Handbook to the Palace of Minos at Knossos, London, 1933

POLIAKOV, L. *The Aryan Myth*, English edn, London, 1974

POOLE, L. AND G. *One Passion, Two Loves: The Schliemanns of Troy*, London, 1967

POPE, M. *The Story of Decipherment*, London, 1975

POPHAM, M. *The Last Days of the Palace of Knossos: Complete Vases of the LMIIIB Period*, Lund, 1964
The Destruction of the Palace at Knossos: Pottery of the LMIIIA Period, Goteborg, 1970

POWELL, D. *The Villa Ariadne*, London, 1973

RENFREW, C. *The Emergence of Civilisation*, London, 1972

ROBINSON, M. 'Pioneer, Scholar and Victim: An appreciation of Frank Calvert (1828–1908)', *Anatolian Studies* 1995, 153–68

ROSSI, P. *The Dark Abyss of Time: The history of the earth and the history of nations from Hooke to Vico*, English edn, Chicago, 1984

SPENCER, T. *Fair Greece Sad Relic*, London, 1954

STEWART, J.G. *Jane Ellen Harrison: A portrait from letters*, London, 1959

STUART, J. AND N. REVETT. *The Antiquities of Athens, Measured and Delineated*, vols I–IV, London, 1762–1816

TRAILL, D. 'Schliemann's "Dream of Troy" – The making of a legend', *Classical Journal* 81 (1985), 13–24

TSOUNTAS, C. AND J.I. MANATT. *The Mycenaean Age:*

A Study of the Monuments and Culture of pre-Homeric Greece, London, 1897

TURNER, F. *The Greek Heritage in Victorian Britain*, New Haven and London, 1981

VENTRIS, M. AND J. CHADWICK. *Documents in Mycenaean Greek*, Cambridge, 1973

WACE, A. AND C. BLEGEN. 'The pre-Mycenaean pottery of the mainland', *BSA* 22 (1916–18)

WALBERG, G. 'A gold pendant from Tell el-Dab'a' and 'The Finds at Tell el-Dab'a and Middle Minoan Chronology', *Ägypten und Levante* 2 (1991), 111–15

WARREN, P. AND V. HANKEY. *Aegean Bronze Age Chronology*, Bristol, 1989

WATERHOUSE, H. *The British School at Athens: The First Hundred Years*, London, 1986

WINCKELMANN, J.J. *A History of Ancient Art among the Greeks*, German edn, 1764, English edns, London, Boston and Cambridge, MA, 1850–

WOOD, M. *In Search of the Trojan War*, London, 1985

INDEX